ELF ♥ GIRL ♥

REV JEN

Gallery Books

New York London Toronto Sydney New Delhi

Gallery Books
A Division of Simon & Schuster, Inc.
1230 Avenue of the Americas
New York, NY 10020

NOTE TO READERS
Certain names and identifying characteristics have been changed.

First Gallery Books trade paperback edition November 2011

GALLERY BOOKS and colophon are trademarks of Simon & Schuster, Inc.

For information about special discounts for bulk purchases,
please contact Simon & Schuster Special Sales at 1-866-506-1949 or
business@simonandschuster.com.

The Simon & Schuster Speakers Bureau can bring authors to your live event.
For more information or to book an event contact the Simon & Schuster
Speakers Bureau at 1-866-248-3049 or visit our website at www
.simonspeakers.com.

Designed by Jaime Putorti

Manufactured in the United States of America

10 9 8 7 6 5 4 3 2 1

Library of Congress Cataloging-in-Publication Data is available.

ISBN 978-1-4516-3166-1
ISBN 978-1-4516-3167-8 (ebook)

For Faceboy

1

i believe in elves

*I don't really miss God,
but I sure miss Santa Claus.*

❤ *Hole* ❤

Responding to an ad I noticed in the *Village Voice*, I
applied for the position of Christmas elf at Bloomingdale's.
I wore my elf ears to the interview and, when asked why I
was right for the job, simply said, "I am an elf." I got the
job.

For four days, I trained in a classroom called the Elf
Academy. At the Elf Academy, I met the twelve or thirteen
other elves and rose to the position of star pupil. Upon
completion of training, we were issued diplomas and
costumes. My vision of what an elf would wear clashed

horribly with the Bloomie's ideal. For starters, the women were given dresses.

"Dresses!" I exclaimed. "But elves are asexual. Can't I wear tights like the boys?" They said no. I offered to get a sex change, and they still said no. Their getup made me look like one of those women that's painted on the inside wall of that ride at the amusement park that goes around and around and usually plays loud rock by bands like Guns N' Roses. It's usually called the Himalaya or something. I felt like those women, sans ski poles, sans feathered hair, and sans cleavage. Also I sort of looked like a flying monkey from *The Wizard of Oz*. The boys' costumes were much sexier. They got to wear pointed hats, green, lace-up tunics, green tights, and white, silky shirts. The male elves refused to wear the tights because their tunics were actually microminis, and if they so much as lifted up an arm to hang an ornament, they revealed their tight-swathed pee-pees to the crowd.

There's a giant misconception about elves, and it's this: elves are diligent, dedicated workers. The elves of Bloomingdale's were disgruntled, exhausted painters, writers, and actors. Being an elf, "elfing" if you will, turned out to be so boring that I considered breaking ornaments for amusement. My elf friend Chris developed a game that consumed many hours. Chris would remove an ornament from a display tree and put it on another display tree, where it clashed horribly. For instance, he'd take a massive yellow

ornament off the Fiesta tree, which had a colorful south-of-the-border look, and he'd put it smack in the middle of a tree decorated in entirely blue and white. I would then have to find the mix-up, take the misplaced ornament off the tree, and return it.

Elfing drove all the elves to drink. We came to work hungover pretty much every day and spent our lunch breaks at the Subway Inn, a heinous bar that served $1 beers.

I once said to Chris, "When you're an elf, there's really not much else."

Sigrid, our boss, had this theory that customers couldn't be mean to employees in elf costumes. She was wrong. People are *meaner* to you when you have a silly costume on. Despite this, Sigrid continually complained about our state of disrepair, firing one elf whose breath smelled of liquor and almost firing two other elves caught playing tonsil hockey in the storage room. Sigrid was the most groomed, sanitized person I've ever met, and she hated the whole motley crew of us, not that I could blame her. We *were* a disgrace. All we did was shoot the shit and steal candy from the stockroom. We refused to clean our costumes and opted instead for scenting them with potpourri spray right off the Bloomie's shelves. Rumors began to fly about the elves, and we almost all got canned when two elves got in a fistfight in the store. Both elves were female, and both were about five feet tall. The cops

were called to the scene, and one elf was taken to the hospital.

A manager named Lisa Newman really had it in for me, and not because I stole candy or smelled or got drunk on my lunch breaks. She had it in for me because of the way I accessorized my elf costume.

To make my elf costume look more authentic, I donned my pointed elf ears, which I wear all the time anyway. I thought the elf ears would make an excellent addition to my elf costume, and most Bloomie's shoppers heartily agreed. None of the other elves wore them, so I was a real standout. Children stared at me awestruck, while still others wanted to touch them. I only encountered a handful of people who were disturbed by my elf ears, and one of those grinches was Lisa.

The first of the hostile encounters was with a trio of supermodels who squeezed out the sentence, "I don't think those look very nice," before sashaying out the exit. Of course supermodels don't like the ears because supermodels represent one kind of beauty, and the ears are a threat to that beauty. Elf ears are the future of beauty.

The second hostile reaction came from a mother who was trying to convince her child that there are no such things as elves. Perhaps she belonged to a strict religious group that equated elves with witchcraft. I didn't see the mother or know of her desire to obliterate her daughter's

belief in magic, so when the adorable girl asked me, "Are you a real elf?" I replied, "Of course."

She asked, "Is that why you have long, pointed ears?"

"Yes," I said.

At that point, her mother arrived just in time to witness the tail end of our conversation. In an exasperated tone, she reprimanded her daughter and me, "She's not a real elf. She's lying to you." The mother looked at me as if she were going to kick my ass.

If she wanted to destroy her daughter's delusions, that was one thing, but I wasn't going to let her fuck with mine. So I said, "Actually, I am a real elf."

"See, I told you so," the child said.

Luckily, it didn't escalate, and the mother grabbed the child's hand and walked off.

I don't know if Lisa caught wind of this incident, but a couple days later, Sigrid approached me. "Now, you don't have to do this if you don't want to," she said, "and I know everyone loves the ears, but Lisa says they're weird and they're scaring people."

Defiantly, I refused to remove the ears. I was *hoping* they'd fire me because it would make such a great story for the *NY Post*, but they never did. To Ms. Newman's ire, they kept me on, and I made a point of letting the other elves know what a scrooge Ms. Newman was.

"Maybe she had a bad experience with elves as a child," my co-elf Nicolasa offered.

"Maybe she's just an asshole," I suggested.

My relations with Bloomie's floor managers continued to be strained, but the higher management really dug me after I'd given them an Eddie Haskell–type speech about customer service while still a student at the Elf Academy. So when the former Duchess of York, Sarah Ferguson, aka Fergie, was doing an in-store appearance, signing copies of her new book, they called on me for help. There was a huge line, and the store was abuzz. Being stuck in Santa Land, hanging ornaments, I wasn't sure I'd get to see much action, and then it happened. The Bigwigs requested the service of an elf, and might I add, they specified, "Bring that elf, Jen, the one that David Fisher likes." Mr. Fisher, the vice president of Bloomie's, who I guess never caught me drinking at the Subway Inn on my lunch break, was a fan. So, I straightened my elf hat, put on my lip gloss, and headed for the main floor, where I was whisked through the ropes.

"Do you want to be in some press photos, little elf?" they asked.

The staff positioned me at the end of Fergie's table where I was told to show fans to the exit once they received their autograph. Fergie stared at me and then looked away quickly. It was as if her eyes were laughing at me, but she dare not utter the jeers. As I've expounded already, I looked more like a flying monkey than any kind of elf.

Though, logically, I view the Royal Family as a "money-

sucking piece of shit," I have been to so many Renaissance Faires that I am practically a Monarchist. Being near an actual Royal person (albeit a deposed one) was exhilarating. Fergie's security guards were standing right next to me, and they were very James Bond. They carried walkie-talkies, and they all wore what looked like hearing aids. They didn't ask my name, but simply called me "the elf." Most fans were dazed and confused after their celebrity encounter, and that's when I stepped in to gently lead them back to reality.

One of the James Bonds said, "Let's get the elf some weapons." Another showed me his weapons and said I could use them on any unruly fans. One guard went so far as to tell me that big, heavy handcuffs keep your underwear "nice and tight upon your bottom."

"As if I don't already know," I told him.

Luckily no one assassinated Fergie while we were having this conversation, and a few hours later, I was sent back to Santa Land, where I recommenced moping around. As I did, some wealthy Upper East Side type of dude said in a mocking tone, "I thought elves were supposed to be happy."

I seriously doubted whether he knew any real elves to compare me to, so I said, "Yeah, well, I'm a real elf."

Later that evening, I embarked on my journey back to the Lower East Side. A group of jovial subway goers noticed my elf costume busting out from beneath my fuchsia

jacket, and one of them asked, "Are you employed as an elf?"

In response, I took off my jacket and showed them my costume.

"My God, you're a real elf! It must be hard masquerading as a human eleven months out of the year," one of them said.

It was the best compliment I've ever received, rivaled only by a mind-blowing, supernatural experience to follow, some months after the holiday season. My friend Fitz and I were walking home from a pub at around 4:30 a.m. As we made our way down First Street, Fitz noticed a gleaming silver box teetering on the edge of a giant Dumpster.

"What a charming box," Fitz said. We walked over to the Dumpster and realized that everything in it had been ravaged by a fire. We began to dig through the layers of stuff, contemplating what had happened to the hapless owner. We found cigar boxes with pretty ladies on them, and I found a clicking counter—the type of thing museum guards use to count how many people enter and exit a specific exhibition, which I decided I would use to count every person who spoke to me for the rest of my life. (I gave up after four.)

Fitz was more of a daredevil than me, digging his hands into the abyss of the Dumpster, as if he knew it contained a priceless holy relic. He pulled out a patch, the kind one might sew on a jacket, and his eyes lit up. Without a word, he handed it to me.

The patch used to be white, but clearly it had been damaged in the fire and was now a grayish brown. An embroidered image of a Keebler elf sat in the upper left hand corner, and embroidered in the center was the phrase I BELIEVE IN ELVES.

2

the enchanted forest

I almost certainly turned out this way because, before I was born, my mother induced labor by riding the teacups at the Enchanted Forest Amusement Park, fifteen miles west of Baltimore, Maryland. At the hospital, I tried to enter the world feetfirst, so the doctor had to reach his hands inside my mother and turned me around. I was born two hours later, at 3:00 a.m. on July 24, 1972. Amelia Earhart, Zelda Fitzgerald, and Jennifer Lopez were also born on July 24. I think this means I am destined to conquer the world while simultaneously inhabiting an imaginary one, all while looking fabulous.

My father, William C. Miller, was born in Kokomo, Indiana. When I was young, I thought the Beach Boys' song "Kokomo" described the place where he was born. Secretly, I wondered how there could be a tropical oasis in the

middle of Indiana, and I wondered if maybe the Beach Boys were being sarcastic at my father's expense.

My mother, Anne, was born in Bellshill, Scotland, a small town outside Glasgow. Like the man of the future in *The Outer Limits* episode "The Sixth Finger," my mother was born with six fingers on each hand. Her extra digits were chopped off in infancy, leaving little stubs next to her pinkies, where she says she gets "phantom finger pain." Maybe the reason why I have spent so much of my life going out of my way to be a freak is that no matter what I do, I will never catch up to the natural freakiness of my mother.

I have three older brothers: Billy, Chris, and Matt, who are from my dad's first marriage to a woman named Ardith, and one older sister, Wendy, from my dad's second marriage to Anne (my mother, in case you are drunk or stoned and not keeping track).

Even though my siblings were baptized, the local priest refused to baptize me because my mother was Catholic and my father was Protestant. My mother walked out of the church that day and said to the priest, "You didn't just lose one Catholic today, you lost five." As I grew into a heathen toddler, my mother tells me I spoke as if I were at a Renaissance Faire, traipsing into the kitchen in footie pajamas to announce, "Thou art hungry. Thou would like thine cereal." The family found this creepy and thought I might be possessed.

Nowadays, parents seem to be really concerned about

whether their children will grow up to be geniuses. Products such as Baby Einstein "encourage discovery and inspire new ways for parents and little ones to interact." But in the 1970s, parents seemed more concerned with keeping their kids out of the house and off angel dust. My parents routinely "encouraged discovery" by telling all five of us to go play in the woods, but come back by seven for dinner.

The filthy, tangled wooded area that stretched behind the row of brick *Brady Bunch*-style houses on our street was a veritable Middle-earth to me and the rest of the scruffy, Toughskins-clad hellions who played there. New adventures transpired daily, whether it was fort-building, picking honeysuckle, or playing our favorite game, war— which was where we simply threw rocks at each other. Occasionally, our cat, Cheeky, wandered into the woods and climbed a tree he'd underestimated, whereupon we had to call a scary local teenaged hippie, who was probably on angel dust, but who had an enormous ladder, to come and rescue Cheeky. He was the eldest son of a large family that lived nearby. The parental units, who were from Ireland, often hung out at a local pub called the Irish Inn with my parents, who brought us there frequently. When their eldest daughter married, Wendy and I were flower girls at their wedding, which took place at the Irish Inn. We had groovy little yellow gowns, but Wendy thought we'd look really sweet with new haircuts, so she gave us the kind of punk-

rock haircuts only a six-year old can deliver an hour before a wedding.

The youngest daughter, a teenaged cheerleader with ass-long, brown, stick straight hair, was a fashion icon to Wendy and me. She responded to our idolatry by occasionally styling our hair (which quickly grew out of its punk phase), so that by ages six and seven Wendy and I were already tomboy/drag queens, climbing trees in our sneakers, but then rockin' wedges and side-ponytails at school.

Early on, Wendy and I also developed an unhealthy obsession with *The Wizard of Oz*, specifically the Munchkins, who we learned were called midgets. We pretended the woods were an imaginary world called Midget-Land, which was populated with invisible midgets. We were bus drivers in Midget-Land, and we drove the invisible midgets through make-believe towns, describing what we saw along the way. Our best friends in Midget-Land were an invisible midget married couple named Gooby and Jim, who broke up and got back together every day.

On weekends when it was too rainy for the woods and therefore too rainy for Midget-Land, we stayed in and made art, using a box of crayons and the bathroom walls, which my parents figured they would never get us to stop drawing on, so they gave up and let us turn them into an installation. When we weren't working on it, we hung out

in our psychedelic pink and purple kitchen watching our dad make art. Though he was a defense attorney and eventually a judge, he described himself as a "frustrated artist." He drew caricatures of lawyers and judges and a comic strip called *The Robed Avenger*. In it, a mild-mannered fellow named Mervin Twittney is, in reality, the Robed Avenger: defender of the oppressed, protector of the innocent, and enemy of the guilty. Aided by a magic gavel and his trusty dog, Solomon, the Robed Avenger's various adventures ranged from stopping a shopper with twelve items from trying to cash a check in the ten-items-or-less line at the supermarket to thwarting a scalper trying to sell $200 tickets to a Redskins/Cowboys game. Aside from the Robed Avenger, my dad also painted our favorite cartoon characters on our bedroom walls and built tiny houses out of Popsicle sticks for the toy mice that Wendy and I collected, eventually creating an entire town called Mouseville.

In the late seventies, my mom's mom, Agnes, who had emigrated from Scotland with her husband, Francis, was diagnosed with ovarian cancer. Suddenly my "Granny" had no energy for peeling potatoes, watching *The Price Is Right*, or dying her blond hair pink. She was sick, emaciated, and terminal at sixty-four. My mother eventually had her moved from the hospital to the spare room of our house, where she took care of her. On the night Granny died, our house filled up with Irish and Scottish people who waved

around rosary beads and cursed the British. A priest even came, which was truly exotic to me, since my last meeting with one had been as an infant.

A neighborhood father came stumbling in, drunker than our alcoholic bunny, Hoppy (who snuck up behind party guests and tried to lap up their cocktails). As a crowd of people stood around Granny's deathbed crying, Walter picked up what he thought was a box of Kleenex, but were actually latex gloves. He began passing them around, and the mourners, who didn't notice, surrealistically dried their eyes with them. Irish rebel songs played on Wendy's Fisher-Price record player until my Granny could no longer take it. She lifted up her head and said one word, punctuated with a thick Scottish brogue: *Bastards.* Shortly thereafter, the priest gave her last rites and my Granny left for the island of eternal bliss.

Her husband, Francis, my "Papa," followed a year later. He was also only sixty-four, but throat cancer got him. After Papa died, we inherited his cat, Zulu, a big, orange tomcat much lazier than Cheeky, who let Wendy and me dress him up in baby-doll clothes and cart him around in a stroller.

For almost two years after that, everyone in our family managed not to die. My sister and I joined the swim team at the local pool and made real friends who were not invisible midgets. We also established ourselves as fine swimmers among the ranks of the Northwest Branch Blue Dolphins. At

eight years of age, I made it to the county championships' fifty-meter backstroke competition. An early creative visualizer, I pictured the gold medal around my neck. But as I got in the pool, I felt a horrible headache coming on, weakness in my joints, and stiffness in my neck. Altogether, I felt as if I were dying. And I swam like it.

Later I was told, "We could have timed you with a calendar." I didn't care. I didn't want to open my eyes. I wanted shade. The sun hurt. Everything hurt. My parents took me home.

"I can't move my neck," I said, then began to vomit green bile all over the shag carpet. It looked just like the slime they sold at Toys "R" Us. My parents rushed me to a pediatrician named Dr. Fink, a large man who wore a bow tie and whose hands always felt clammy. He examined me and seconds later told my parents something that I didn't hear because everything was hazy. Then suddenly I was at Holy Cross Hospital, where I'd been born eight years earlier. I don't remember how I got there, but it's a big, white, grim building with a statue of the Virgin Mary out front looking sad, probably because she had every reason to feel sad: she got pregnant but never even got to enjoy the boning that would lead to pregnancy. Then her son's father sacrificed him in a brutal manner, for reasons that have never been entirely clear to me.

Then, suddenly, I was on a stretcher. Don't remember how I got there, either, because as it turns out, I had spinal

meningitis, and one of the symptoms is dementia. It kind of felt as if I were floating from spot to spot on a river of death, but I was pretty sure I wasn't dead because a surgeon said, "I'm not gonna lie to you. This is gonna hurt."

But doctors *always* lie. They *always* tell you it won't hurt, and it *always* hurts. Was he practicing reverse psychology?

Then I had a spinal tap sans anesthesia.

He wasn't lying. It hurt. I cried.

That's how I knew I was alive. Eight years earlier, when the doctor turned me around and pulled me from the simplicity of intrauterine existence and slapped my ass to let me know, I cried and knew I was alive. And it's how I knew I was alive when I watched my granny go, feeling tears burn my cheeks and watching the other mourners crying too, wiping away their tears with latex gloves.

3

jen magazine

I came away from my meningitis recovery with three important things. The first was a stack of psychedelic coloring books my cousin Robin, who was an art student, gave me in the hospital. The second was some minor brain damage that resulted in a lapse in memories about pre-meningitis life. For instance, I only know I was a bus driver in Midget-Land because Wendy tells me I was, and I only know I spoke in a made-up language because my mother tells me I did. Details are hazy, nonexistent, or constructed.

The third thing I came away with was the knowledge that all life is suffering, but not in the "life sucks" sense of the word, more in the "being separated from the primordial goo from which all beings come and go is suffering" sense of the word. Less of a goth phase, and more of a never-ending existential crisis.

It was the kind of existential crisis that could only be quelled by starting a magazine.

I wasn't going to let being a child with no money get in the way of my dream. As a youngster, I wasn't interested in books, but I loved magazines, the trashier the better. My mother came home from the grocery store with them, and I plucked them out of the bags before she had a chance to read them, primarily the *National Enquirer* (I found *People* and *Us* a bit highbrow).

From the student body of Cannon Road Elementary, I assembled an editorial team: my friends Lorena Rivas and Jen Platnick. With their assistance, and the help of the Xerox machine in my dad's office, *Jen Magazine* was born. This was before *Oprah*. It was even before the ill-fated *Jane*, in a time when people hadn't started naming magazines after themselves yet, but given the number of girls I knew named Jennifer, it seemed like a great title. *Jen* was full of recipes, poetry, celebrity fluff pieces, and apocalyptic "Jen Dixon Predictions."

Jen survived into the early eighties, but when I got to junior high, I simply had too much to do and let it go. There, I established myself as an exemplary nerd by openly collecting troll dolls and becoming president of the foreign-language club, due to a passion for Latin. This, combined with my not having developed the curvature necessary for a training bra—even after puberty—meant I was largely shunned.

A few years later, I got to Springbrook High School, where the faculty assumed I was going to be trouble because my brothers Chris and Billy had done such things as coming to school drunk, getting in fights, and stealing the giant statue from Bob's Big Boy and then depositing it on Springbrook's front lawn. While my brother Matt was well behaved, Wendy, who had become the most popular girl in the state of Maryland, frequently skipped school to frolic with her quarterback boyfriend.

The popular girls dated jocks and had big hair. The outcasts wore ripped-up Iron Maiden T-shirts and carved their boyfriend's initials into their arms. I flew under the radar. I had four friends: Emily, Andrea, Jenny, and Lorena, and we did none of these things. We liked art, beat poetry, and punk rock. Considering the top hitmakers of our day were Foreigner, Wham!, Glenn Frey, and Starship, it's not surprising we embraced punk. Sometimes we went on expeditions to the 9:30 Club in D.C., where we attempted to mingle with real punk rockers, but we stood out like sore thumbs with our unscuffed Keds and delighted smiles.

Luckily, Emily had an older brother who was in the marines. He took pity on us for being uncool. We were too young to drive or buy beer, so he did both for us. No day was ever boring with this drill sergeant organizing our activities. He gave us lessons in tourniquet tying, grenade-throwing, and camouflage makeup application. He introduced us to the fun of minor vandalism—stealing garden

gnomes and "forking" lawns (obtaining a box of plastic forks and depositing each fork individually in someone's lawn the night before a big frost). Another time, he took us to the supermarket, where we purchased several pounds of flour. We then snuck onto our school's football field and wrote WE LOVE SATAN in flour on the field the night before a game. We returned the following week and tried to write FUCK YOU but only had enough flour to manage FUCK.

These acts enriched my high school experience. So did my getting accepted, at fifteen, to a free art program at another school, taught by the most maniacal art teacher in the western hemisphere: Oroon Barnes, a deer-hunting, chain-smoking painter from Alabama, who would toss your painting across the room and accuse you of being legally insane if you didn't stay up all night working on it. Oroon once ripped the PA off the wall with his bare hands when the school's morning announcements interrupted a lesson he was giving on cubism. He taught his students to sacrifice sleep, sanity, and any semblance of a normal life in order to be artists. From him, I learned that being an artist wasn't a way to coast through life. It required discipline. My idols became Warhol and Picasso. I'd been obsessed with Warhol ever since seeing him on an episode of the *Love Boat* as a child, and Picasso I loved because he was the Michael Jordan of painting. I hung a picture of Picasso over my bed and prayed to it, "Please, Picasso, let me rock the world with my art."

My older brothers teased me, "Picasso was a faggot! Picasso was a faggot!"

"No, he wasn't," I'd scream, shooing them out of my room. "Picasso got a lot of ass!"

In Maryland, anything creative is commonly associated with satanism or homosexuality. Hence, I was regularly persecuted. When I was sixteen, the cool kids in my high school painted YOU ARE A ART FAG in giant letters on the street in front of my house. I knew it was the cool kids because of the grammatical error. It should have been "an art fag." Because the street was state property, the state hired people to come to our house and pave over it. The graffiti incident embarrassed my parents, but only boosted my self-esteem. It meant I was already the most famous artist on my block.

My confidence bolstered, I left the following year for New York City.

4

everything under the sun

In 1990, I arrived in New York to attend the School of Visual Arts. Because SVA didn't have traditional dorms, I took a room at the Parkside Evangeline, a Salvation Army residence on Gramercy Park South that looked like a haunted mental institution. My tiny room came with a desk, a bed, and a closet, and that's all there was space for. My only decorations were a replica of a shrunken head, a Ramones poster, and one troll from my collection.

It was my first time being away from Maryland for an extended time, and I had not one friend in New York. To top it off, the Parkside was an all-female residence. It was like *Bosom Buddies* without Tom Hanks or the other guy to keep me in high jinks.

Eventually, I did make one friend while dining in the Parkside Cafeteria. Her name was Julia, and she wore

red, hip-hugger bell-bottoms and had long, straight, jet-black hair, just like a true beatnik chick. I started talking to her because I was desperately lonely and also because she looked like the type of groovy person I'd get along with. Turns out I was right, because we spent the next ten hours conversing rapidly. She was also an SVA fine arts major, and like me she loved Kerouac, 1970s TV shows, and punk rock. We started hanging out daily and eventually moved into a more spacious double room together.

Julia and I both wanted to make more friends, but aside from us, most of the women at the Parkside were absolute freaks—not tattooed, pierced freaks one might expect to find in New York, but women who looked eerily like zombies. Their skin had an unearthly green glow to it, and Julia even claimed to have witnessed one of them turn into a bat and fly off the roof. We became convinced that Major Miller, who ran the Parkside and was therefore the only dude allowed in the residence, was actually drugging the food. Because we were broke, we ate it anyway, sure that it would soon transform us into shape-shifting members of the undead.

Our favorite of the freaks was a woman we nicknamed Shinehead, who slathered her entire head, hair included, in Vaseline. Shinehead had a mischievous hobby of dumping buckets of ice-cold water out of her window onto unsuspecting pedestrians. She also monopolized the

Parkside's communal television, cranking it to its highest volume and laughing hysterically while sitting an inch from the screen. Even if it was *Cagney & Lacey* or *60 Minutes,* she found it uproariously funny. If anyone got to the TV before Shinehead, she disregarded that resident's desire for entertainment by sitting directly in front of whoever was there. Despite finding Shinehead's behavior fascinating and amusing, we realized more than anything it was sad. We also realized that if we didn't get out of there and get laid, we would be guffawing right along with her.

Whatever feminist coined the phrase "a woman without a man is like a fish without a bicycle" never visited the Parkside. I had been told that the Parkside was a residence for young women, but found many of the residents to be elderly women who had lived there since they were young women, and who had in that time developed romantic liaisons with other formerly young, now elderly residents. This produced a constant stream of soft-core, elderly lesbian porn in the cafeteria, lobby, and elevators.

At least I'll make friends at school, I thought, expecting other art students to be free-spirited Bohemians. To my horror, most of my classmates listened to Phil Collins and wanted to work in advertising. It seemed hopeless until I switched my schedule around and took a writing class taught by an old hippie who addressed me as Sunbeam. His class was filled not with fine arts students but with film students. They were quick to befriend me, especially since I

was willing to write their term papers in exchange for money and pot.

A girl named Karen offered me LSD in exchange for a paper on Euripides. Even though I'd spent my adolescence watching ABC after-school specials where hippies jumped from windows during bad trips, I wanted to try it. Karen suggested I spend my first trip with her and her friend Matt at the Museum of Natural History's Hayden Planetarium, watching the Pink Floyd laser light show. By offering a variety of laser shows throughout the years, the Museum of Natural History has catered to youths who misuse their planetarium as a place to experiment with hallucinogens.

Julia came along, and she, Matt, Karen, and I each did two hits of acid, which came in pill form, a little disappointing since I thought LSD came in the form of stamps with psychedelic imagery like hookah-smoking caterpillars on them. Once we were seated in the planetarium, an amplified voice announced that we were "about to embark on a journey" where we would see "colors as bright and vivid as the universe itself" while "hearing the music of a band from planet Earth: Pink Floyd." We prepared for liftoff by putting our laser glasses on and kicking back. At about the exact moment the first beam of light was projected, the LSD kicked in, transforming the world into a bewildering circus of beauty. I could breathe in color and feel light caress me as each dormant atom in my body rushed forward and danced to

the music along with every creature in the universe. "Everything under the sun is in tune," Pink Floyd sang, and I couldn't have agreed more. It was as if LSD were a sorcerer casting a spell on whoever took it. And it was all so funny! So funny I cried. So spectacular I realized that all I knew was that I knew nothing.

After the show we went to Matt's, still tripping, and spent the next twelve hours drinking beer, dancing to the music of the Doors and watching the walls turn into bloody liquid, which for some reason was hilarious. When it was finally time to crash on Matt's floor, he handed me a corduroy pillow. Because corduroy makes that *wah-wah* sound, it's already hilarious, but a *corduroy pillow*! "I'm making headlines!" I said, which was a joke I'd read in *Highlights* as a child. *This* was so funny, I laughed for almost an hour.

After that, I fell in love with LSD, 'shrooms, and mescaline—anything that could make my day a little more like a Disney movie where all the pots and pans and clothes and other inanimate objects come alive and dance. And like a character in a Disney movie, I was usually the only one aware of this dance and certainly the only one dancing along.

Most of the time I tripped with Karen, Julia, and Matt. When the Oliver Stone movie *The Doors* premiered, we dropped acid and went to see it. We began to peak just as Jim Morrison was having a freak-out in the desert. Elation

soon followed, but toward the end of the film, we were dumbstruck with horror as the film melted. Not just in our minds—the film really melted. On another occasion, we wandered into a supermarket looking for gummy worms (a great food to eat while tripping), where I ventured into the coloring-book/magazine aisle. As I wrote my name in the "this book belongs to" section of every book there, someone handed me a coloring book. It was opened to a page that featured Big Bird, Ernie, and Bert depicted as the cubist women in Picasso's *Les Demoiselles d'Avignon*. I did not know that the book was titled *Sesame Street Visits the Museum of Modern Art*, so I thought that Bert, Ernie, and Big Bird had become cubist only in my mind. Terror engulfed me as I thought I was finally going insane, until I flipped the book over and saw the title.

On average, Julia and I were doing psychedelics a few times a week, and our room began to reflect this. At the entrance, we'd hung a banner that said SWEATHOGS FOREVER—a nod to the characters on our favorite TV show, *Welcome Back, Kotter*. Lining the walls was a manifesto we'd written called "The Sweathog Constitution," which referred both to *Welcome Back, Kotter* and various art techniques. The actual tenets of the manifesto I can hardly remember, only that it was signed in Ben & Jerry's thumbprints and cigarette ash.

At the center of our room sat a Hasbro Easy-Bake oven we'd purchased, since hot plates and microwaves were

strictly forbidden at the Parkside. Because the Easy-Bake ran on a lightbulb, it took over twenty minutes to bake one cookie. Since we were on acid and therefore not sleeping, we didn't mind! Surrounding the Easy-Bake was a growing mess of unwashed laundry, overflowing ashtrays, schoolbooks, and huge, trippy paintings. Despite our love affair with psychedelics, we still worked hard at school. I even replicated Vermeer's *Woman with a Water Jug* twice, once using tiny pieces of paper cut from magazines and once using colored pencils. As much as I loved hallucinogens, I loved art more, because art would keep my ass from having to return to Maryland, where I'd have to work at the mall for the rest of my life.

We painted day and night, and our formerly brown but now rainbow-hued carpet was evidence of this. Therefore it was no surprise that after Major Miller and his cronies inspected our room, we received a nasty letter from him informing us that if we didn't clean up our space, we'd be evicted. The letter went so far as to mention our "dirty underwear" on the floor. "How did he know it was dirty? Did he pick it up and smell it?" Julia asked.

Terrified that we would be thrown out and subsequently forced to leave school, we set to work cleaning. Julia mixed paint to create a shade the exact color of our carpet, which she then used to paint the carpet back to its original brown. Meanwhile, I went to the SVA student library and checked out every Holy Bible there. We placed these conspicuously

around our room. Next we took down our manifesto and replaced the SWEATHOG banner with a pink, taffeta bow. We were allowed to stay, though Julia was still paranoid we'd be thrown out at any moment. One night while we were tripping on mescaline, she went into the bathroom and hallucinated an entire scenario where the major came into the room and told me I had to move out.

As the school year wound down, Karen invited Julia and me to a party in Jersey City at a building where a number of SVA students lived. It was a seventies-themed party, where everyone dressed in butterfly-collar shirts and bell-bottoms. Because Julia and I only had enough money to shop at the Salvation Army, we wore this style of clothes anyway. That night we were drinking instead of tripping, and by the time we got to Jersey City, I was drunk. The dude who opened the door to let us in had long blond hair and a handlebar mustache. He wore skintight, powder-blue slacks and a tight, ivory, blue, and brown shirt with the top three buttons undone, revealing ample chest hair and a hamburger-patty press he wore as a medallion. His nickname was Dog, short for his longer nickname, Dog P.

Since kids nowadays tend to do lots of Internet dating, they might not be familiar with the phenomenon of love at first sight. It's a curious feeling separate from lust. Basically, it's what happens when you look at someone and he looks at you, and your *soul* recognizes *his soul* and vice versa, in a way that even if you're a hardened atheist, you suddenly

believe in *the soul*. And you suddenly believe in Santa Claus and the Easter Bunny and elves and every other magical thing ever imagined, because you have just experienced *love at first sight* and it's as mind-blowing as seeing a unicorn.

I'm sure it's what I felt when I saw Dog, and I'm fairly certain it's why we went into his bedroom, smoked a joint, took off our clothes, and made love. I'd only lost my virginity a few months before leaving for New York (to a hippie named Travis on the floor of the Ebb Tide Motel in Myrtle Beach, South Carolina), and I'd certainly never had a boyfriend. Despite my lack of experience, Dog and I had the kind of chemistry that ensures great sex.

We lay in bed holding each other, until the pot mixed with the booze mixed with the magical feelings made me suddenly queasy and I leaned over and vomited in a cup next to his bed. This demonstration of my unbelievable uncoolness did not prevent him from chivalrously inviting me to sleep over. In the morning, we didn't exchange numbers, but I knew I would see him again.

We didn't meet up again till the next school year when I moved into the unofficial student housing in Jersey City. The apartments there were huge, and I knew attempting another year at the Parkside would kill me. Julia thought I was crazy to move to Jersey and she moved into a cheap hotel on Ninety-Seventh Street. My new roommates were Jackie, Monica, and Camilla. Monica was an elfin hippie

with long, red hair. Jackie was a skateboarding graffiti artist. And Camilla moved out shortly after moving in.

I'd been there for a day when I heard a knock at the door. Opening it, I found Dog and two of his friends. I had no idea what to say. The last time I'd seen him, I'd fucked him and vomited in a cup next to his bed. He handed me an invitation to a party he was throwing, to which everyone in the building was invited.

At the party, people danced to disco and drank King Cobra malt liquor. Dog had three roommates: Goat, Jonathan, and Simon. Goat looked like Derek Smalls from *Spinal Tap*, was obsessed with *Star Trek*, and had a shrine to porn hidden under a unicorn tapestry in his bedroom. Their apartment was the single foulest thing I have ever witnessed. Toys and action figures were everywhere. They had located a Hasbro toys Dumpster around the corner from SVA, and they raided it for decorations. Giant "My Little Pony" displays stood alongside defective Mr. Potato Heads and stacks of beer cans. At the center of the living room, they'd erected a shrine to Jim Henson, which was festooned with *Sesame Street* figurines, pictures of Jim Henson, a giant *Dark Crystal* poster, and candles.

As the party wore on, more visitors arrived. I met Dog's friend Cheese, a video-game addict who loved cheese and who had the notoriety of being the only person to ever fail out of SVA. I also met Alan and George, two film students, who were obsessed with the Don Johnson/Mickey Rourke

vehicle *Harley Davidson & the Marlboro Man*. When I visited Alan's dorm later that year, I bore witness to the fact that his walls were covered in posters from *Harley Davidson & the Marlboro Man*, which wouldn't have been so odd except that they were all the same poster.

Most of Dog's friends were film and animation students, and they all shared an obsession with the number twelve. Dog explained that twelve is a magical number. Twelve inches in a ruler, twelve hours in a clock, twelve signs in the zodiac, twelve months in a year, a dozen, a twelve-pack, twelve apostles in the Bible, and so on. They penned songs about twelve, did paintings of twelve, wrote about the greatness of twelve, and created twelve types of dances, each based on a different type of cheese. Because I lived on the twelfth floor and had a mother born with twelve fingers, Dog considered me a sort of demigoddess of twelve.

Once the party cleared out, Dog and I went upstairs to my room on the magical twelfth floor and made love for the second time. From that moment on, we became inseparable. As high as I'd been watching *Floyd Laser* under the influence of LSD, I was now higher. I was nineteen, in New York City, and in love.

5

slurpee technician

While I was going to art school, Wendy was attending Frostburg State, a "party school" in western Maryland. Following my sophomore year, she invited me to spend the summer with her and her friends at a beach house in Ocean City, Maryland. I wanted to stay in Jersey City with Dog, but that was financially impossible, so off to O.C. I went. Before I left, Dog gave me a troll necklace he made.

The beach house was a three-bedroom shanty, and my "bed" was a busted mattress in the corner of a room I shared with three blond sorority girls. My four male roommates were out-of-control frat boys whose company I'm ashamed to admit I enjoyed. One of them, Byrd, was the neighborhood pot dealer. Like most potheads, he worked at the boardwalk's amusement park, until he was fired after forgetting to strap a child into the giant swings. Luckily the

child was uninjured, but frantically swung his arms around while his parents looked on in terror and Byrd stared out at the ocean unaware of the debacle.

Because I was the youngest in our shanty, I became the butt of my roommates' jokes. My first week there, I found a bikini-clad troll of mine strung up by a noose, its tiny body swinging back and forth. One night while I was sleeping, my male roommates came into my bedroom with a large fishing net. They threw it over me and shouted, "We caught a big one! Let's reel her in!" To infuriate them, I pretended to continue sleeping while they piled foreign objects upon me—pillows, suitcases, dishes, and finally a bicycle. I responded in turn by helping Wendy torture the drunken Byrd, who took no notice when she tied dumbbells to his shoelaces.

After Byrd was fired from the amusement park, he spent all day in our shanty with his friend Hal, who now lived rent-free on our couch. Byrd cleaned our apartment furiously because he had nothing else to do. "You damn bitches are dirty!" he hollered at my female roommates and me. "You left your goddamn running shoes in the hall," he'd scream at Wendy.

"Yeah, well, you left Hal on the couch for the past two weeks," she screamed back. Hal and Byrd soon took to crabbing in the bay out back, where they were miraculously the only people in Maryland to crab every day for two months and never catch a crab.

I needed a job, so I headed to the boardwalk, where I tried to obtain work in a T-shirt shop, hoping I'd be able to steal troll T-shirts. It was 1992 and troll fever was at its peak. Every store on the boardwalk sold troll T-shirts, but no one wanted to hire me.

The only place that would hire me was the Ninety-Fourth Street 7-Eleven, or Sleven as it's called in Maryland. Perhaps some of you have been to the 7-Eleven where I worked. Or maybe you even came to my 7-Eleven and made fun of me.

It was by far the busiest Slev in a town full of them, and it had a reputation as the wildest partly because the night shift (for which I was hired) was staffed with stoners and surfers. When we got off work, usually at 4:00 a.m., we often hit the tail end of a party before passing out on the beach at sunrise.

The Ninety-Fourth Street Sleven was small so it only carried the essentials—wine, porn mags, candy, cigs, and beer. More beer is sold in Ocean City, Maryland, during the summer than in all the other counties in Maryland combined during the rest of the year. I know that Maryland is a small state, but Ocean City is only five miles long.

My sadistic roommates mocked me for working the most uncool job at the beach, referring to me as a "Slurpee technician." My sister, on the other hand, had the coolest job at the beach. She was a beach lifeguard and had it all: the red bathing suit, the lifeguard paraphernalia, and the

perfect tan. I was pasty from working under the Sleven fluorescents.

Every day, I roller-skated to Slev, which was considered unhip, especially since I fell on my ass frequently. Whenever this happened, a car full of tan, shapely teens invariably drove by, slowed down, and applauded. Another time I was sweeping the lot when some teenagers in a Jeep hurled their gnawed buffalo wings at me.

As uncool as I was, I still made a lot of friends because I had access to beer. The terrible thing about selling beer in Maryland is that you can't sell beer after 2:00 a.m. After two, we put locks on the coolers. Customers responded by trying to pull the locks off or bribing me. Sometimes I got phone calls from people who were too drunk to leave their homes, asking me to deliver beer.

Tobacco products were kept over the registers along with packs of single condoms. The condom trios and fancy brands such as Rough Rider and Kiss of Mint were kept in the medicine aisle. I had worked at Slev for about a month before we started selling condoms since Sue, a Holy-Rolling Sunday-school teacher who worked there, had convinced the owner, Hoss, that selling condoms was immoral. My coworker Kim responded by going to the clinic and getting a bag of free condoms, which she sold under-the-counter for ten cents each. Eventually Hoss caved and I was forced to assemble the condom display with Sue, who uttered one word the entire time: "Sluts."

Later, my coworkers Chippy and Eric (a long-haired surfer with a troll tattooed on his ankle) decorated the condom display. Above each row, they scrawled a size—peewee, xxx small, xx small, x small, and small.

Although beer and cigs were our bread and butter, Big Bites, or large, grilled hot dogs, were also popular. The worst thing about them was the chili and cheese designed to go on top of them, both of which smelled like canned dog food.

At most Slevs the customers are free to use the chili and cheese dispensers, but at Ninety-Fourth Street we had too many crazy, drunken customers to let them play with the machinery. So they hovered over me shouting commands about their chili and cheese. Usually it was enough to just wash your hands beforehand, but one customer freaked out on me.

"You're not going to pick that up with your hands?" she asked, referring to the hot dog bun. Wendy told me that I should have responded, "Would you prefer that I pick it up with my ass cheeks?"

While the chili and cheese machines were off-limits, customers were allowed to use the microwaves, which commonly equaled disaster. Often a wasted person would put a frozen burrito in the microwave and accidentally set the timer for fifteen minutes, during which time it would explode. I'd then have to scrape the microwave's bean-blasted interior with a widget while the customer looked on sheepishly saying, "Sorry, dude."

Ofttimes, I'd walk around the store "fronting the shelves" (pulling all the merchandise forward) and customers wouldn't know I was a Slev worker. This was because Ninety-Fourth Street Slev workers weren't made to wear the beige smocks that say 7-ELEVEN in red all over them since Hoss recognized they were demeaning and unattractive. Because smocks were a company requirement, we threw on secret smocks that we kept under the registers when the inspector paid us a visit. My secret smock had a name tag that said SEAN. We were also supposed to wear long pants, so I had to throw on a pair of purple, elastic-waistband sweatpants we kept stashed under the register. I don't know why they wanted us to look so uncool. Someone at the Sleven corporation should think seriously about redesigning the getup.

I've heard that working at Slev is one of the most dangerous jobs in America. I don't know how accurate this is, but I know that in our Slev bathroom we had instructions on what to do if the store got robbed. Despite that I was probably putting my life on the line daily, I loved Slev since it was a great place to study people. All types of people shop at Slev and they all want different things. Little boys want tattoo gum. Truck drivers want Vivarin. Sick people want Theraflu. Stoned people want Ben & Jerry's. Thirsty people want Gatorade, water, Fresca, or Mr. Pibb. What they choose is of little importance. It's all about the ability *to* choose—to rot one's teeth with Fun Dip, one's

lips with chewing tobacco, one's liver with Mad Dog, or ones lungs with Marlboro.

Oh Thank Heaven for 7-Eleven, the slogan declares, and if you've ever needed condoms at 4:00 a.m. in Ocean City, Maryland, you know that's no bullshit.

One night I was working and some hipsters came in. One of them said to me, "You're so cool. In fact, I think you're the coolest person I've ever met. Why do you work here?"

"Aside from the fact that I have no marketable skills, I really like it here," I said. And it was true. Though I missed Dog and school, my time at Slev was satisfying on some deep spiritual level. I'd plummeted to the depths of uncoolness, like descending into the underworld, and had come back with divine knowledge. I wasn't sure what exactly that knowledge was—only that I was wiser for it.

6

pop rox

During my third year of art school, I started wearing prosthetic elf ears. I don't really remember why. The only thing I can remember from 1992 is that a forty of King Cobra cost $1.63.

That year I spent a lot of time hanging out with Dog, Julia, Monica, and my art nerd friend Erik whom I met in philosophy class. Erik and I discussed our favorite artists endlessly.

In the early nineties every art student in the world wanted to be either Matthew Barney or Basquiat. The kids who wanted to be Matthew Barney spent a lot of money on their art, and the kids who wanted to be Basquiat spent a lot of money on heroin. I had never done heroin and planned on never doing heroin. I only tried cocaine once in the parking lot of a Dunkin' Donuts with Karen and an ex-

convict named Jimbo. I hated it. I was not cool enough to be either Barney or Basquiat. The polished aesthetic of Barney did not appeal to me, and the expressionistic aesthetic of Basquiat did not appeal to me.

Erik and I took a performance art class with art world luminary Mike Smith, which only about five other people signed up for. It was the best class I'd ever taken. People did the outrageous and Mike Smith encouraged it.

"Performance art," he explained, "is about becoming a giant asshole." This concept thrilled me because most contemporary art was austere, slick, and superficial. I went to galleries every week and they were filled with minimal pieces that were all about artists pretending like they didn't have assholes.

• I had a part-time job at the time working for a sadistic art consultant named Alice. She worked out of her two-story apartment on the Upper East Side, where she earned $75 an hour and I made $7, even though her taste in art was crap. We went to corporate locations and decided what art they should have on their walls. I watched people work in their cubicles as if I were on a wildlife safari. I noticed they did a lot of moving papers around as if they were dazed and confused. I felt sorry for them and even more sorry for them after Alice hung up the framed pieces of shit she considered "charming." Her greatest compliment for a painting was to refer to it as charming.

In response I made a sculpture that was a little chair,

upholstered in a hideous plaid fabric and shaped like a human butt. Legs made from adolescent books such as *Are You There, God? It's Me, Margaret* and *Blubber* held it up. I called it Charming Butt Chair. I made several other butt chairs and even a rococo-style butt swing.

Around the time I was making butt chairs, I became interested in video art. Dog, who was an animation major, taught me how to cast stop-motion animation dolls, and I made two elf dolls who looked exactly like me. Their names were Jen and Jen. I made a short movie where the dolls come to life after witnessing my classmates taunting me for getting a bloody nose during a critique. Both Jens then butcher my classmates in an extremely bloody manner much in the way a doll attacks Karen Black in *Trilogy of Terror*. The film was not well received. People were also scared of the dolls, which I hung from my studio doorway like bats.

After the total lack of success of my first video, I decided to make another. I spent four weeks building a tiny replica of a Subaru Brat complete with snakeskin upholstery and beaded chair-covers. Subaru Brats have always been my favorite car/truck since they possess a heinous aesthetic that could have only existed for a few years in the 1970s. Plus they say BRAT on them in block letters and come in strange color combinations such as orange, brown, and yellow ocher.

Once the mini-Brat was complete, I built two unicorn

dolls whose manes were blond mullets and who wore Metallica T-shirts. In this video, the unicorns meet the Jen dolls and make out with them to Led Zeppelin's "Kashmir." Then they get in the unicorns' Subaru Brat and get in a horrible accident where they all die. I then pick up all of the dolls and cry intensely while carrying their corpses to the toilet. As "Amazing Grace" plays in the background, I flush the dolls down the toilet, and in a surprising moment we see that the water is now bright blue as if it were cleansed with their souls. Again the film was not well received.

My minimalist sculptor professor asked, "Why would anybody make this?"

I responded to the misanthropic art school coolness all around me with humanism. I made a T-shirt emblazoned with the phrase I LOVE HUMANS to counteract the legions of black Joy Division T-shirts my classmates wore. Julia photographed me wearing it in SVA's cafeteria while being shunned by everyone there. I titled the photo *Hanging Out with My Friends*.

My feelings of uncoolness were compounded by my fear that I'd developed halitosis. My wisdom teeth were coming in, and my amateur theory was that all of the action in my oral cavity was causing stinking bacteria to build up. I was a social cripple—afraid to laugh in the presence of others for fear of offending them with my dragonlike halitosis. Instead of having my wisdom teeth removed, I suffered quietly.

Julia thought this was hilarious and she began to refer to me as Hal—short for Halitosis. Soon, we both began to refer to anything uncool or marginal as Hal. We made lists—a monkey's red butt, a Dodge Dart with flames on the sides, the drawings in *Teen Beat*, David Hasselhoff's hair, sandals from Woolworth's—all very Hal things. Even after my wisdom teeth found a home in my mouth and my halitosis was a thing of the past, we realized that *we were Hal . . . that Hal is everywhere and that Hal lives in every creature great and small.*

By our senior year Hal became our religion. We wrote a bible, *The Hal Bible*, which explained the basics of Hal and which claimed we were the sons of Hal. Julia wrote a chapter in which she described Hal's soul entering our bodies as we traipsed up Lexington Avenue. We dubbed Woolworth's "the house of Hal" and we ate lunch there every day. The Woolworth waitresses were priestesses of Hal wearing Hal's greasy secretions upon their stately red and gray robes. The soda was Hal's blood and the food, his body. A few years after we graduated, Julia even got a job at Woolworth's, where she worked until the great five-and-dime's demise. I tried to get a job at Woolworth's but they wouldn't hire me. I was too Hal for the house of Hal.

We went straight for the most Hal aesthetic possible. Julia made collages from Woolworth menus and hung them in her studio. I painted my entire studio bright yellow with red stripes to look like a generic Always Save product from

Waldbaum's. At the entrance to my studio, I placed a tin that said PLEASE GIVE TO THE EAR ENHANCEMENT FUND OF AMERICA, and it had a drawing of a normal ear with a line through it and, next to it, an elf ear. My fund made fifty cents all year. I barricaded my studio with trash cans so that the teachers, most of whom were anti-Hal, couldn't see what I was doing or bother me.

Eventually my studio became too messy and I moved into Julia's studio. We lined the floor of her studio with upholstery foam so that after our carbohydrate-filled communions at Woolworth's, we could lie on the floor and conceptualize projects. One day while conceptualizing we decided to start a band. That neither of us could sing or play an instrument did not deter us. Julia was under the delusion that she could sing, and I had spotted a $2 toy guitar at Woolworth's, which I thought I could use to rip some tasty chords. Within a day of our preliminary discussion, we had everything planned out. We named ourselves Pop Rox after the candy treat, which is rumored to have killed Mikey from the Life cereal commercials. Our band uniforms were snow-leopard-print unitards, which aptly revealed our out-of-shape Hal bodies. Our goal was to preach the ways of Hal through rock 'n' roll. We decided to hold our first gig in one of the lecture rooms of the sculpture building. We invited our classmates and our professors. To ensure that no one would walk out during our gig, we would put a lock on the door. We also scented the room with a bottle of perfume

from Woolworth's and we drank two forties of Schaefer before our gig.

Once our audience was seated, we locked the door and put the key in a safe place. Looks of horror spread across the faces of the crowd, as they were now captive. Our first show was all covers—"Enter Sandman," "Sweet Child of Mine," and "School's Out for Summer" were just a few of the tunes we belted out. We had taken pieces of foam off the floor of Julia's studio and painted faces on them. They were Buddy (on drums), Friend (on base), and Ted (on keyboards.) Actually, on Ted we hadn't drawn a face, just a bunch of acne because Ted was the youngest member of our band at fifteen. Every now and then we turned to our "band" and said something like "Friend, take it away!" Then we would just watch the piece of foam do nothing.

Most people sat through our first gig in agony, but a few enjoyed it, including our friend Derrick, who became our biggest fan. He was so supportive that we gave him his own piece of foam, named Derrick's Friend.

After our first show, we began to write original material. Our first song was called "Woolworth's, You Are My Best Friend" and it dealt with our love for Woolworth's with lyrics like "Woolworth's, you are my best friend. Woolworth's, I love you to the end. Cheese curls and cream drops, Ambervision, Thighmaster, ooh, it's the tops!" We also had a song called "Sleep All Night," which was set to the tune of "Rock All Night" only it went, "Sleep all night!

Sleep all day!" The reaction to our new material was positive, but the art students whose studios were near Julia's were forced to experience the daily hell of trying to work while listening to us rehearsing.

Julia and I fought constantly. She often got mad at me for accessorizing my unitard with a vest, and I would get mad at her for making fun of my hair. At the time, I had short hair and she told me I looked like Michael J. Fox.

We decided that what Pop Rox needed was not guitar lessons or animate band members but a set of wheels to go touring in. Because our combined savings did not exceed $3, with three huge pieces of cardboard we fashioned a van that we harnessed to our bodies while using our legs to propel us. Because grunge was the fashion and music choice of the day, we called our new wheels the Grunge-Mobile. The day we premiered the Grunge-Mobile, we wore flannel shirts and drew heroin tracks on our arms, but because we didn't know what heroin tracks looked like, ours looked like train tracks. We "drove" the Grunge-Mobile several times down the middle of Seventeenth Street.

Julia and I spent a lot of time sitting in my tiny room at the youth hostel where I now lived, watching Hal movies. One night we rented *Just One of the Guys*, a film that I remembered as being Hal. In it, a high school girl who writes for the school paper becomes incensed when her article does not receive an award that she thinks it deserved. When she overhears her male English teacher

make a remark to another male teacher about her miniskirt, she chalks her failure up to sexism. She reasons that if she goes to another high school dressed as a dude and submits a piece of her writing as a dude, she will win the award. So she dresses as a dude and goes to another high school, and wackiness ensues.

As Julia and I watched this, a lightbulb went off in our heads. We would go to school dressed as dudes! We were the only female sculpture majors at SVA at the time, so it seemed appropriate. Sculpture has always been on the macho side, and SVA certainly had no shortage of manly "penis builders." But we would be manlier than any man there. I already looked like a boy with my short hair and small breasts so I transformed easily into Victor, my fictional older brother and manager. Victor, a sleazy little man, sported a thin, John Waters–style mustache. I was sort of attracted to him, actually. Julia had a tougher time because of her large breasts and hips, but we figured if we made her character fat, we would be able to cloak her feminine features, so Julia became Cecil—Pop Rox's bodyguard. Victor and Cecil made frequent appearances at school where they had conversations about their "girlfriends" while Victor chain-smoked cigarillos. Derrick found a stash of some of the most hilarious porn I'd ever seen—*Big Butt* and *Juggs*. Cecil and Vic often sat in lawn chairs inside the sculpture building, thumbing through the porn mags while our fellow students made things.

Victor and Cecil even made an appearance in the Patrick Swayze vehicle *To Wong Foo: Thanks for Everything, Julie Newmar*, after Julia saw an ad in the *Voice* looking for club kids and drag queens to appear as extras. We arrived at the audition carrying candy and flowers for Sylvia Fay, the casting agent. She cast us immediately. But our foray into Hollywood turned out to be a disaster. The shoot took over thirteen hours, and as we weren't union, we received no overtime. As the shoot wore into its tenth hour, the drag queens became furious, threatening to walk off the set.

"I can't even buy my hormones with this money!" they screamed at the frightened production assistants, who attempted to appease them by tossing hundreds of McDonald's hamburgers at them.

The school year was winding down and many of our classmates were preparing to go to grad school at Yale, which had a prestigious MFA program. Julia and I also thought we'd like to go to Yale, but considered ourselves too important to apply, let alone pay, for more schooling. Instead we drafted a letter to admissions at Yale wherein we explained the importance of spreading the word of Hal to Yale students. We suggested they pay our room, board, and tuition and provide us with Commando G.I. Joe Jeeps, which were little children's battery-operated cars we'd seen at Toys "R" Us that cost about $300 apiece. We sent Yale descriptions of our daily agenda—rolling out of bed in our

camouflage outfits at sunrise to begin handing out *Hal Bibles*. We received no response.

Even though we were both only twenty-one, Julia and I thought Pop Rox should have a major retrospective at an art gallery. We didn't waste time meddling with smaller galleries. Instead we went straight to the most prestigious gallery in New York—Leo Castelli on West Broadway. We also didn't waste time sending slides or a video. Instead we went there in person in our Pop Rox outfits. "Is Leo here?" I asked the receptionist.

"No. He's in Europe," she replied.

"Do you mind if we wait for him?" I asked.

"Yes," the receptionist said.

"I guess we'll have to wait for him outside," Julia suggested.

"Can you tell him Pop Rox stopped by?"

On the way out we slipped a letter to Leo under the back door, which explained the Hal religion and the music of Pop Rox.

With the end of the school year came many parties, which meant many Pop Rox gigs, only the people throwing the parties didn't know they were Pop Rox gigs. Usually these unexpected "shows" were greeted with shouts of "Go Away" and "Shut Up." The final party we crashed was SVA's end-of-the-year-pizza party.

"What can we do that is so Hal it will ruin everyone's appetite?" we pondered. The answer was quite clear—we

would dress as pieces of shit. Our shit suits consisted of brown leotards and brown hats with fake dog-doo glued to them. We looked like shit, alarmingly hideous. When we arrived at the party, people moved away from us exclaiming that we were grotesque. People put their food down and looked at the floor.

After the pizza party, Julia and I took the Grunge-Mobile for a spin with Friend, Buddy, and Ted taped to the backseat. Only on this journey, Ted never came back. When we got back to the sculpture building, we went to untape our foam friends and saw that Ted was gone, just like that. The wind had taken him.

7

no users, losers, boozers, or mimes

After graduation, I got a room at the Greystone Hotel on Ninety-First Street through SVA. My roommate never showed up so I only had to pay half the rent for a place big enough for two. Julia soon moved in with me, followed by a lesbian friend of Julia's ex-boyfriend. The room was large for one person, small for two, and claustrophobic for three.

I got a job as a cashier at Canal Jean Company, where I worked long hours for little pay in an environment filled with obnoxious tourists who treated me like crap. Julia landed an even more prestigious job at Pearl Art Supply, where she worked insane hours on the crafts floor, selling Bob Ross paint sets and candlemaking kits. Each day, our

dreams died just a little more. We salvaged what little money we could to buy new Pop Rox outfits and equipment. I splurged at Toys "R" Us and bought a mini-drum kit that said ROCK THE WORLD on the bass drum.

But Pop Rox was obviously going nowhere fast. Leo Castelli was apparently not getting our proposals. Art stardom was a long way off, and working for The Man made it seem a pipe dream. This reality proved too much for Julia. She took off for a farm, where she stayed with some relatives. I promised Julia I would get Pop Rox a real gig somewhere. She promised to come back when I did.

As the fall rolled around, I was booted out of SVA housing to make room for actual students. I looked at the housing section in *New York Press* and found an ad for a room that only cost $325 a month in Williamsburg, Brooklyn. It simply said, "No users, losers, boozers, or mimes." The author was a painter named Robin, who despite being unwilling to live with mimes was very kind. We hit it off and I moved in. She had an amazing collection of books and I read everything she had, from Iceberg Slim to Henry Miller to cheesy paperbacks about the Mafia.

Robin hung out with an all-girl rock band called Thrust. At one of their gigs, which featured a dancing vagina and penis, I spoke to a man who told me he was a reverend. He explained that the Universal Life Church, a nondenominational church in Modesto, California, had

ordained him and that they'd ordain anyone for free. I went home and sent a letter to the ULC requesting ordination. Within a week, I received my certificate. Contacting Julia, I urged her to do the same. Soon we were both reverends.

A bar near my new pad called 612 became my fave hangout. Shockingly, all I did was ask and they gave Pop Rox a gig. They didn't even ask to hear a tape, which was lucky for Pop Rox. The gig was to be a memorial for Ted, our foam keyboardist who fell off the back of the Grunge-Mobile. I made fake milk cartons with Ted's face on them that said MISSING and wrote poems about Ted to be read in between songs. I contacted Julia and told her the good news.

A couple of days before the gig Julia arrived. We went shopping and bought monk robes and new Pop Rox costumes. The new costumes were bright orange, sleeveless unitards, which featured gold quilting around the stomach. They were cut off at the thigh, like hot pants, and from the thigh down to the ankles hung orange fringe. They were the most disgusting, unflattering outfits we'd ever seen, and we coveted them. We wore our monk robes around SoHo and handed out flyers for our gig.

But on the night of the gig, Julia complained that she felt ill and didn't want to do the show. The thought of Julia's backing out of the performance horrified me.

"You have to do the gig!" I exclaimed, which was completely unreasonable. Julia *was* sick. The gig was *not*

elf girl ❤ 55

important. In fact, it was a *memorial for a piece of foam*. But looking around at all the milk cartons, the pictures of Ted, our new outfits, and my drum kit, I wanted to cry. Julia and I fought, and in an instant she left New York City to go back to the farm.

I'd made a promise to 612 to put on a show, so I called Monica.

"Will you be one-half of Pop Rox tonight?" I asked.

"What do I have to wear?" she asked, frightened.

"You'll see."

She almost backed out when she saw the outfit, but I gave her a blond wig so she wouldn't be recognized, and I wore a long, black wig with pink streaks in it. At the bar, I put pictures of Ted on each table and set up the ROCK THE WORLD drum kit. A few audience members trickled in, along with Dog and one or two of his friends. Once about six audience members were present, the show began. Monica knew none of the lyrics so she just kept a beat on the drums while I sang.

At the end of the show, three people were left. Pop Rox was over, never to rock the world again. The next few days I spent lying in the bathtub, sobbing. Julia had chosen nature, happiness, and a real quality of life over the world of make-believe I was still trying to inhabit. Would I be next? I worked six days a week at Canal Jeans and made exactly $300 a week. I certainly couldn't afford paint or canvas, so I bought ninety-nine-cent composition books

and began writing. It was the only thing that helped me escape the despair of the breakup of the world's most Hal rock band and, more important, the loss of Julia, who would probably never speak to me again.

incantations

My meager retail job hardly paid the rent, so Monica offered to introduce me to Lauren Wittels, a gallerist in SoHo, who needed an assistant. I was shocked when Lauren hired me. I had no experience, computer skills, or social skills, and I dressed like Shirley Partridge. Working at an art gallery meant going to other galleries and picking up art, press kits, and bios whenever there was a group show. I dreaded the chore because it meant dealing with gallery receptionists who treated me like an ass. Then one day Lauren sent me to American Fine Arts to pick up a press kit. In the back of the gallery sat a man in blue suede shoes, a 1970s prom-style dress shirt, and more gold rope chains than Mr. T. I had never seen anyone like him working at a gallery. I had no idea he ran the place.

"What's your name?" he asked.

"Reverend Jen."

He asked where I was from and I told him Maryland. He said that John Waters, who showed at American Fine Arts, was also a reverend from Maryland.

"Maybe I should curate a show of all reverends from Maryland," he said.

"Maybe you should give me a one-person show," I said.

He introduced himself as Colin de Land and told me he would think about it. He asked me to bless the show since I was a holy woman. I walked around doing an impromptu incantation while Colin took pictures. It was the wackiest art gallery I'd ever been to, and I was fascinated. That night I wrote Colin a fan letter and asked if he'd like to go to Woolworth's with me for a cup of tea. A few days later I received a response. According to Colin, my blessing worked. The show had been selling well since my incantation. He requested I come to their next opening and bless the show.

To that opening I wore a denim jacket upon which I'd hand-painted ART STAR on the back in pink glitter puff paint and REV on the breast pocket. Like a seasoned professional I waved my hands around in front of the art and chanted in a made-up language. Again my blessing worked. They even sold a piece on opening night. Colin was now fairly convinced that I had magical powers. When a Mark Dion sculpture of a tar-covered tree with tar-covered taxidermic animals hanging from it failed to sell,

Colin had me come back in to bless it a second time, after which it sold.

He had the kind of faith in me that Peter Pan had in Tinker Bell, and for a couple of years I blessed every show at AFA, until one day my powers ceased to work. Colin asked me not to bless any more shows, for fear people might start returning artwork.

I still attended the openings because they were the craziest show in town. Colin could often be found in the gallery's back room talking on a giant inflatable phone that was taped to a normal phone. "People laugh at his giant phone when they come into the gallery, but he forgets that he's on a giant phone and he thinks they're laughing at him," his assistant told me. Faceboy often brought his giant bong to the openings, sat on the floor, and smoked bong hits. People always thought he was part of the exhibition. Another time I came to an opening dressed as an old lady. A dude sat in the middle of the gallery singing artists' contracts in a monotone as people stood still listening. I started dancing wildly as if I were Courtney Cox in the "Dancing in the Dark" video. Colin looked at me and said, "What you're doing is important." It was the first time (maybe the only time) anyone called my work important.

One eccentric who religiously attended AFA openings was Ed Schott, a painter who became my official biggest fan. Ed went so far as to cover the sides of his truck in giant, detachable paintings of me. One painting depicted

me kissing a frog. Another painting was of my head on a nude troll's body. It was titled *Rev. Jen Naked*. Some people thought the truck was scary, but I loved it.

I dropped by AFA regularly, where I befriended Danny and Patterson, who'd been members of Art Club 2000, an art collective that showed there. Eventually Patterson asked me to be part of a show that involved his starting an art school in the back of the gallery. I made a coat of arms for the school emblazoned with heraldry symbolic of art school: an ass, an X-Acto knife, a unicorn, a can of beer, and a roll of duct tape. Eventually Colin also invited me to show some of my videos at AFA, specifically one where I'm wreaking havoc around town in a brown Teletubby costume. It was almost as if I had gallery representation.

Tragically, Colin de Land died of cancer in 2003 at only forty-seven. If young art stars were like Jedi Knights, he was our Yoda, the only gallery owner to whom I will ever write fan mail. He brought fun and openness to an art world that desperately needed both.

9

faceboy

During downtime at Lauren Wittels Gallery, I composed several notebooks of writing. I wanted to read from them onstage somewhere, but didn't think a place existed where I could. I wished there were a place like Cabaret Voltaire, where the dadaists assembled eighty years earlier. Drafting a letter to Bill Gates, I requested $300,000 to open such a place. When Bill Gates failed to respond, Monica suggested I read at *Faceboy's Open Mike*, a weekly show at a theater around the corner from her East Village pad. Faceboy was the younger brother of John S. Hall, the lead singer of King Missile, Monica's favorite band.

I was wary, expecting to wander into a room filled with pretentious poets who, in an attempt to appear cool, were regressing to a much cooler era by emulating the poetry-reading style of Kerouac and Ginsberg. I wanted to progress,

even if it meant facing the fact that my own era was totally lame.

The open mike was at Collective Unconscious, a run-down theater on Avenue B and Second Street. Actually, to call it a theater was a stretch. It was more of an art hole where artists lived and made art. When I approached the space, a crusty hippie at the door told me it was their Con Ed benefit night and collected $3. I met the show's host, Faceboy, whose real name was Francis Hall, a handsome, bald young man. He told me to write my name down on the list of performers. Because of my recent ordination, I wrote *Reverend Jen*. I never expected it to stick. At least twenty performers went on before me, all doing something different: comedy, dance, music, poetry, and storytelling. People smoked weed and brought their own beer. I sat in the audience transfixed. All I could think was *So this is where art went*.

I became a regular there and began to worship Faceboy, considering him the coolest person alive. One week he announced he needed a stage manager for a play he was directing. I shot my hand in the air and took the helm as stage manager for a play starring John S. Hall and Maggie Estep. I almost peed myself when Faceboy invited me to a "cast party" at his apartment after the show. He was so cool! However, when I got to the party, I found Faceboy and his friend Jeff sitting alone, drinking vodka. I couldn't believe it Faceboy was the epitome of Hal. We quickly became buds.

The open mike inspired me to write every day. It was unreal to me that only a few months earlier I'd written beneath an essay, *I don't know why I'm writing this because no one will ever read it or see it.*

Before Faceboy's open mike, I'd felt hopeless. But now people were seeing and hearing my work. I was asked to perform in several shows around the city. Andrea Scott, who was curating a performance series at Lauren Wittels Gallery, asked me to do two performances as part of the series. Other performers included my former teacher Mike Smith and my former classmate Toland Grinnel. The first night I performed a twenty-minute informative lecture all about Hannah, a stray cat that my sister and I found living under our house in Maryland, whom my parents adopted. The place was packed wall to wall with people who were forced to listen to a detailed account of Hannah's daily activities and to my theories regarding what happened to Hannah's parents and siblings. At the end of the performance I gave out Hannah Fan Club Memberships.

The following week, I performed a twenty-minute piece about trolls where I showed informative charts explaining different troll brands. I also passed around trolls for audience members to caress and observe. One particularly sad-looking troll in a nautical outfit got passed around and came back to me sans its clothing. Later Monica admitted to having undressed the little fellow. Years later, the same

troll lost its mane of yellow hair when I lent it to Mick Rock for a photo shoot.

One artist who'd been included in the series was Lauren Szold, who gained art world recognition because of installations consisting of heaping masses of pancake batter solidified on gallery floors. She planned on doing a performance where she would drench her nude body in pancake batter. Lauren the gallerist told me that Lauren the pancake-batterist asked if I could help her mix the pancake batter for her performance. Lauren the gallerist told me I didn't have to do it. I was paid to be a gallery assistant, not an artist's assistant, and she would understand if I refused. I agreed to do it anyway, always trying to make up for incompetence with enthusiasm. The next day Lauren Szold came to the gallery carrying giant buckets and pancake mix.

From the get-go, she spoke to me as if I were her indentured servant. Not a *please* or a *thank you* was uttered as I mixed and carried thirty-pound buckets of pancake batter from the hallway sink into the gallery. Keep in mind my arms are like two spindly sticks. As I carried the giant buckets back and forth, she sulked and only spoke to me to make demands. I should have told her to shove her vats of batter up her ass. But I did not want to cause strife between the artist, curator, and gallerist so I kept my mouth shut.

I was carrying one of the final buckets to the

homestretch when my arm gave out. The bucket tipped over and pancake batter ran down the hall at lightning speed. It seeped into my shoes and covered my socks. It was everywhere. Lauren Szold flipped out.

"Look at what your assistant has done!" she screamed at the other Lauren, my boss. Meanwhile, though I was on the verge of tears, I jumped into action, cleaning up the mess, but the batter had already begun to harden in my shoes so it was hard to walk. Lauren Szold stormed out in a huff.

Once she was gone, Lauren and I were seized by uncontrollable laughter over the complete and total absurdity of what had just occurred. I decided that Lauren Szold was simply the Gallagher of the art world. (Gallagher is a hack comedian who achieved fame in the eighties by destroying watermelons in a maniacal manner. He hands out emergency ponchos to audience members so they won't get covered in watermelon.) So, after work I went to Woolworth's and picked up a ninety-nine-cent emergency poncho, returning to the gallery for the eight-o'clock performance. Once again, the place was jammed. When it was time for Lauren Szold to take the stage, she waltzed out draped in a towel and laid a drop cloth on the ground. She dropped the towel and stood naked. At that moment I went into my backpack and got out my poncho, which was folded into a tiny square. As I unfolded it, the sound of vinyl unfurling was thunderous. People stared. It must've

taken three minutes to unfold it completely. Finally I draped it over myself and took a deep, exhilarated breath. Lauren Szold continued her performance, covering herself in pancake batter, rolling around and screaming. I was also performing, but I didn't have to utter a peep. My bright yellow poncho did my screaming for me.

10

the anti-slam

Like a nursery school production of a Midsummer Night's Dream without a nursery school's budget.

♥ *Faceboy* ♥

Where performance meets a cry for help.

♥ *Village Voice* ♥

Arriving at Collective Unconscious one Sunday, I found a sign on the door stating that a blazing inferno had destroyed the interior of the theater. The sign announced that Faceboy's show had moved to Surf Reality, a theater located on Allen Street, a few blocks away from Collective. I wandered until I found Allen Street, a desolate thoroughfare on the Lower East Side. Surf Reality was distinguishable from the other run-down buildings on Allen Street by its

welded-metal front door that looked like something out of *Mad Max*. Behind the metal door lay a steep staircase flanked by walls festooned with psychedelic mural paintings. At the top of the stairs lay the cozy theater.

Beneath Surf stood a bodega that sold crack pipes and one dusty can of Coke that no one ever bought because people only went there to buy crack pipes. Next to the crack bodega was a storefront psychic, and next to the psychic a bodega that sold many varieties of Budweiser.

A married couple named Jenny and Robert Prichard ran Surf Reality and lived in a loft directly behind it. The two met on the set of *The Toxic Avenger*, where they both played villains. Robert had long hair and huge biceps covered in tattoos. He had one rule that he strictly enforced in the theater, and that was *no smoking of tobacco products*. You could smoke as much as you liked in the hallway, but Rob went ballistic if he smelled tobacco inside the theater. At one open mike a performer was receiving an onstage blow job from another performer, much to the audience's delight. But when the performer who was being fellated lit up a cigarette, Robert ran into the theater and screamed, "Put out that cigarette!"

Faceboy's show attracted artists who didn't belong anywhere else, where outsiders could feel like insiders. The more I went to Faceboy's, the less I cared about the acceptance of the formal art world. Stepping outside of the gallery scene and looking in, I realized it was too well

behaved for my own taste. If being in the art world is like being in the army, then art school is like boot camp. If you get out of art school and decide that you don't care to be part of the art world, it's like going AWOL. But I had to be true to myself, and I didn't share the art world's goal of legitimacy.

At most art openings, the attendees looked as if they'd just stepped out of a Gap ad. People dressed conservatively and kept their voices down because, with the exception of Colin de Land and a few others, no one wanted to stand out. It was all about keeping quiet, sending out your slides, kissing ass, getting a gallery show, and then (hopefully) being granted legitimacy by the handful of critics who could ruin your life. But at Faceboy's show, I'm not so sure any of the artists even *had* goals.

My favorite open-mike regular was Michael Portnoy, a performer who later gained notoriety for jumping onstage during Bob Dylan's set at the Grammys with SOY BOMB written on his chest. Michael was tall, svelte, good-looking, and quiet—the kind of guy you'd like to bring home to meet your parents. Onstage, however, he was a lunatic. One night he arrived at the open mike in a cheerleading uniform with two orange cones attached to his chest, carrying a bullhorn. He dragged the entire audience down to the sidewalk and leapt into the middle of Allen Street, where he began directing traffic. A truck slowed down and he jumped onto the hood.

"Hey, get off my truck!" the driver screamed.

"No. *You* get off the truck!" Michael screamed back.

Another night, Michael was naked, ranting onstage, when he spotted an audience member reading a book by Roland Barthes. He snatched the book out of the audience member's hand. "Roland Barthes!" he screamed. "Can Roland Barthes do this?" he asked, yanking his penis about and dancing wildly. He pulled a tube of purple paint out of his bag and began to paint his penis purple. "Can Roland Barthes do this?" he asked, holding up his now purple penis.

A friend of mine recently reminded me of a time when Portnoy emptied his bottle of Prozac onto the stage and then attempted to stick his penis inside the bottle. On still another occasion, I saw Portnoy play the theremin with his penis.

A few weeks after Faceboy's show relocated, I relocated to an apartment two blocks away from Surf Reality. I liked Brooklyn, but I needed more space even if it was in the form of a filthy sixth-floor walk-up tenement apartment that smelled like urine, which it was. I moved in with a girl named Christie I'd met at my new part-time job selling clothes at Antique Boutique, where I worked on the days when I wasn't working at the gallery.

In 1995 no one wanted to live on the East Side below Houston Street. For readers unfamiliar with Manhattan, Houston Street is a big street that runs east/west. It separates the Lower East Side from the rest of the world,

and it is pronounced How-Stun, not Hyou-Stun like the city in Texas. In the early nineties the Lower East Side was still a junkie's paradise paved with overflowing garbage and dilapidated buildings, so the rent was cheap.

Everyone in my building was Dominican and Catholic, hence my elf ears and style of dress weren't welcomed too warmly at first. When I climbed the stairs after a long day at work, children playing in the hallway shrieked, "It's the witch!" before running inside to hide from me. Eventually, the children grew into teenagers who realized I was just a strange but ultimately harmless person, and that even if I was a witch, I must be a good one.

Shortly after I moved, Collective Unconscious found a new home on Ludlow Street, a block away from my apartment, in a building that had formerly been a brothel that fronted as a tailor shop called Cucho Taylor. They painted the exterior of the new Collective silver and affixed what looked like monster-robot pieces to the awning. Inside they painted the walls black and decorated the bathroom in mannequin parts, flashing lights, and a "real mirror," which is a nonreversing mirror that my friend Bex pointed out makes it difficult to style one's hair.

While Collective was preparing to reopen, I ventured into other theaters. A poet friend of mine, Jen Webby, went to the Nuyorican Poets Cafe to check out their Wednesday-night poetry slam. Afterward, she described to me a scenario where hipsters paid a door cover of $5 to get into a

dimly lit bar. At the bar, the MC for the evening randomly selected three judges from the crowd. Then poets graced the stage and did three-minute sets. At the end of each act the judges rated the poet's work on a scale from one to ten, so a perfect score would be thirty. At the end of the evening, the high scorer won the slam. Webby was a finalist, so they asked her to come back to compete in the more distinguished Friday-night slam. She didn't do well at the Friday-night slam and told me later that she felt creatively raped by having her art reduced to a numeral.

Fresh out of art school, I resented all forms of art criticism. The thought that people were voluntarily subjecting themselves to it was shocking. I decided to pay the slam a visit. I paid my five bucks, signed up, and read a piece about nose picking. While the piece received a combined score of twelve—the lowest that evening—someone from the audience yelled out, "She's ahead of her time!"

I went back the following week to see if I couldn't score a little lower. I wore my Pop Rox "shit suit," and my friend Kyle also donned a brown outfit. Onstage, we made a variety of fart noises. The audience booed and screamed for us to get off the stage. However, we remained onstage for the entirety of our three minutes. Not only that, we signed up twice. So that night we made fart noises for a total of six minutes. The two performances received a combined total score of five.

Sitting in my kitchen one evening with Faceboy, we discussed the poetry slam phenomenon. Faceboy pointed out that by going to the slam weekly, I was contributing to its success financially. Instead, he suggested I create an alternative, and together we came up with the idea for Reverend Jen's Anti-Slam. It would be kind of like the slam, only performers could do whatever they wanted, and they'd all receive perfect scores no matter what. Faceboy was an experienced host and he offered to help me. I decided to host the Anti-Slam at Collective Unconscious, which was almost ready to reopen.

Opening night of the new Collective, I staged a production of a play I'd written called *Halitonia* about a fictional land of Hal ruled by three deities named Roy, Gee, and Biv. Faceboy directed the play, and I made all the scenery and costumes out of cardboard. An hour before the show, we realized there were no curtains to conceal the actors backstage from the audience. So Faceboy ran out and bought five ninety-nine-cent mildew-resistant shower curtain liners, which served as Collective's curtains for the next five years. I propped up the scenery with twenty-four-ounce cans of Budweiser. The actors drank the beer throughout the production, and by the show's end all of the scenery collapsed. The play was a success except for when Michael Portnoy, who was playing a unicorn, threw a chair at the audience. Lauren had brought two friends to the show, and the flying chair just barely missed their heads.

A few days later, I held the first Anti-Slam. I'd spent two weeks giving out flyers to everyone in the free world. I even managed to slip a flyer to Allen Ginsberg at a Chinese restaurant, and he commended me on the concept. Later I expanded this event to be "the time I had dinner with Allen Ginsberg." On the Anti-Slam's opening night, I stationed Monica directly outside the Nuyorican poetry slam, handing out flyers to people who looked as if they'd lost.

Despite my efforts, only four people attended the first show, and they were freezing because the space had no insulation or heat. Determined that the show must go on, I worked even harder at promoting, sending out press releases to every paper in the city. Within a few months, people began to come in droves, which was hardly surprising given the show's many selling points. At the Anti-Slam, performers got six minutes instead of three minutes for almost half the price of the slam. And if they kept under six minutes, they got special little prize packets called Rev. Jen's Funless Packs. The Funless Pack was modeled after Faceboy's Fun Pack, which included a Blow Pop, a mint, a condom, and a picture of Faceboy that he claimed was for masturbatory fodder. The Funless Pack included one square of toilet paper, one Q-tip, one Band-Aid, and one tea bag with the little tag torn off the end so you burned your fingers when you made your tea. The Fun Pack and Funless Pack were good devices for encouraging performers to stay within the time limit so that everyone

got to be heard. I also posted two signs above the stage that reminded performers DON'T BE DICKS, SAY IT IN SIX! and, DON'T BE A WHORE, SAY IT IN FOUR! Like the Funless Pack, a great deal of the Anti-Slam was modeled after Faceboy's show. In many ways, it was a spin-off, my *Joanie Loves Chachi* to Faceboy's *Happy Days*.

Both of our shows had three main rules: no heckling the performer, no assaulting the audience, and no trashing the space. (Considering the original Collective burned down, the third rule was extremely important.) Still, performers often had the misguided notion that they were the Who, and attempted to trash the stage. One performer, Steve Naidich, used to smash the Anti-Slam timer just to piss me off. One night he even went so far as to steal the microphone while onstage and run out the door with it. I chased him down Ludlow till I got it back. Another time, a nude performer ran his spread-out buttocks along the mike stand, and I was not quite sure if this was a transgression of rule three. Nevertheless I ran to the kitchen and returned with 409, which I used to carefully clean the violated mike stand.

Under the influence of alcohol, I occasionally added extra rules. For two years, no one was allowed to insult John Tesh (former star of *Entertainment Tonight* and solo recording star), and I have no idea why I brought this rule into existence. But then a performer named Pete Gerber, who claimed to have met John Tesh, did a set where he

described him as a major asshole, and I was forced to change the John Tesh rule to a "no insulting Alf" rule. I also added a "no mugging the audience" rule (and I didn't mean Mr. Furley-style mugging; I meant actually stealing money) after one performer who claimed to be doing a conceptual performance piece mugged an audience member named Frank. Frank eventually tracked down the perpetrator, who was a regular at the Anti-Slam (pre-rehab) and got his wallet back, but it was missing twenty bucks. I also occasionally added a "no hurling chairs" rule because certain performers went through phases where they hurled chairs. I also had to add a "no kicking art stars in the head" rule after a performer named Handsome Joe Hanley kicked another performer, Jason Spiro, in the head.

Performers who broke the rules too many times were commanded to sit in "the chair of shame," a tiny child's chair, for six minutes. I used to place the chair of shame onstage and force the penalized performer to sit in it with his or her back turned to the audience. But then I realized performers were *trying* to get into the chair of shame for more stage time, so I started placing it directly outside the bathroom.

Every week, new performers attended the Anti-Slam. Usually they either excitedly embraced the lunacy of the show or they never returned. Sometimes they became regulars, but then they'd start getting laid or they'd get a job, only to return a few years later after they'd gotten

dumped or fired. Many of the regulars at the Anti-Slam became regulars because they had nowhere else to perform. For instance, Tommy D. Naked-Man (aka Tommy Nutsack) a fiftysomething man who appeared to have elephantiasis of the balls, was also a nudist and a poet. He fit right in at the Anti-Slam! The first time he disrobed at the show, wild applause and shrieks of joy and horror broke out. People did the wave.

"His nutsack was like a frigging Hippity Hop!" my friend Tom later said.

The long-term Anti-Slam regulars became my second family, and like any family we gave each other nicknames. Mostly, we referred to each other by last name even when the person already had a wacky stage name. A comedian named Mike Raphone became Raphone. Francis Gleason, a retired lawyer who drove up from Philadelphia every Wednesday for the show, changed his name to Francis McNerdz, which eventually got shortened to McNerdz. Don Eng, a Chinese interpretive dancer, became Eng or sometimes Mr. Don Eng Rising. Vinny Fallon became Fallon. Walter Gambine became Gambine, and Peter Gerber eventually became Gerber, which eventually became a widely used verb. (To *gerber* someone's joint meant to hold on to it for just a bit too long.)

One of the ways I managed to continually keep new performers and audience members coming was through special-event Anti-Slams. Throughout the years, I held an

Anti-Slam prom (where I hired a limo to take me exactly one block to the show), an Anti-Slam Christmas Pageant, a "Bring a Normal Person to the Anti-Slam" night, and a Professional Secretaries Day Par-Tay, which is still an annual tradition. Because Professional Secretaries Day (also called Administrative Professionals' Day) always falls on a Wednesday, it is the official Anti-Slam holiday. Each year, I fill a piñata with stolen office supplies and do live reenactments of *Nine to Five*.

At the Anti-Slam and at Faceboy's Open Mike, audience members could (and still can at the Anti-Slam) witness anything and everything. The Anti-Slam taught me an important lesson: just when you think you've seen it all, a performance artist out there will do something with food items you could never have imagined. Just when I thought I'd seen it all, a man would gallop onto the stage in a Speedo and explain Hegel while simultaneously pouring baking soda and vinegar into his Speedo, forming a science fair-like volcanic explosion to occur within his swimsuit, which then began to seep out of the tiny holes in the Speedo's fabric and explode on the stage, causing the first row of audience members to run in terror. No, I have not seen everything, but I have seen that.

The main selling point of the Anti-Slam has always been that everybody receives a ten no matter what. I even select three judges to yell "Ten" after every act. At one point I also made giant hands with 10s on them like the

kind you see football fans waving at games, for the judges. (They were eventually covered in cat pee and I had to throw them out.) The mandatory ten system was embraced by most. But a few were critical. One woman said to me, "If you baby the performers, they won't get better."

I told her, "If you want to get better, go take an acting class or a writing workshop. If you want to express yourself, come here."

A couple of weeks into the Anti-Slam, a regular named Diana Moonmade told me she had a dream wherein the Anti-Slam regulars were singing in a choir while wearing robes with ART STAR emblazoned upon them.

Inspired by her dream, I began to refer to every performer who graced the stage as an Art Star. Soon the performers referred to themselves and each other as Art Stars. Eventually, we began referring to the open-mike scene as the Art Star Scene. While ours was not the first group to use the term *Art Star*, we were the first to use the term to apply to artists who are unknown, unsuccessful, and poor. In the past, other artists waited for critics, gallerists, and magazines to label them Art Stars. We did not need to be legitimized by anyone, so we took it upon ourselves to become ASS—the Art Star Scene. ASS is the most democratic art scene ever, in that anyone can be part of it simply by showing up. Though we are not confined to one geographic location (since many Art Stars have been exiled to the outer boroughs by high

rents), the eye of the Art Star storm has always been on the Lower East Side.

Despite that pretty much anyone (except for maybe Dick Cheney) can be an Art Star, I am often asked, "How do you become an Art Star?" So even though this is *not* a how-to book, I am including a simple thirteen-step plan to attaining Art Stardom.

How to Be an Art Star
(in Thirteen Easy Steps)

1. Eliminate hobbies

Everything an Art Star does should be done with obsessive/compulsive zeal. To take an example from my life, it wasn't enough for me to simply collect troll dolls. Instead, I turned my home into the Troll Museum. If you're thinking of collecting LEGOs, why not build a giant LEGO hut and attempt to live in it?

2. Carry through on even the craziest ideas

You might be sitting at a bar with a friend, discussing Teletubbies, and you might say, "Wouldn't it be fun to dress as a drunk Teletubby and visit various toy stores throughout the city?" True Art Stars wouldn't just talk, they'd go out and make a Teletubby costume, then they'd actually go visit the toy stores.

3. Avoid self-improvement

Unless you plan on learning Elvish or Klingon, avoid self-improvement. Self-improvement is for people with time on their hands, and Art Stars have no time on their hands.

4. Practice dating as performance art

Nothing will sap an Art Star's energy faster than a serious relationship. So, date only as a form of performance art. Date people who fascinate you, not people who appear to be boyfriend or girlfriend material. You can save a lot of money by dating a crazy person because you don't even have to go out. Just listening to your date's delusions will be entertainment enough.

5. Be fashionably early

If you are invited to a party with an open bar and the party is scheduled to start at eight, be sure to get there no later than 7:59. There is no sense in pretending you're not all about the free booze and food. Stand right next to the kitchen so that you can snag the hors d'oeuvres as soon as they're available and piping hot.

6. Only take jobs that offer *no room for advancement*

The last thing you want is to get roped into a job that will prohibit you from staying out until four in the morning five nights a week. That's why I recommend taking the

crappiest job you can find, but also try to find a crappy job where you have access to a copy machine, the Internet, and a fax machine. With a copy machine, one can make flyers, books, and posters. With a fax machine and the Internet, one can send out press releases in bulk. Do accept raises, but don't accept promotions. A promotion means more work.

7. Get a strange-looking pet and name it after yourself

That way, if you die, you leave behind a tiny, four-legged Art Star who will carry on your name. Don't bother having kids: a pet cannot rebel against you. It's important to get a *strange-looking* pet so that you can incorporate it into your art. Being an Art Star is sort of like being a superhero without the superpowers, and all superheroes have a sidekick.

8. Take your hair seriously

It's fine if you want to wear elf ears, platform shoes, wacky hats, or underwear over your outerwear, but *don't* joke around with your hair. You still want to get laid, after all.

9. Develop a signature style

A good rule of thumb is to take all of your favorite clothes and put them on at once.

10. Learn to deal with rejection

Rejection is no big deal. It's simply a person's deeming worthless everything into which you've poured your mind, heart, and soul. Accept that he or she must be a bad person, and move on.

11. Make art

I would do this, but I am too busy.

12. Write filthy gossip about yourself in local bar bathrooms

Once you scrawl your first bit of filthy self-aggrandizement on a bathroom wall, you will be amazed at the far-reaching consequences. Hundreds of bars are out there, and that means hundreds of free quotes all pertaining to your remarkable skill as a lover.

13. Have fun

If you're having fun, you probably don't need this list. Being an Art Star means figuring out exactly what you want to do and then *doing it*, even if it is absurd, illogical, or insane.

11

performance art:
drunk and topless

After five years together, Dog and I split. The magical unicorn emotions I'd felt in the beginning had begun to fade. He still blew me away and I still loved him, but our lives were moving in two different directions. He had California and success on his horizon, and I had the Lower East Side and instability on mine. We were both about to grow up, and I didn't want our love to grow up too, since part of growing up means rotting, weakening, and eventually dying. Instead, I chose to preserve what we had in the perfect time capsule of youth. So one night I broke up with him. As easily as he'd let me into his life, he let me go, without a fight. He knew me too well to try to possess me. Instead he let me dig a hole in the invisible

space between my heart and soul. It's a spot you only know is there when you feel some great loss in it, and I buried the sweet, gooey memories of first love along with the notion that he was the one I was supposed to grow old with.

Now I wasn't sure I'd grow old with anybody. I wasn't sure I'd even grow old. I was free from school, free from parental guidance, and free from a future with the man I loved. It was scary, but also liberating. My main motivation during this time was getting it while I could, whatever *it* was. I think every personality correlates to a deadly sin. There are *greed people* and *sloth people*, but I've always been a *lust person*. I lust after everything—art, adventure, people, stories, and life. I enjoy *lusting* more than *having*, and I now approached each day with this lust for life. I wanted to *do everything* (except for heroin and climbing Mount Everest).

I started spending most of my time with Faceboy, whom I developed a mad crush on, and eventually we started sleeping together. But soon after we started, we determined this would be detrimental to our friendship and we stopped. We then managed to do something few people have ever accomplished—we became best friends who only fooled around once or twice every few years. Most of the time we sat on stoops or in my kitchen, platonically drinking Budweiser and thinking up shows. Because Budweiser, aka the King of Beers, came in such a mind-boggling number of

varieties, it became one of my many obsessions. I even compiled a descriptive list of Bud sizes found in Lower East Side bodegas. The list became part of my act, and I'm sharing it with you now so that if you were a child back in the old millennium or if you were living in some remote village where Bud wasn't sold and you want to imagine what being an Art Star shopping for beer was like back then, this should help.

Bud Varieties Found in Lower East Side Bodegas during the Last Millennium

The 7-ounce pony: Rare gems, hardly ever sold on the LES. Mostly I found these little waifs at weddings and at 7-Elevens in Ocean City, Maryland.

The 8-ounce: This is the "elf" of beers. In keeping with its elfin nature, it mischievously comes in an eight-pack. Like the 24-ounce, it presents onlookers with a surreal and ultimately confusing image. This can is so small it makes tiny hands look big.

The 10-ounce Bud Light: This is a weird one. The first time I saw it, I thought I was hallucinating. The strange thing about the 10-ounce is that it only seems to come in the Light variety. These were and are hard to find. Luckily they always seemed to have

them at the bodega on Stanton Street that smelled like cat pee and had meat hanging in the window.

The 12-ounce can: This is the ultimate classic. If one were to liken Bud to perfume, this would be Chanel No. 5. You can't go wrong here. The 12-ounce is the cornerstone of American civilization. Easily found then and now.

The 12-ounce bottle: Bottles are always a bit pricier than cans, and I think people attempt to justify the price because bottles are supposed to taste less metallic and stay cold longer. But the real reason they're more expensive is because the bottle makes them a bit "classier" in the eyes of bourgeoisie.

The 16-ounce can or "tall boy": This one is extremely popular. I'd even venture a guess that in the midnineties it replaced the 12-ounce can as the Bud of choice. But what can you expect from Americans? After all, Americans invented the supersize meal and the Eldorado Cadillac.

The 16-ounce bottle: The subtlest of Bud varieties. If one were to liken different types of Bud to painters, the 16-ounce bottle would be Robert Ryman.

The 22-ounce bottle: This always served as a good preperformance beverage (and still does.) It's not

quite two beers and packs more of a love tap than a punch. Makes it so you can still remember your lines but deliver them without nerves.

The 24-ounce can: This is two beers in one so you only need one container. (Sort of like shampoo plus conditioner.) No one looks particularly cool drinking a 24, but other Bud drinkers will respect that you are willing to drink from a can that NASA can see from the moon.

The 40-ounce bottle: "If you love Bud so much, why don't you just drink a 40?" onlookers often asked. The answer is simple: a 40 is too heavy, and really meant for malt liquors. Anyway, who wants to lift weights *and* drink beer? Not me!

The 24-ounce became the Art Star can of choice back then because it only cost $1.25 and because it looked so silly. Faceboy and I even discovered a toll-free number on the side of the 24. We dialed it and an actual Bud representative picked up. We soon found that nothing was more fun than calling the number and quizzing Budweiser employees on the different sizes of Bud available.

Eventually, I wrote a letter to Bud proposing they shoot a commercial at the Anti-Slam. I said they could even cast actors who dressed like us but who were better and cleaner looking. Within a month, I got a letter back in which they

gently rejected my proposal, stating that Bud didn't accept commercial ideas from outside sources.

Recently a group of Art Stars tried to figure out how many ounces of Bud have been consumed at the Anti-Slam over the years. This proved a mathematical impossibility. The closest anyone could come up with was "as many as there are stars in the sky" and "enough to fill a Great Lake with hoppy goodness."

Often Faceboy and I ventured to other neighborhoods and new open mikes where we'd hand out flyers for our shows and recruit Art Stars. Faceboy sometimes brought along his friend Jeff, a long-haired comedian who had an extraordinary love for the sauce. Jeff and Face met while working together as telemarketers for NYPIRG, a nonprofit environmental preservation and consumer advocacy organization. They both made almost no money due to their fondness for crank-calling people. Jeff would crank-call people that he knew wouldn't donate based on their history: "Mr. Wong, I see that you haven't donated in five years. *What's wong with you?*"

Faceboy would occasionally crank-call the boss posing as a member: "I just got a call from Francis Hall. He said that if I didn't renew my membership, he was going to come to my house and taunt me with a brisket of beef. And I'm a vegetarian!"

Jeff had two rituals he occasionally performed upon hearing something shocking or hilarious. The first was

called a shirt-off, where if something was funny enough, he ripped his shirt off and spiked it on the ground, exhibiting his hairy, white chest. The other was called a flat-out, and this was reserved for extreme moments of hilarity, when Jeff lay down flat on his back, relishing whatever had been said until he was able to stand up again.

You knew you had said something brilliant when Jeff did a combo—a shirt-off-flat-out. Later he expanded on the shirt-off by taking his shirt off and putting my jacket on, which was powder blue and about ten sizes too small for him. Jeff often took his shirt off to combat pretension in local bars. If a small bar was filled with too many people who looked as if they'd just stepped out of a magazine, he took his shirt off and sat down. This invariably cleared the room, as people didn't quite know how to react to the shirtless man drinking a martini in the corner. Jeff's most shocking shirt-off occurred during a fashion show at the nightclub Webster Hall, where Faceboy and I dared him to take his shirt off and work the runway with the models. We discovered a passageway to the stage through which Jeff easily maneuvered unseen. Once onstage, he flung his shirt over his shoulder and made his way down the runway without interruption.

Jeff became a regular at the Anti-Slam, where he wrought havoc. At one Anti-Slam he held a beer in one hand and a cig in the other. Unbeknownst to him, a lit ash flew off his cig and landed on his scarf, which sat atop his

bag. The ash ignited his scarf, but not until I got onstage to introduce the next act did I or anyone else in the theater notice the flames shooting off his scarf.

"Oh, no, dude! Your scarf is on fire!" I screamed.

The Art Stars stood up and stared at the scarf, confused, still holding their beers. Finally one Art Star had the good sense to stomp out the flames before the whole theater caught fire. No one was willing to spill even an ounce of beer to douse the flames.

Jeff once observed, "The Anti-Slam is a great rebuttal to people who claim you can't be an alcoholic if you only drink beer."

Anti-Slam Art Stars were such notorious beer drinkers that the man at the bodega across the street from Collective said, "Enjoy the show!" to anyone buying beer on Wednesday.

Barramundi, the bar next door to Collective, became my living room. It had big, round tables that could seat at least ten Art Stars at a time. It also had a little back room with a fireplace. We named it the make-out room. After Barramundi closed at four in the morning, Jeff and I would walk to a Mexican restaurant a block away and drink there until seven. Walking home we did flat-outs the whole way, laying our bodies down on the dirty sidewalk, soaking up the sunrise.

I was depressed from my recent breakup with Dog, but the great thing about Jeff was that no matter how bad your hard-luck story was, he could come up with something

more extreme. Once I said to him, "We should be happy, right? We each have two legs and we're able to walk."

He responded, "Yeah, well, if I had no legs, at least then I'd have a goal to walk." Jeff was mistrustful of the human race, a state of mind that fueled his monologues, but which meant he was doing constant battle with coworkers and roommates.

He was also skeptical of technology. If we popped into an ATM and it charged us a fee, Jeff screamed, "Ouch! This ATM fucked me in the ass!" He'd then hold his ass as though he were in pain and limp out of the bank as people stared in horror.

Faceboy started producing a show called *The Faceboy Show*, which prominently featured Jeff and me as performers along with musical acts and sketch comedy. Each week the show had a different theme and special guests. We did one called "Performance Art: Drunk and Topless," where all the performers were both drunk and topless, and another titled "Our Shirts Are Too Small," where everyone wore a shirt several sizes too small. Despite the obvious brilliance of these themes, we had trouble getting an audience. We decided the only way we were going to get an audience was if we featured a famous special guest star. We knew there was no way we could get famous people to do our show, so we opted for a simpler approach. We would *imply* that there was going to be a famous special guest without bothering to book one.

The following week's show, which had originally just been called "Farts," was changed to "Farts with Eric Bogozian." We misspelled *Bogosian* with a *z* on the press releases so we couldn't be sued. Unfortunately, the papers corrected our misspelling. A line formed outside Surf Reality that night as people clamored to see the famed performance artist, and we were forced to cancel the show rather than incite a mob of Eric Bogosian fans.

12

uncle steve

A few weeks after *The Faceboy Show* premiered, I was asked to perform in a science-fiction serial play called *Ulna Capella, Private Biologist.* I was cast as Spartina, a female character based on Spartacus. *Ulna Capella* was set hundreds of years in the future in a world where Rome never fell, the rulers wore togas, the aristocracy resembled the avant-garde of Weimar Republic Germany, and the moons of distant planets had been colonized. Spartina led a slave revolt on Io, a moon of Jupiter.

During the run of *Ulna Capella*, Patrick, a strapping, blond actor who lived in Collective Unconscious and who played a sadistic aristocrat named Barron Von Necronome, asked me out while onstage at the Anti-Slam. I was shocked that he liked me. He was gorgeous. I was dorky. Plus, I was growing my hair out and it had entered a bowl-

haircut stage that made me look like Little Lord Fauntleroy. On our first date we went to CBGB's Gallery to see my favorite band at the time, Anti-Slam regulars called Leopold and Stange's Jangletown, who did raucous Andrews Sisters' covers. After that, we continued to date off and on. We were almost like my invisible midget, childhood friends Gooby and Jim, breaking up thrice daily. Patrick and I had fun, sitting in Collective Unconscious telling each other stories till five in the morning, but we fought over minutiae constantly. The relationship exhausted my emotional energy and liver. Together, we supported Barramundi for at least two fiscal years.

One night at Barramundi, I saw that someone had drawn a rainbow on the bathroom wall and written over it, "Reverend Jen is my personal rainbow." I don't know who wrote it, but foul graffiti soon appeared under it like "Reverend Jen is my personal jizz-coat."

That's when I realized graffiti is a great form of promotion. I told this to Faceboy and we began writing graffiti about each other in local bars. Most of what we wrote pertained to our expertise in the sack.

The Art Stars referred to Barramundi as the Regal Beagle because we went there with the same frequency that Janet, Jack, and Chrissy went to the Regal Beagle on *Three's Company*. If I wasn't at Barramundi with Patrick, I was there with Jeff, staring out the bar's octagonal windows, looking for Patrick. Jeff tried to reason with me.

"Jesus, Rev, you could have anyone," he'd say, pointing to a cute bartender. "Look, you could have him! Here, I'm writing you a prescription for side wenis." (Wenis being Arr Star slang for *penis*.) Jeff didn't believe that after a breakup you should spend time alone getting in touch with your feelings. He believed you should start boning someone new immediately. And he believed in employing side wenis before you even broke up with the person in order to alleviate the pain of the ensuing breakup.

Jeff understood my attachment to Patrick and theorized that it was Patrick's large, fit body on top of mine that kept me hooked.

"Listen to your uncle Steve," Jeff said. "It's scientific." For some reason, Jeff referred to himself as Uncle Steve or sometimes Steve Wenis. Uncle Steve became my therapist.

He gave me one crucial piece of advice that I was never able to adhere to: "Just stay away from dudes, Rev, and you'll be okay."

If I got in a fight with Patrick, I called Uncle Steve. "Rev," he advised, "I want you to go out and buy exactly one twelve-ounce Budweiser and no more. Take it home and drink it. Then go to sleep."

Sometimes Uncle Steve suggested I visit the "wing house." Jeff developed the main-house/wing-house theory after seeing the documentary *Crumb*. In the film, the comic-book author R. Crumb talks candidly about boning women other than his wife. When the interviewer asks R.

Crumb's wife how she feels about this, she tells him it's fine because she bones other dudes. The main house is where you cuddle and love your partner, and the wing house is where you bone people other than your partner. In theory this seems ideal. But this kind of thing almost never works due to human nature. Even men who preach about the unnaturalness of monogamy are forced to eat their words when their formerly monogamous partners decide to visit the wing house. Someone always gets hurt. The only way wing house/main house can work is if the partners are no longer attracted to each other or are bored with each other.

When Jeff met a guy who he deemed worthy of me, he'd say to him, "You can visit the wing house anytime." And if he really liked the guy, he'd say, "You're welcome at the main house."

Despite his benders, Jeff was miraculously able to write and perform prodigiously. One show he was involved in, called *Toilet*, was a live-action sitcom staged every month at Surf Reality. *Toilet* revolved around the lives of three dudes living on the Lower East Side. Jeff played a temp who hadn't gotten an assignment in two years. Steve Naidich played his roommate, a nerdy Web designer, and Mike Raphone played their upstairs neighbor, a weathered punk rocker. *Toilet*'s director, Noel, asked if I'd play Jen, Mike Raphone's sixteen-year-old rocket-scientist/kleptomaniac daughter, who runs away from home. I'd always dreamed of

being on a sitcom so I said yes. My character had several adventures, including joining a cult, building a rocket ship, and almost losing her virginity. A lot of audience members thought I was actually sixteen, hence they'd be mortified when I did such things as chug beers onstage or take my shirt off. In the "Toilet: Christmas in July" episode, Steve is forced to design a website for the Mafia, but when Jen Raphone steals Steve's computer, he tries to kill himself, whereupon he hallucinates that he is visited by the ghost of Christmas Past, who it turns out is really just an exterminator there to combat a roach infestation. Somehow the whole thing ended happily with Jeff dressed as Jesus, mounted to a cross while a hot stripper danced onto the stage, climbed under his robe, and simulated giving him a blow job.

The sight gags in *Toilet* were endless. One scene opened with Steve shaving Jeff's back. Another opened with me making my stage entrance on the back of a Harley. It took eight dudes to carry the Harley up the stairs, but it was worth it for one laugh. At every show, the script ensured something would get thrown down the Surf Reality stairs. Televisions, a shopping cart, and chairs were all tossed down the stairs. *Toilet* sold out every show. Admission to the show cost $5 and included a complimentary Budweiser. When the chairs filled up, people sat on the floor or stood in the back. The show attracted audience members who would normally never be caught dead at any type of

theatrical production—barflies, bikers, and punks. They were a rowdy audience. If one of the dudes appeared onstage shirtless, they'd scream, "Put it on!"

Jeff and I used to walk through the Theater District and dream about the day *Toilet* would make its Broadway debut. "It'd be so much more fun to trash a Forty-Second Street theater," Jeff said.

Sometimes we fantasized about *Toilet*'s becoming a real sitcom and all of us drunkenly spilling out of a limo at the Emmys en route to receiving our awards for best acting and writing. Sadly, *Toilet* never made it that far. In fact *Toilet* never left Allen Street.

13

love chemicals

I looked for work, but most prospective employers were not impressed by a résumé that said "elf" at the top.

After scanning the *Village Voice* for several weeks, I found a job listing stating that the only requirement was a college degree. Perfect, because that's all I had. So I headed uptown to the Metropolitan Museum of Art, where I applied for a job as a security guard. They hired me and told me to come in for training and a uniform fitting. I have been told that Bill Blass designed the Met's guard uniforms. I don't know if this is true, but I do know that if it is, Bill Blass was one sadistic son of a bitch. My heavy polyester uniform weighed about seventy pounds. It featured a knee-length skirt with a minuscule waist that cut into me and left an imprint upon my pasty gut weeks after it was worn. It also featured a boxy blazer and clip-on tie. It hurt to wear

it, and it hurt even more to wear it for twelve hours straight, which was the allotted shift two out of my four days a week.

They don't let guards at the Met carry a gun. Given the situation, standing still for so many hours, forbidden to talk to anyone or lean on the walls, most guards would use a gun if they had one.

Often, my boss asked me to work "the clicker" at a special exhibition's entrance to count the visitors. I always started out earnestly clicking whenever anyone entered, but then midway through I zoned out and forgot to click. I would then try to make up for it by clicking several times in a row. At the end of the day, my superiors were shocked when my clicker announced that approximately 285,000 people came through the exhibition.

During my stint as a guard, my relationship with Patrick was deteriorating. I felt unloved, ugly, and weary. Every Friday night, I witnessed happy, fashionably dressed couples traipse through the Met's corridors hand in hand, smiling and stopping to kiss in front of a painting while I stood next to them going insane in my too-tight outfit. I listened, enraged, as dudes attempted to de-pants their dates with tidbits of art history.

I used my imagination to try to escape the pain of being at the Met. If I was in the Japanese garden, I pretended I was an emperor and that it was my garden. The visitors to the Met were simply my subjects.

It was impossible to make friends with the other guards, who were, with few exceptions, overzealous low-level fascists. So I spent my lunch breaks alone, exploring the Met. Usually I was hungover from the night before with Jeff, so most days I had a runny nose and bleary eyes. But I didn't mind having a runny nose or being sick. Hacking up gruesome globules of blood and phlegm made the day more interesting.

I asked one guard what he thought about on the job and he said, "I put a Velamints in my mouth and see how long it takes to dissolve."

One night after work, with the imprint of my polyester uniform still burning into my abdomen, Patrick dumped me, this time "for good." His ex, whom he was still in love with, was moving back to New York. When I cried, he held me and begged me not to cry. Still I was devastated. I thought Patrick's leaving meant I would be alone forever.

"It's lonely at the top," Monica said.

"But I'm not at the top," I sobbed.

"You will be," she assured me.

"It's the chemicals," Jeff and Faceboy told me. According to them, "love chemicals" stay in your body for a year, so recovering from heartache is like getting off heroin. After the breakup, I couldn't go to work. I tried to go and ended up sobbing in the bathroom, tears running onto the blue polyester under the fluorescent lights of the Met's bathroom. The nurse sent me home, which seemed like a good enough reason to drink.

The following morning, I woke up and Jeff was in my bed. We were fully clothed, but assorted beer cans were scattered around the bed.

"I can't go to work," I said.

"Me neither," Jeff said.

"I'm gonna call in sick."

"Yeah, call in sick. Say, 'I'm sick of you!'"

I quit my job at the Met two weeks before my health insurance was supposed to kick in. Lack of medical care seemed less suicidal than continuing there. Each day that I did not have to wear a polyester uniform brought me unending bliss.

Meanwhile, my living situation was headed for the crapper. Christie and I made the mistake of opting to share the lease to the apartment. This is the stupidest thing you can do under any circumstance. Even if you have been married for twenty years, DO NOT SHARE THE LEASE, whatever you do. Most roommate situations cannot last more than two years, and ours was coming to a boil.

Christie began hanging out with an anarchist organization (which sounds like an oxymoron to me) and rebelling against her parents in a variety of ways (not the fun ones, unfortunately). One day she came home with a stick of dynamite tattooed on her arm and I knew it was all over for me. A month later she came home with a belly piercing and a giant Chinese symbol tattooed on her back, which for all she knew probably translated to "jackass."

Because of the tattoo on her back and the piercing on her stomach, she could only lie on her side, and this made her quite irritable.

I responded to her petulance by attempting to fill our home with positive energy. One day while she was at work, I surprised her by painting on our kitchen wall a mural of a kitten riding a unicorn and asking a weeping flower why it was sad. Previously she would have thought this was excellent, but it seemed that she now found this trifling and disgraceful.

She was prone to fits of anger, and one day, while enraged that I'd imbibed her Pepsi, she grabbed a handful of my hair and slammed my head into a cement wall several times while uttering threats that she would kill me. I did not hit back, either because I'm a giant pussy or smart enough to know you can't beat the strength of the insane. Instead, I called the cops.

That night, I walked up to Beth Israel Hospital, where I waited for six hours for a doctor to check my head while Christie spent the night in jail.

Years later, I met someone who'd been in the emergency room that night. He said, "I wasn't sure why you were there, but you had on elf ears and a Barbie nightgown so I was kind of fascinated."

Despite that I'm sure this incident left me with irreparable brain damage, it also left me with the lease to a rent-stabilized apartment in Manhattan, and for that I am extremely grateful.

Even though the apartment was cheap, I couldn't afford it on my own. I put the word out at the Anti-Slam and got not one but two new roommates: a comedian named Beth and a photographer/actor from Alabama named Jason "J-Boy" Thompson. Beth took the larger of the two bedrooms, and J-Boy slept in the tiny room at the front of the apartment, where he built a loft bed.

It was not an ideal living situation to be sure, and people marveled at how we managed to coexist there without bludgeoning each other, but we reckoned immigrant families had been living in cramped quarters on the LES since the 1860s, so there was no reason we couldn't do the same. Also, we were certain that within a short time all three of us would be rich, famous, and able to move into huge loft spaces in SoHo. How I was going to get famous, I wasn't sure; I only knew it seemed inevitable.

14

mount never-rest

In between working crap jobs, I used whatever free time I had to make art, do one-person shows, drink heavily, and sleep with a variety of insane people. By that time, the open-mike scene had become quite the hookup scene. Faceboy and I weren't sure whether we were running shows or sex cults. For historical purposes, we decided to keep track of who among our open-mike attendees was boning using a piece of paper we called "the links list." On it, we recorded this information: dotted line if they made out, thick line if they had sex. Our open mikes had only been going a couple years, but already the links list looked like a topographical map of the Himalayas. And we were all over it. In fact, as mentioned earlier, a thick line connected us.

Each time Faceboy unearthed the crumpled, heavily marked links list from the drawer of his desk, I shuddered

to see the people I was attached to via both dotted and thick lines. The only other person we allowed to see the links list was Jeff, who helped us with the enormous task of its construction.

I felt something was lacking in my life, and looking at the links list, I could tell that something was romance. Not heeding the wise words of Uncle Steve (to just stay away from dudes), I attempted to find it. Unfortunately *romance*, which has always gone hand in hand with *trouble* (for at least as long as opera has been around), found me first.

An article appeared on the cover of *New York Press* entitled "The World According to C. Brodeur." Its subject was an artist, activist, and musician named Christopher Brodeur, who'd created his own religion, called Brodism, a strict faith that forbade sex, drinking, and smoking. Despite that Brodism was unlike Hal, a religion where killing one's awareness with alcohol and sex is celebrated, I felt close to Brodeur. We both had our own religion and lived in imaginary worlds defined by self-grandiosity and delusions.

The article featured a photo of Brodeur wearing a plaid jacket and smirking at the camera. He shaved his goatee into a checkerboard, a style he called an "anti-goatee." And even though it was the nineties and every dude south of Houston Street was sporting short hair or a bald head, Christopher defiantly wore his hair long with bangs. He looked like a missing member of the Sweet.

Brodeur, who often went by his initials, CXB, was a

regular at the open mikes, where he performed in a band with Michael Portnoy called the Liquid Tapedeck and handed out leaflets documenting his ongoing war with the Giuliani administration's policies, a war that had already landed CXB a few brief stays in jail for "harassment." One could catch tidbits of this battle on the mayor's Friday-morning radio show, which CXB often called, using fake personas and voices to get past the screeners. Once he was on-air, he would ask Giuliani something intentionally infuriating, and sparks would fly. During one call, Giuliani flipped and called CXB a "perverted little freak." This provided hilarious entertainment for the Art Stars.

I'd always noticed Brodeur sitting in the audience, paying rapt attention to whatever was happening onstage. Once I looked over and noticed he was wearing Stormers-brand moon boots from Kmart. I also wore Stormers, only mine were gray with hand-painted pink stars on them, and his were black. I was shocked. I didn't think anyone else in the western hemisphere, especially in the hipster-laden East Village, wore moon boots at the time (now they've kind of made a comeback).

In retrospect, I realize that one should never judge a man by his choice of footwear. Just because we were both courageous enough to dress poorly, it didn't make us soul mates.

Soon enough I received an anonymous letter. It began, *I'm a big fan of yours (that's not to say I'm large) and I*

would love to take you out for a drink or a cheap dinner but I am so very bashful and fantasies are better left unfulfilled.

The letter described how the author had shoplifted works of art by Monica and me from a gallery show we'd done a year earlier in the project room at Lauren Wittels Gallery. Immediately, I knew the author was Brodeur. I should have been frightened, but instead I was elated. A love letter meant romance.

The letter was signed, *I'll think of you tonight when I hug my pillow—Your fan always.*

I looked up Brodeur's number in the phone book and got his address. I wrote him a letter telling him about my life. He responded with a second letter, enclosing a sacred "Brodie Brush"—a little head made of tape with a lock of his hair sticking out like a troll's. The letter instructed me to rub the Brodie Brush on my cheek. I responded by rubbing the Brodie Brush all over my body while Monica snapped photos, which I then sent to Brodeur.

He wrote, *Your letter was very nice. But I'm not sure if that's good or bad. I always end up pissing people off or infuriating them. This is one of the many reasons I avoid humans. For everyone's benefit.*

He explained that he was the perfect fusion between Richie Cunningham and the Fonz, and that his role models were Kermit the Frog (reluctant leader of his species), Mr. Spock (excessively logical), and Casper the Friendly Ghost (people are afraid of him).

That Brodeur was obviously crazy did not deter me. I was still heartbroken over Patrick and not thinking clearly. I eventually called Brodeur and told him I wanted to hang out. Not so reluctantly, he agreed. We met at a show where I was performing and afterward walked to Union Square because he said he wanted to "kiss my hand." We sat down next to each other on a bench, where he held my hand to his lips and kissed it for a good twenty minutes. I then took his hand and attempted to reciprocate.

"You're a nymphomaniac!" he screamed, jumping up from the park bench.

"But you kissed my hand."

"I know. But you can't go kissing *my* hand."

I didn't know the rules. I felt like Alice in Wonderland, using a flamingo to play croquet.

He sat back down and resumed kissing my hand while also running his fingers through my hair. When he lifted his lips from my hand and turned his face toward mine, I tried to kiss him on the lips. He turned away.

"You're not allowed to kiss on the lips?" I asked.

He told me Brodism forbade it.

We walked back to the Lower East Side and hugged good-night.

In the following weeks, more letters from Brodeur followed. He excused his absence from the open mikes as due to his ongoing war with Mayor Giuliani. But before long we met again at another show. Afterward, he invited

me to his place for a sleepover. He pulled a Superman-sheet-clad mattress up onto his roof. It was a breezy summer evening, and I wore a slinky vintage evening gown. He stood behind me and slowly unzipped it while he ran his hands down my back. I was headed for frustration and pain, but I couldn't help it. He was so tender and sweet that it took me back to more innocent times, necking under the stars when I was sixteen. Eventually we lay on the mattress and explored each other's flesh. He told me my breasts were like two warm muffins and my ponytail like the tail of a squirrel.

He wore tight, hideously patterned polyester underwear at all times, even to bed, because he claimed that unlike cotton, polyester underwear didn't breathe and this prevented him from becoming aroused. Though it hardly worked that night. As I ran my hands over his manties-swathed package, his manhood sprang to life, and I was certain his Brodist vow of celibacy wouldn't last the summer.

Soon I found the reason Brodeur slept on the roof was that his bedroom was a disaster. The FBI had searched it looking for weapons, drugs, or any proof that he was out to harm Giuliani. They'd turned it upside down, and in the end all they found was some gay porn he'd been using for Liquid Tapedeck posters. He hadn't bothered to clean up the aftermath. Bright polyester clothes were everywhere. Papers were piled up on the floor. A cardboard cutout of

Jaclyn Smith with I LOVE BRODE scrawled on her chest lay on its side in the midst of it all. It was chaos.

During Giuliani's second bid for office, Brodeur ran against him as John Doe, a candidate who wore a brown paper bag over his head. This was so voters who are prone to voting only for good-looking candidates wouldn't vote for him solely on the basis of his looks. Brodeur chose to declare his run for office at a press conference on the steps of City Hall, where he was forbidden due to a restraining order.

For the press conference, Brodeur made a piñata with a pig body and a Giuliani head that was filled with fake money.

The proceedings got under way. I was the first to take a swing, but was unable to make a dent in it. Next came Michael Portnoy, who managed to do some damage. As a trickle of fake dollar bills sprang from the pig body, several plainclothes and uniformed officers approached us. The paper bag that I'd fastidiously duct-taped to Brodeur's head was ripped off, and cuffs were placed on his wrists, whereupon he was whisked away in a police car.

Once it got cold, Brodeur began to sleep at my place every night. We were in love. He left love notes on my bed and gave me massages. I called the Giuliani radio show and pretended to be a sweet old lady complaining about a busted traffic light in order to get past the screeners. Brodeur gave me endless hugs and hand kisses. We took

showers together (in our bathing suits) where we washed each other's long hair.

We walked by empty parking lots and he exclaimed, "That's where I'm going to build Mount Never-Rest, and you and I are going to live at the top and make art all day."

Together we imagined a much different world than the one we inhabited, and Christopher did many kind things for me. But there was one thing he wouldn't do: he wouldn't make love to me. We'd wake up together and he would invariably be sporting morning wood. He'd place my hand on top of his manties ever so briefly, and I would then take his hand and slip it between my legs.

"You're a nymphomaniac!" he'd scream. "Let's just hug."

I was sick of hugging. During fights he'd hang on to my ankles and scream, "Hug me," while I tried to kick him off.

I insisted on sleeping naked at night, but sometimes I'd come home to find that he'd laid out pajamas for me.

What made Brodeur's not-fucking-me worse was that he ogled other women. One evening we were lying in bed, me reluctantly wearing a pair of footee pajamas he'd laid out, and he in his fake-denim-print, three-sizes-too-small underwear. He was jotting something on a program he'd gotten at a dance show earlier that night. Next to one dancer's name, he'd written, *Her breasts are a work of art.*

I grabbed the piece of paper, crumpled it up, and threw it

across the room. "You piece of shit!" I cried. "Go torture *her!*"

"You're destroying my notes," he complained calmly.

Exasperated, I stormed out in my footees and over to Barramundi, where I knew Art Stars would still be hanging out.

Brodeur told me if I needed to get laid, I could go outside of the relationship, as long as he didn't know about it. He had keys to my apartment, which made it difficult. Plus he went everywhere I went. I couldn't even walk down my block without him whizzing by me on his little yellow bicycle.

One day, I came home and found a note on my bed: *I know I'm not boyfriend material, but neither was the last messiah. Love, CXB*

15

once upon a time there was a giant frog at the central park zoo who had no health insurance

Once again finding myself lacking employment, I turned back to the *Village Voice*, a wonderful source for crappy jobs requiring no skills. I knew a job was for me if it involved a silly costume and some form of humiliation that could only be cooked up by capitalism.

Noticing an ad that called for "costumed characters" to work at the children's zoo in Central Park, I leapt to my feet and dialed the number. Working with adorable animals and children was sure to be a healing experience. Within days I was earning $7.50 an hour as an animal at the zoo,

wearing more on my body than I ever thought possible—namely, gigantic, unwieldy animal costumes. These I donned and then waved to people.

I catered to the undersix crowd, saying things like "Hi. I'm Bullfrog. Do you know why I'm green?" or "Hi. I'm Catfish. Do you know where I live?" or even "Do you know how to hop like a frog?"

In response to my patronizing questions, many children beat me. Hippies used to say, "Don't trust anyone over thirty." *My* motto became "Don't trust anyone over three." As far as I'm concerned, once you learn to put a sentence together, once you learn to use words, you become an asshole.

The zoo where I worked was the newly opened Tisch Children's Zoo in Central Park. The aristocratic family donated $6 million to build the tiny animal oasis. Opening week of the zoo, the Tisch family had a private party, and I was forced to attend in a catfish costume. Everyone ignored me, so I eavesdropped in on the Tisch family's conversations.

The next day, the zoo opened to the public. Rudolph Giuliani attended, along with his entourage. They put Giuliani in the goat pen and photographed him helping toddlers feed the pygmy goats. It was ninety degrees out. I psychically encouraged the goats to attack.

The goats' names were Spanky, Suzy, Sparky, and Sandy. The zookeepers made a ribbon out of Suzy's fave snacks and

hung it in front of the entrance. Suzy bit through it for the opening ceremony and the crowd went wild.

Jeff, who worked for Viacom at the time, came by the zoo to visit me. He saw me shake the hand of a toddler while wearing the frog costume and said, "Wow, that's better than anything I did all day, maybe all month." He added, "I was watching the feeding of the seals. Those seals are getting big laughs."

And I said, "Those seals get bigger laughs than anything I'll ever write."

Each day when I came into work, I chose which animal I wanted to be. I had four choices: (A) guinea fowl, which is like an African chicken; (B) bullfrog; (C) catfish; or (D) turtle.

All the costumes were velvet with foam-rubber insides. They each had a hole in the neck or face where my face came out. All of the animal heads smelled like vomit.

Unfortunately, guinea fowl was out of the question because it was just too big. I wore the turtle only when there were no other options. It was by far the most masochistic. The immense shell made it impossible to get through doorways, and the mouth hole wasn't really big enough to see out of. I found myself most often rotating between catfish and frog. Each of these costumes had its unique set of problems, as well.

First of all, it was almost impossible to decipher what the catfish actually was. However, I liked the surreal aspect

of being a bipedal fish on land. I got a throatache the first day from saying, "Hi. I'm Catfish. Hi. I'm Catfish. Hi. I'm Catfish." I had to say this repeatedly because everyone was saying, "Look at the walrus. Look at the penguin. Look at the salamander." I wanted so badly to say, "Hey, lady—I'm a fucking catfish."

The thing is, the catfish was grossly misinterpreted, but the frog, the frog was disturbing. Frogs are cute. Little frogs and Kermit are cute. But a giant frog with a human face coming out of its mouth is maniacal-looking. Not to mention, the frog feet were aquatic flippers upholstered in velvet, and flippers on land for eight hours is no walk in the park. The frog's mouth was giant, red, and smiling, and at its center was my usually hungover face.

When I approached youngsters in this getup, I got one of three reactions.

The over-three cynics would say, "You're not real! You're just a lady in a frog costume."

I'd say, "Hi. I'm Bullfrog. Would you like to shake my hand?" They would then stare at my hand, which was a long, four-fingered thing that looked a lot like Freddy Krueger's knives, raise an eyebrow, and saunter off coolly.

One adult observed this reaction and said, "How does it feel to be rejected?" It felt horrible, but not as awful as when children punched me in the stomach and shouted, "You're fat, Frog!"

To which I always responded, "I eat children like you."

The second reaction was the antithesis of the first: complete adoration. Toddlers screamed, "I love you, Frog!" Then they would throw their little arms around my big, fat velvet body and hug me. Sometimes they would stand around in groups, taking turns hugging me. After all the pain I'd experienced that year, I needed those hugs.

The most sublime moment was when one young boy said, "Frog, will you sit next to me on this rock?" So I sat next to him. He was holding a little, stuffed lamb animal that had a pink bow around its neck and he said, "I'm going to fix her bow now, okay?" The cool thing about this was that the stuffed lamb was very real to him, and I was really a frog to him. Many children can't differentiate between real and fake or even animate and inanimate. I once saw a little boy kiss and pet a fire hydrant.

The final reaction was born out of the same lack of distinction between real and fake: fear. I learned the best thing to do when a toddler cried because it was scared of the giant frog was to make myself scarce. But the parents and nannies failed to grasp this technique. They often pushed the toddler, until it was on the brink of psychosis, into touching the giant frog. And when toddlers saw my weaponlike fingers, it was all over.

"Don't worry, honey, it's just a lady in a frog's body," the parents cooed. That made it worse because then the children thought the frog ate me.

Another day I made an entire classfull of children cry.

When they saw me, they all started weeping in unison. When I asked their teacher why, she told me it was because their class frog had died that morning.

I usually ended up hiding behind a large rock at the end of the day searching for what little dignity I had left.

Finally I understood what Kermit meant. It's not easy being green.

16

you don't know the line
until you've crossed it

As November approached, I lost my job at the zoo. It was simply too cold for humans to stand outdoors in silly costumes.

Scanning the *Voice* every week, I searched for the "elves wanted" ad, but found nothing. Reluctantly I called Bloomie's and asked if they'd be hiring elves. They told me they weren't sure. I called back several times, and when it finally appeared they weren't hiring elves, I went to Macy's and applied for an elf job there. At Macy's elf orientation, I was disappointed by the lousy wage and the unmanageable hours.

The day after the Macy's orientation, the cover of the *NY Post* announced in so many words, "Santa gets the boot

from Bloomie's." Inside, a feature length article told how Bloomingdale's had nixed Santa and the elves from the store. Remembering the behavior of the elves the previous year, I wasn't shocked. The article went on to describe Giuliani's fury over the situation. For once, I was glad that Giuliani cared more about absurd trifles than real problems. In this instance, the power of the right-wing media would work in my favor. Bloomie's would never get away with this.

A day or two later, I called Bloomie's Human Resources and was told to come in for an interview. They rehired me with an impressive pay raise and the same old stinking outfit. Bloomingdale's learned its lesson and had not run an ad in the *Voice*. Instead they ran a help wanted ad in the actors' publication *Backstage*. This time around, my coworkers were a bunch of ass-kissing thespians. There were no fistfights and no drunken midafternoon lunches.

Meanwhile, Jeff sobbered up. We stopped hanging out because he said he couldn't look at me without wanting a beer. I knew Jeff needed to quit drinking, but I loved him and wanted to hold onto him. So I kept calling and leaving messages, but I never heard back from him. Finally I stopped trying.

With Jeff sober, I drank a lot less and was amazed at how much I got done. Still, I was lonely. Jeff and I talked every day, and not hearing his voice was agony.

But just when I thought it would be a sad holiday, I got a

call from a fellow I'd never met, John Ennis. He directed a Manhattan Neighborhood Network TV show called *Toolz of the New School*. Manhattan Neighborhood Network is a series of cable channels devoted to showing programs made by regular citizens, not "TV people." All you need to do a show on MNN is to have a tape with your show on it, hence most of the programs are not of the highest quality.

John Ennis heard through the grapevine that I had an elf costume he might be able to borrow for the *Toolz* "Christmas Special." I *did* have an elf costume, only it wasn't the Bloomie's one; it was one I'd bought for the "Toilet: Christmas in July" special.

"Hey, do you wanna be in this episode?" he asked during the costume handoff, and explained that this installment focused on a fictional "elf stalker" who was slowly killing off the elves at Macy's. The aforementioned Fitz (who found the Keebler elf patch) played an elf who'd just lost his job. The unemployed elf then wanders into a bar where he has the misfortune of running into the elf stalker, who swiftly does away with him. A *Toolz* cast member named A.J., an extremely intimidating former paratrooper who now worked as a bartender, played the elf stalker.

I played a misfortunate elf who in the end dangles from a shower curtain rod by steel handcuffs, a gag in her mouth and a look of terror ablaze in her eyes. I'd only known John Ennis for a day, so it was a little weird to be wearing an elf

outfit and dangling from handcuffs in his bathroom. But he was a wonderful director. He was also incredibly handsome and funny. Following the Christmas special, we miraculously worked together for five years and managed to never touch each other's "parts."

In shooting the *Toolz* "Christmas Special," Ennis used a hidden video camera, which captured moments of hilarity using unsuspecting members of the general populace. Ennis and A.J. floated past Macy's security, and A.J., who is bald, six foot four inches, and at least 250 pounds, sat atop Santa's lap.

Santa sweetly asked, "And what would you like for Christmas this year?"

"An elf," A.J. said.

In another segment of the *Toolz* "Christmas Special," Fitz dressed as Joseph, and his girlfriend dressed as a hugely pregnant Virgin Mary. The two wandered into the lobby of the upscale Gramercy Hotel.

"My name is Joseph. We'd like lodging for this cold evening. My wife is expecting," Fitz said in a biblical voice.

"You should have been here before nine o'clock. Those are the prices," the man behind the counter said curtly, pointing to the hotel's rates. No sense of humor whatsoever.

"Well, what do we do tonight?" Fitz asked, tears welling up in his eyes.

"Do you want me to call 911?"

"We didn't mean to cause any trouble. I can work. I can

build a chair," Fitz suggested pleasantly, referencing Joseph's carpentry skills.

"Do you want me to have you removed?" the man said.

Finally, Joseph and Mary turned away and hung their heads as they exited the lobby.

As the holiday season came to an end, I again lost my elf job, but my behavior had been so good that Bloomie's offered me a part-time sales position in the Calvin Klein jeans department, where I made a pretty penny working on straight commission.

With a somewhat normal job under my belt, I had less free time, and what time I did have, I devoted to working on *Toolz*. Though it was on MNN, it appeared to be the best show on television, and people who recognized me on the street agreed.

"Toolz of the New School!" my neighbors yelled out when I walked down the street.

I soon learned that most *Toolz* episodes ended with someone threatening to call the cops. Our motto eventually became "You don't know the line until you've crossed it."

In one episode, A.J. and Ennis went to the Jehovah Witnesses' headquarters and gave them a taste of their own medicine by trying to convert them to *Toolz*'s religious practices of casual sex and blaring hip-hop at four in the morning. Security was called, of course.

Ennis, who'd been an NYU film student, had an idea for a character he wanted me to portray—a former New York

University student who owed so much money in student loans that she was forced to prostitute herself to the NYU student body.

Together we brainstormed and came up with "Whitney LeBlanc: NYU Hooker." Ennis knew that NYU held second-semester "freshman orientations" where new students were welcomed along with their parents by student supervisors who gave them tours of the campus. He called NYU to find out when one of these tours would be going out because we planned to be there.

Whitney's apparel consisted of a child's NYU T-shirt rolled up à la Daisy Duke, a too tight cheerleading skirt, black fishnet thigh-highs, black pumps, black garters, smeared lipstick, and pigtails. I thought I looked so absurd that no one would believe I was a real hooker. But from the moment I left my apartment, no one could see anything but a hooker.

Ennis placed a body mike under my shirt and concealed his camera inside a pile of newspapers. For six hours he shot footage of Whitney LeBlanc on campus. I no longer worked for Lauren Wittels, and a friend of hers saw me wandering around and thought I'd become a crackhead. Alarmed, Lauren called Monica and was relieved to find out I was only acting.

Whitney LeBlanc terrorized NYU. Our first stop was the financial aid building, where I stumbled around and asked the clerk behind the desk, "Can I borrow twenty dollars?"

"You can fill out these forms," the clerk answered, sliding some papers to me.

"Yeah, but what if I didn't learn nothin'? Can I trade in my credits for cash?"

"No."

Ennis videotaped me sleeping in the park with financial aid forms strewn across my chest and soliciting students as they hurried to class. I then tried to enter the dorms while openly drinking a forty to see someone named John and was denied access by security, who threatened to call the cops. Eventually, we located the freshmen on their welcome tour and Whitney followed them around, slurring, "You better enjoy that nice dorm life cuz it's not gonna be like that when you graduate."

They pretended she wasn't there.

Being Whitney was mortifying, an exercise in humiliation. Several times I said to Ennis, "I can't do this. It's too embarrassing," and he somehow convinced me I *had to*.

He was right, because when the episode did air, the tables were turned. My role was far from embarrassing. If anything, the people who'd been cruel to Whitney, who shunned her, who tried to ignore the elephant in the room, were most likely embarrassed and stunned that they'd been fooled by smart-asses.

It was social commentary disguised as television comedy, and I loved being part of it.

The Whitney LeBlanc segment was part of our "Quality of Life" episode, which addressed Mayor Giuliani's Quality of Life Campaign, which had just gotten under way. The campaign was mostly aimed at ruining the quality of life of the poor and the artistic, while improving the quality of life of the rich and the boring. As a result, almost every square inch of Manhattan had become unaffordable, with few exceptions.

The episode also featured A.J. and a girl named Francesca dressed in tuxedos on a subway filled with commuters. The disgruntled passengers quickly perk up when A.J. yells out, "As part of Mayor Giuliani's Quality of Life Campaign, we bring you champagne and appetizers!" The stunned commuters cheer as A.J. pours them champagne and Francesca hands them mini-quiches and spinach pies.

As the now delighted commuters sip their champagne, they call out, "Thank you, Mayor!" and "Giuliani is the man!"

That's when A.J. approaches them, pulls out a notepad, and begins to write them tickets. "I'm sorry, but as part of Mayor Giuliani's Quality of Life Campaign, I'm going to have to cite you for public drinking."

The Quality of Life Campaign was mostly aimed at people who had very little, such as the "squeegee guys," who cleaned windshields for change. Giuliani vowed to get them off the street. The absurdity of this was that the

squeegee guys had *nothing*, and once you took their squeegees away, they had less.

Next it was topless dancers and peep shows Giuliani went after, closing up shops where one could see boobies. Porn vendors were now forced to sell at least 60 percent non-porn-related videos if their businesses were to stay open, causing many to close for lack of customers. Before long, Times Square, which had once been a hotbed of sex and debauchery, had a Disney store and a T.G.I. Fridays. The only good thing about the 60/40 rule was that you could now easily find rare G-rated videos such as *Mr. T's Be Somebody or Be Somebody's Fool.*

It was classic bully behavior: picking on the underdog. The cast of *Toolz* wanted to stand up for the underdog, to beat the bully at his own game by making him look a fool. We wanted to give the underdog a voice, one that was smarter, wittier, and funnier than that of the bully.

The annual Greenwich Village Halloween parade was approaching, and Ennis wanted to do something spectacular to address the Quality of Life Campaign. We decided to present a mock Giuliani for President float, which we created by decorating a flatbed truck with red, white, and blue balloons. We then assembled our friends to play various characters who'd been screwed over by the Quality of Life Campaign that year.

They portrayed topless dancers, street vendors, jaywalkers, underpaid cops, squeegee guys, cabdrivers,

bashed gays, squatters, illiterate public school students, and welfare moms. A friend who works at children's parties "borrowed" a giant Mickey Mouse head, which I wore along with a shirt that originally said I LOVE NEW YORK. Only I crossed out the LOVE and wrote OWN in its place. Finally I held a Giuliani look-alike on a leash and continually whipped him as he spoke of his presidential plans.

"All crazy people who talk to themselves will be chained to other crazy people who talk to themselves!" he announced through a loudspeaker.

Meanwhile, we tossed hundreds of bright yellow GIULIANI IS A JERK stickers out to the cheering masses.

Our Giuliani for President float might seem oddly prophetic today, though anyone alive in New York City during his two terms could've told you the man would run for president someday. To us, he was a supervillain—and like most supervillains, he was hell-bent on taking over the world.

17

will vj for food

I was tired of working at Bloomingdale's, hawking jeans to "normals." I weighed my options and figured there were only two paths to instant financial security: either win lotto or get on a major TV network. I figured if I could get on TV, then everything would follow—my books would be published, my clothing line produced, my drawings collected. It was a simple plan.

Because I don't fancy myself an actor, I thought the fastest route to fame would be on MTV, working as a VJ. I had no idea how to become a VJ so I wrote MTV a letter, addressed to Judy McGrath, MTV's president.

My letter listed the many reasons why I would make an excellent VJ: (1) I have a lot of friends; (2) I am a local celebrity on the Lower East Side (a really cool neighborhood); (3) I am the coolest person alive (just as

Socrates was the wisest man alive because he knew that he knew nothing, I am the coolest person alive because I know that I will never be cool); and (4) I am the chosen one.

Ms. McGrath never responded. Guerrilla tactics were needed. I used my "industry" connections to find out when MTV was having its Christmas party. Then I made a sandwich board that said WILL VJ FOR FOOD on the front and MEET REVEREND JEN on the back. I marched in the freezing cold while wearing the sandwich board in front of the party, handing out informative brochures about myself to the various employees who came and went. Most avoided me and completely ignored me . . . or so I thought.

Shortly after my stunt, MTV announced it would be holding its first-ever "VJ Search" later that year. I was thrilled, not realizing they probably got the idea from me. I saw it as my chance to *finally* get on TV where I belonged.

When I did arrive at the contest, it kind of dawned on me that maybe MTV's creative geniuses had stolen my idea when I saw they were handing out signs that said WILL VJ FOR FOOD to the prospective VJs. This was my first inkling that being avant-garde sucks. You think of everything first and never see a cent. Now I'm used to it, but at the time it was upsetting.

Still, I had come to win, so I waited in line for hours along with the other hopefuls. When I finally went in front of a judge, he stared at me with the intensity of an elf-

hating orc. Despite his mean demeanor, my audition was a head-turner. All eyes were on the young elfin warrior who introduced the Puff Daddy video with such ease and comic timing. *I've won*, I triumphantly thought. Then, to my shock the orc snapped, "Next," and shooed me away like a bad scent. Defeated, I hung my head and slowly made my way to the exit.

As I walked away, I heard him mutter, "I just draw the line.at the ears." Not only had I been rejected, my elf ears had been mocked. The days of eccentrics such as Tiny Tim and Phyllis Diller appearing on TV were over. I was too strange for modern television.

At least I still had *Toolz*, where nothing was too strange.

Shortly after the VJ search debacle, I was lying in bed next to Brodeur, whom I was still dating, though I was also now "dating" several other Art Stars. He told me about an ad he'd seen that claimed MTV was looking for people to be on a new talk show. All you had to do was send in a tape where you talked about yourself and answered a few questions about politics.

I told Brodeur I didn't want to bother with MTV anymore since they'd stolen my idea and made fun of my ears. He persisted until I agreed to let him videotape me, though I told him he had to send in the tape. I wasn't wasting postage on those bastards.

The morning he taped me, I had no makeup on and he shot me from a really heinous angle, looking up my nose.

So I was shocked when MTV called and asked me to audition.

The night before my audition, I went to a party in Brooklyn with my friends Zack and Jonah. There, I saw a friend of Michael Portnoy's named Tommy Bigfinger. He'd gone to Vassar with Portnoy and had been to the open mikes a few times. He was good-looking in an all-American, sandy-haired, blue-eyed kind of way, and he kind of dressed like Peter Fonda in *Easy Rider.*

"Hey, Rev! Do you want some 'shrooms?" he asked.

I have a rule. It's *never turn down 'shrooms.*

Forgetting I had an audition the following day, I swallowed a handful. Soon I even forgot that I'd taken 'shrooms, but within the hour, everything started to look *extremely pretty* (and I was in Brooklyn), so they were certainly working.

After the party, we walked along the now glistening sidewalks of Brooklyn to Montero's, a dive bar that used to have an ancient parrot hanging in a cage above the bar. Eventually the parrot died and was replaced with a stuffed-animal parrot. According to legend, Montero's, which was once a sailors' bar in the fifties, also used to be the home of a monkey who kept customers amused until it began pissing in their drinks, after which they were no longer amused and said monkey was forced to find a new home. Montero's is so well lit you could perform brain surgery there. I like it because it's filled with model ships, has

cheap beer, Neil Diamond on the jukebox, and a surly midget who sits at the bar starting arguments.

I had a crush on Zack, a performer who came to the Anti-Slam every week and who introduced me to Montero's. Zack was a gifted writer who'd won a *Sassy* magazine writing contest at the age of fifteen. His motto was "If you can't find it in a supermarket, it's not a book."

That night as Donna Summer's "On the Radio" played, we shared our first kiss. I started to fall in love with Zack to the degree that when he had the flu, I ventured to a store in the snow to buy him a can opener so he could open a can of soup he'd purchased. That is how you know you really love someone. You buy them a can opener so that they can open one can of soup. On the last night we spent together, I'd just acquired a mini-planetarium, and we lay naked on my bed staring at the stars mixed with the peeling paint on my ceiling. But as I climbed on top of Zack, my foot kicked the planetarium over, and we were plunged into darkness. A fitting metaphor for our fling, because not more than a few days later, a screenwriting job whisked him away to LA, where he remains.

The morning after our Montero's outing, I was a bleary-eyed mess at the audition and was sure I had sabotaged my chances. Hundreds of chipper-looking people were there, who had probably bathed before their audition and who probably weren't hallucinating. After a few minutes, I was

called into a conference room, where I sat at a long table with TV people.

They asked me questions about Marilyn Manson and Pamela Anderson, subjects I am far better at discussing than, say, quantum physics. They asked me why I wore elf ears and I said, "Because elves are pretty."

I aced my audition and wasn't surprised when MTV called a few days later. I was one of six twentysomethings cast for the pilot. I'd be playing myself in a daily talk show. A week later, we shot the thing. It was supposed to be like *The Breakfast Club* meets *Politically Incorrect*, but really it was more like *The View* with hipsters. It could have been decent had they let us discuss a topic for more than thirty seconds or if they'd just fired everyone else and turned it into the *Reverend Jen Show*.

The show was canceled before it even aired, axed by focus groups who prefer to watch people light farts on fire.

I was crushed. My first concrete hope of becoming a household name had been squashed by MTV's focus groups. In another sense, I was thankful. Did I want to be a washed-up former reality-show celebrity? Plus I was still steamed over having my ears mocked at the VJ search.

When the Second Annual VJ Search rolled around, I sought vindication in an episode of *Toolz*. I sent hordes of Rev. Jen "fans" to Times Square wearing Rev. Jen T-shirts and carrying giant REV. JEN FOR VJ signs. They lined up in

front of the Viacom building and awaited my arrival. Curious pedestrians asked, "Who is this Reverend Jen?"

Moments later, I pulled up in a stretch limo. My "bodyguards," who were actually A.J. and two other actors in dark suits and earpieces, opened the limo door and I stepped out, clad in a fake fur, a sequined dress, and rhinestone sunglasses. My "fans" went wild, pushing through the crowd to get to me. Some tried to grab my elf ears, while others tried to kiss my feet. MTV security was thrown for a loop because although they'd never heard of me, they figured I must be famous if my fans were so ravenous. Soon they began to tear my fans away from me as if I were a famous person. The NYPD noticed the madness and joined MTV's security in the struggle to keep me safe from the masses. One burly officer grabbed Faceboy and said to him, "You're acting like an idiot!"

"I just want to touch her ear!" Faceboy screamed as a police officer tossed him to the sidewalk.

Eventually, I was ushered inside the building, flanked by security guards. I still didn't win the VJ search, but I did manage to cut the line and steal a doughnut from craft services.

18

sex symbol for the insane

By the late nineties, several storefront theaters were below Houston Street, and each one had cool shows. At Nada, a subterranean space, a troupe called the Neofuturists performed a popular show called *Too Much Light Makes the Baby Go Blind*. A roll of the dice determined admission price, and Sal Rosario, the local pizza guy, delivered pizza to the entire audience at midnight.

I befriended the Neofuturists, who arrived at the Anti-Slam one night in clown costumes. They stormed in, threw a net over me, and carried me out the door. A downtown-celebrity kidnapping! They placed me in the back of a bicycle-drawn carriage and drove off, ordering me to stand up and look under my seat. Doing so, I found a six-pack of Bud and a pack of cigs. The clowns then drove me to a party held in my honor.

My own apartment was as full of activity as the surrounding theaters. It was like Warhol's factory without the money, assistants, wealth, or recognition. Beth was constantly doing shows, J-Boy was amassing an incredible photography portfolio, and I was making guerrilla television.

I was still seeing Brodeur, who'd reluctantly begun to bone me. Unfortunately, each time he did, he reminded me of how I'd "stolen" his "second cherry" and "ruined his life."

J-Boy encouraged me to cut Brodeur out of my life, not just because he made me miserable, but also because he was a disruptive presence in our home. He'd recently been canned from his seafood-restaurant delivery-person job after his coworkers all threatened to quit if he was not fired. Now he was at the apartment *all the time*, yammering endlessly. He subsisted on a diet of Little Debbie snack cakes and Tropical Fantasy soda, which only fueled his constant mania.

I did eventually break up with him, and as a result, endless letters crammed my mailbox for the next two years. Some of the energy he'd focused on writing to Giuliani he now focused on writing to me. Sometimes I had relapses and let him sleep over as long as he agreed to give me a massage and not speak. During one relapse, he stole two beloved stuffed animals from me—Chachi, a snow monkey, and Bongo, a little chimpanzee. He wrote evil letters from Chachi and Bongo.

The more naive of the two, Bongo, scrawled in child's handwriting, *I heard Uncle Chris call you a cunt. I asked him what it meant, but he wouldn't tell me. I asked Chachi, and he wouldn't tell me. Is a cunt a bad thing?*

In another, Bongo wrote, *I'm staying with Uncle Chris still and it's a lot of fun. I get to climb on piles of his clothing and listen to him call up politicians and his room is dense like a rainforest. He's also teaching me to play guitar, but my hands might be too small. And I don't have any fingers. (Maybe I should learn to play keyboards instead.)*

Many of Brodeur's letters depicted me as a witch, flying through the sky on a broomstick or hugging Giuliani. The letters ran the gamut from hilarious to frightening.

Brodeur was still forced to appear in court almost weekly for his various harassment charges. On one occasion, he appeared in court wearing short shorts. When the judge reprimanded him for his inappropriate clothing, he started sieg-heiling her and got sent to Rikers for a month. There he wrote me several letters.

A bad man came to take Uncle Chris away, an alarmed Bongo wrote.

Chachi, the older of the two, wrote, *It's me, Chachi . . . the authorities came and took Chris away. I'm hiding under his piles of clothing until I feel that it is safe to come out. I know not what has become of little Bongo—I do not believe the authorities captured him.*

The ones that were actually "from him" could fill an entire book on their own. But some of the highlights include:

I have made some new friends here in Rikers, and perhaps I will bring them by the Anti-Slam someday to teach you all how to commit large-scale credit card fraud and about how to sneak heroin into jail.

And: *Thank you for the stamps, but you could've included some dirty pictures of you, which I could've traded to my fellow inmates for 100 stamps (and some cookies).*

With Brodeur in the crossbar Hilton, I found new relationships to sap my emotional energy. I engaged in a string of disastrous affairs with comedians, who are the most depressed people on earth. I started sleeping with a married man who was also a fairly well-known comedian with a minor drug problem who was depressed, which is really win win win when you're looking for love, but the sex was great and he was brilliant. Some sick part of me enjoyed the game of sneaking around. Some people need to go skydiving or mountain climbing for a thrill, whereas all I seemed to need was a few pints and a married man. But he and I were so different that I'm not sure anyone suspected our affair. He was successful. I was unsuccessful. He was aboveground. I was underground. But when clothes came off, we were similar in one respect: we really liked fucking each other. We hardly ever spoke, and when we did, it was usually in a whisper over the phone.

He: "I've tried to be good, but my God, you're like candy. I can't stay away."

Me: "Then don't. Come over."

That's about as lengthy and as G-rated as it ever got. He'd show up at my door and I'd invariably wear something he'd find tremendously disturbing and erotic such as kneesocks or pigtails. We'd fuck and smoke cigarettes and he'd look around my wildly psychedelic room full of trolls and ask, "What the fuck am I doing here?"

Then he'd come back a week later, and we'd do it again.

"Are you a witch?" he asked once.

"I'm an elf."

"Well, what do elves do?"

"We make you forget where you are."

"For how long?"

"Could be a minute, could be eternity."

"Oh, shit."

In this case, it was more like a year.

As far as I was concerned, things were perfect. I didn't want him to leave his wife. I didn't want anything to change. I *could* have had an affair with him for eternity. But *he* wanted to change. He wanted a fresh start. He wanted his home wrecked, and I was just a slut, not a home wrecker. Eventually, he stopped calling, and I found out that he'd met someone else, fallen in love with her, and left his wife.

Meanwhile, Beth began having a closeted lesbian

relationship. She also began studying the Meisner technique. This involved her working several thousand hours a week to pay for her acting classes. It also meant that she and her acting partner spent most of their time torturing me by doing "repetition" exercises in the kitchen. Repetition exercises are like the adult equivalent of the "I know you are, but what am I?" game.

When Beth finally landed an agent, he encouraged her to lose weight because apparently no one can be on TV who weighs more than a hundred pounds. For some reason, she also decided that this would be a good time to stop smoking and drinking. All at once, she gave up smoking, drinking, and eating. In short, she became unbearable. She got angry with me for having friends over who smoked and drank, despite that she had only quit for a month and it was still my apartment. I'd suffered mild brain damage for the lease to my apartment, and I wasn't about to let someone else set the house rules.

I often escaped my psychotic living situation by going to the movies, where I could lose myself in fiction and air-conditioning. On one trip to the movies, I saw *Cannibal! The Musical*, which was written by the creators of *South Park* and produced by Troma films. I liked it so much I wrote Troma a fan letter asking to appear in one of their films. Along with the letter, I sent a photo of me taken in front of the forest scenery at a Kmart portrait studio.

They asked me to audition for the part of "Tina, the

script girl" in an upcoming film called *Terror Firmer*. The screenplay was based on Troma head Lloyd Kaufman's autobiographical book, *All I Need to Know About Filmmaking I Learned from the Toxic Avenger*. The action took place on a B-movie set, where a hermaphrodite serial killer was on the loose, murdering off cast and crew and then turning them into pickled body parts. It starred luminaries such as Lemmy, Joe Franklin, and Ron Jeremy.

At the audition, I was told to perform anything I wanted for five minutes. Using trolls that were in my purse as costars, I performed a monologue from *Saint Joan* by George Bernard Shaw. I got the part, and within a few days I was bused to a film set in New Jersey. My part was small, but I got to learn things such as how, using only a watermelon, to make it look as if you've squashed a person's head. And I got to be in a scene where a woman's breasts explode.

Sometimes I brought my trolls to the set, to groom them during downtime. Sean, the guitarist for the Toilet Boys, who was also in the film, told me he detested trolls. So one day while he was napping, I put one of my trolls in his arms and started snapping pictures. He woke up and stuffed the troll down his pants. Two days later, he plucked the soiled troll from his underpants and handed it back to me.

Shortly after filming ended, I began handcrafting a book filled with my writing. Inspired by my relationship with Brodeur, I titled it *Sex Symbol for the Insane*. Beth, who

was working for MTV at the time, lent me her MTV ID card. This enabled me to walk into Viacom's office building and make eighty-five copies of *Sex Symbol for the Insane* at no charge. I then bound them in hot glue and duct tape, burning the crap out of my hands.

Printed Matter, a bookstore specializing in artists' books, picked up *Sex Symbol for the Insane*. It quickly became one of their bestsellers, though I could hardly keep up with the demand, considering the time it took to copy and bind each one. Given its success, my attention began to turn from trying to get on TV to trying to get published—a whole new prescription for frustration and self-doubt. Just as I'd been too weird for modern television, publishers told me I was "too fringe" for modern publishing.

19

doo-doo

When *Teletubbies* premiered, I became an obsessed fan. Though the show is intended for one-year-old viewers, it seems designed for LSD casualties and potheads. (It's also the favorite show of the gorillas at the London Zoo.) Most plots are simple. Laa-Laa might decide to put on a tutu and dance, and that somehow takes up a half an hour.

Faceboy's brother, John S. Hall, made me a tape of six hours of *Teletubbies* because I'd expressed an interest in them. Ennis and I smoked some wacky tabacky, popped the tape in his VCR, and watched it from beginning to end. I was hooked.

Steve Naidich had given me a secretarial job at the time, working at his Web design firm. He had a big-screen TV in his office, and I started going in to work early just so I could watch *Teletubbies* on the big screen.

I wrote essays about my four heroes, in which I compared them to the Beatles. (Po is John. Laa-Laa is Paul. Tinky Winky is George, and Dipsy is Ringo.)

"You should do a character, Jen," Ennis suggested, "one that's a bad Teletubby who's been thrown out of Teletubby-land."

This seemed like the perfect concept for channeling my obsession into art. I offered a friend some money to whip me up a Teletubby costume. Within a month, my new alter ego was born: Doo-Doo, the Pete Best of the Teletubbies. Unlike the four brightly colored Teletubbies, Doo-Doo was shit brown with missing teeth, a bruised face, bloodshot eyes, and a cockney accent. Doo-Doo, who had once been the creative genius behind *Teletubbies*, was expelled from Teletubbyland after the television on her stomach began to only show scrambled porn. Without her television career, Doo-Doo spiraled into an abyss of drug and alcohol abuse. Attempting to clean up her act, she moved to New York, where she was trying to make it as an actor.

Theo Kogan, lead singer of the Lunachicks, asked if Doo-Doo would like to host their next show at Coney Island High. Knowing this was going to be a comedy gold mine, I agreed, and Ennis followed with his camera. Before the show started, Ennis filmed Doo-Doo getting drunk, snorting lines, and cavorting backstage.

Doo-Doo ventured onto the stage, rolling around and giggling while the *Teletubbies* theme song played. She then

shared several songs she'd written, including one called "Fuck the Custard," which disses the Teletubbies' favorite food, pink custard, while accusing them of being corporate sellouts.

The Lunachicks' manager asked me to give away T-shirts and records to audience members. "But don't just give them out," he said. "Make them do something for them."

So when I got back onstage after the opening band, I screamed, "Who wants to make out with Doo-Doo?" A beautiful, long-haired dude who looked about eighteen hopped onstage and we shared a lengthy tongue kiss in front of the crazed crowd.

When the Lunachicks began to play, I hollered from the stage, "Who wants to see me stage-dive?" I was clearly possessed by Doo-Doo at this point because *I* would never stage-dive, for fear of breaking my bones or face.

Considering Doo-Doo's size, the audience looked terrified, but I paid them no mind as I launched myself into the crowd, where luckily I was caught. The audience lifted their hands to support me as I floated from the foot of the stage to the back of the club. As I was passed around, my Teletubby hand flew off and went whirling through the air.

"Me hand! Me bleedin' hand!" I screamed, but it was for naught. The next time Doo-Doo appeared, what had once been her little brown hand was now an oven mitt.

Backstage, I saw the cute boy I'd made out with and he said, "I didn't even know if you were a boy or a girl. I just really wanted to make out with a Teletubby."

A few days later, Ennis and I made our second stop in the Doo-Doo segment—the high-end Fifth Avenue toy store, FAO Schwarz, which at the time was filled with *Teletubbies* merchandise and displays. When I got to the store's entrance, the doorman, who was dressed as a toy soldier, asked, "Who are you?"

"I'm Doo-Doo, the fifth Teletubby," I grunted.

Naively, the toy soldier let Ennis and me in. Confused children gawked at me as we headed straight for the *Teletubbies* section on the second floor.

"Who wants an autograph from the creative genius behind the Teletubbies?" I shouted.

Customers recoiled in horror.

"Dance on the giant floor piano," Ennis begged.

Waltzing over to the floor piano that had been featured in the movie *Big*, I began to dance and sing mostly about how I was the true creative genius behind the show. A stunned crowd formed, and that's when FAO's security guards approached me. I tried to explain that I'd once been a famous TV star, but they weren't listening. Doo-Doo was not welcome at the uptown toy store. Several brawny men who were not amused by Doo-Doo's antics escorted both Ennis and me out of the store.

Our next stop was the Times Square Disney store, where I asked onlookers if they'd seen Michael Eisner. Gleefully, I rolled around on the ground until security escorted me out.

After being rejected there, we hopped on the subway, where I begged for change with my outstretched oven mitt. People cast their eyes downward, trying to ignore me.

Once we were downtown again, Ennis had me beg for change in front of a bank and dig through the garbage looking for food, all for the camera.

"Doo-Doo—*Exile in Teletubbyland*" premiered as part of the *Toolz* "Celebrity Episode," which also featured A.J. playing Ginger Spice. In this particularly evil segment, Ennis and Francesca dressed as MTV executives and stood outside the Spice Girls concert at Madison Square Garden, where thousands of young girls in Spice Girls T-shirts stood with their mothers. Somehow Ennis convinced many of these girls that Ginger Spice, who'd just left the band, would be attending the show and that they might just catch a glimpse of her if they waited long enough.

When a limo pulled up, the youngsters stared with bated breath. But when the limo door opened, their delighted faces turned to horror as A.J. staggered out, drunk on a bottle of champagne. He was clad in a sequined minidress, waving a giant Union Jack as he approached the crowd. He

wore a long red wig but hadn't bothered to shave his goatee. Clutching the empty bottle of champagne in his hand, he attempted to dance like Ginger Spice. The fun ended when A.J. attempted to gain entrance to the concert by insisting to the security guards that he was "in the band," until he and Ennis were thrown out.

20

x-day

After one particularly drunken Anti-Slam, Tommy Bigfinger and I got to know each other in the biblical sense. It was an enjoyable sense in which to know him, and we started "hanging out" quite a bit, even though he lived on Long Island and hardly ever came into the city.

He called me one afternoon to see if I wanted to go upstate with him to attend the Church of the SubGenius's X-Day celebration. I knew little about this church except that they worshipped a man named Bob Dobbs and expected aliens to come for them on X-Day. It was Fourth of July weekend 1998. I had no plans, so I hastily grabbed my things and went to meet Tommy.

First I was to take a train to Port Jervis, where Tommy would meet me and we would then drive the rest of the way. Because I am confused about geography, I didn't

realize how long the train ride would be and I grew paranoid, thinking maybe I'd taken the wrong train or, worse, maybe I'd died and this was a train to Hades. I cursed myself for leaving the comfort of the Lower East Side.

All I had on me was a set of elf ears (which I was wearing), a pair of purple sunglasses with a plastic bat face in between the lenses that I'd gotten at the zoo, a talking Laa-Laa Teletubby doll, a copy of *Midsummer Night's Dream*, a treasure troll, deodorant, a little money, and a clean pair of panties. Why had I packed in such a hurry? *Lesson learned*, I wrote in my journal. *Never leave the city. Travel only on foot, and always bring beer.*

Imagining that Cerberus would greet me as I exited the train, I started to write my will, donating my entire troll collection to orphans and my manuscripts to Faceboy. As I was debating what to leave my parents that wouldn't offend them, the train pulled into Port Jervis.

Tommy was there to greet me with a joint. Reminded of the preciousness of life, I inhaled on it deeply in the backseat of his VW bus, which sported the required troll hanging from the rearview mirror, announcing to law enforcement everywhere that we were taking drugs or looking for drugs. Because I am a horrible driver, Tommy drove the whole way while I drank beer and sang along to a Neil Diamond CD. Soon I was groping Tommy,

unbuttoning his colorful polyester shirt and removing his blue-blocker sunglasses. We pulled over for truck-stop sex, got back on the road, and pulled over for more truck-stop sex. We must've stopped at ten truck stops without actually getting anything.

X-Day was at a campground filled with nerds who lived for the Church of the SubGenius. They gathered under a massive tent where giant images of Bob Dobbs hung from the ceiling. Within five minutes, a large man sold us four hits of acid for only a few dollars. He asked us how much acid we'd done in our lives and we both said, "A lot." He said that, even so, we should only take one each.

The acid hit us perfectly. There was no sweaty speed-induced nervousness, just a casual coasting through infinite dimensions. We sat by a pond giggling and hallucinating.

"Look!" I said, excitedly pointing to my hallucinations as if Tommy could see them. The acid was so powerful that when I looked at my watch and it said nine, I had to ask a stranger, "Is it a.m. or p.m.?" They said it was p.m. and this seemed like a good excuse to go back into the van and take two more hits. We tried to fool around again, but I couldn't stop staring at his arm, which was a swirling pattern of pink and purple waves.

We exited the bus and followed the sound of drums to a nearby campfire, where a group of hippies were drumming

and dancing. I had on my elf ears and they all stopped and did double takes. These people believed in elves.

Many of the hippies were topless or nude. One was even in a silver leotard, doing some sort of Jazzercise routine. But I was too cold to get naked. Instead I began to dance with them in my hot-pink mini-muumuu while Tommy played the drums with an elderly hippie.

Moments later, the most beautiful naked woman I have ever seen appeared as if she'd suddenly crystallized out of thin air. She was tall with long, stick-straight blond hair down to her ass, pendulous natural breasts, and shapely legs. She grabbed my hands and spun me in circles like John Travolta twirling his dance partner in *Saturday Night Fever*.

"Are you a changeling?" I inquired.

Her eyes gleamed with lunacy. "How did you know?" she asked in a hypnotic Southern drawl.

It had been obvious to me that she was a magical creature, and I wondered if she was a hallucination or some sort of goddess, but changeling was the first thing that came to mind.

"I'm a changeling too," I told her.

At this she grabbed the sides of my face and began to tongue-kiss me, while the hairy eyeballs of various unsavory hippies latched onto us. Fear engulfed me, as I've always been slightly afraid of hippies, perhaps because I read *Helter Skelter* at too young an age. Since then, I have

expectantly been waiting for the day when I am "dusted" by a long-haired satanic cult and subsequently sacrificed to the dark lord.

"Let's go to the pool," she said abruptly. "I want to go swimming."

I grabbed Tommy's hand, because I noticed he'd been admiring her and also because she did look a little crazy. We walked up a hill to a swimming pool that was being watched by a bored-looking lifeguard who was probably used to this sort of thing. I took off my muumuu and got in. Once submerged, we all swam about together like a spirited group of horny porpoises.

"My mother was a mermaid and my father was half-elf, half-human. I think my grandfather on my mother's side was an elf king," my new girlfriend said with total sincerity.

She told me her name was Sara. She was from Tennessee, eighteen years old, and into witchcraft. She continued talking rapidly, but all noise was gurgled. I could only stare at her long, blond hair floating in the water like a million separate golden eels as her breasts bobbed above the water like safety flotation devices.

More hippies and freaks soon joined the orgiastic pool party, although we were all so far gone that there was no actual penetration. Inserting body parts into other body parts would have been too confusing.

Our nude pool party was rudely interrupted when a

long-haired young man who looked like Fabio's well-endowed little brother sauntered into the water and delivered a flurry of kisses upon the lips of the blond changeling. Young Fabio clearly was her lover and they were about to have their own private party, so Tommy and I got out of the pool. We had no towels, so we threw our clothes on over our wet bodies and ran back to the fire.

The bonfire dried me off immediately, but things around the fire became even stranger than before. The acid salesman now wore a blond wig and raved like a lunatic in different voices. As I listened to him, I realized Sara had actually given me a towel with which to dry off and that I'd been holding it in one hand the entire time, oblivious.

A man approached us, wearing what he referred to as a "magic hat." The hat had red, green, and blue lights on the brim. I put on the magic hat and it added another layer of strangeness to the experience. I felt that if I took the magic hat off, things would become normal again.

Frogs in a nearby pond enunciated, "Rib-it, rib-it," just as the cartoon frog does on the cereal commercials. I stared up at the universe in awe, which I rarely feel since I am more a fan of industrial waste than nature.

A plethora of freaks gathered around the fire. A woman named September told me she loved *Teletubbies*, so I went

to the VW bus and got my Laa-Laa doll. September put it on her head and danced around the fire.

I briefly wandered away from the crowd and found a little garden called the "fairy garden." I picked some flowers, held them to my nose, and inhaled.

As the sun came up, everyone gathered in a field to await the aliens, or rather to await disappointment. The Murphy's Law regarding aliens is that you can't *wait* for aliens. They'll only come for you if you're doing something, such as riding a tractor in a field or walking on a deserted road in a small town.

I found the crumpled flowers in my pocket and inhaled again. They still smelled good.

The sun burst through the clouds, and a white stretch limo made its way onto the field. Revelers chased the limo all the way to the tent where the Reverend Stang, the SubGenius Church leader and his girlfriend, Mary Magdalene, emerged. I was too short to see most of the action, but I could see that Stang was naked, being covered in oil and feathers. He claimed to have a note from Bob Dobbs stating that the aliens had landed but they wouldn't arrive at X-Day till 2098.

"What will they do with their religion now that the aliens didn't show up when they were supposed to?" I asked Tommy. This is something I've often wondered about religions that place dates around certain events. Say a

religion decides that the world's going to end on such and such a date and then it doesn't. What do you do the next day? Do you just say, "Oops," and move on?

"They'll just have another X-Day next year," Tommy answered, which was correct. In fact, since that first X-Day, the Church of the SubGenius has thrown an X-Day celebration every year without fail. The aliens still haven't shown up.

21

dance liberation

One morning I bumped into Robert Prichard, the proprietor of Surf Reality. He told me that the previous evening, Baby Jupiter, a club where I performed every Monday, was busted because their customers had been dancing.

I wasn't sure I'd heard him correctly.

"Dancing?" I asked.

Rob explained that to crack down on nightlife, Giuliani had dusted off a law from the 1920s, "the cabaret law," which states that more than four people dancing in an unlicensed venue serving alcohol is illegal. Out of the thousands of bars in NYC, only a handful of the richest clubs are able to obtain the dancing license.

It took a minute to process the Kafkaesque concept: dancing is illegal in New York City.

Once my disbelief subsided, I realized something had to be done.

Rob suggested we create a group, the Dance Liberation Front, or DLF, to bring to light the heinous crime Guiliani's nightlife task force was perpetrating on the public.

The same night Baby Jupiter was busted, a woman was raped in the hallway of my building and then dragged to an ATM where she was robbed. Why were the cops busting dancers when real crimes were being committed a block away? I was furious.

I sprang into action and wrote a manifesto. It began, "You thought the illegality of dancing was the stuff of science fiction, of Kevin Bacon movies, of small Midwestern towns . . . YOU THOUGHT WRONG."

I brought up the many reasons why dancing was good for the human body, mind, and spirit and why it was simply un-American to prevent free people from moving their bodies however they saw fit.

"What's next?" I asked. "No fidgeting, no holding hands, no laughing, no kissing, and no smiling . . . Pretty soon everyone in Giuliani's New York will have to sit perfectly still."

I was curious how the Department of Consumer Affairs defined dance. Was it doing "the robot" or shaking your hips? How can you regulate something you can't define?

After writing the manifesto, I went to the army/navy store, where I bought four black ski masks. Next stop was

Surf Reality, where Ennis set up his camera. Faceboy, Robert, our friend Liam, and I donned the masks and set to work recording our first communiqué to the public. We read my manifesto along with a manifesto written by Robert. We then aired our communiqué on MNN and sent tapes to the media.

Baby Jupiter had been padlocked all weekend and was set to reopen the following Monday night, when a private party for a slew of journalists was scheduled. It was an opportunity we pounced on.

After the journalists had a few drinks in them, we invaded, clad in our new ski masks and happy disco outfits. Face and Rob handed out manifestos, while I made my way to the sound booth. Taking the microphone, I started to read the manifesto, but was quickly chased away by the angry DJ. We ran back to Surf Reality, where we brainstormed two dance actions to take place the following weekend. One would occur uptown, where we would get a groove on in front of the Richard Rodgers Theatre where *Footloose the Musical* was being performed, and the other would take place downtown on a street corner.

When the following weekend rolled around, we headed uptown with a large group of Art Stars and disco in my boom box. There we cut a rug in front of *Footloose* while also handing out manifestos. A few of our "dance commandos" who attempted to dance *inside* the theater

were ushered out as the police came. But the cops found us somewhat entertaining and let us stay for a few more minutes before insisting we be on our way. When we got downtown, word was already out, and huge crowds of dancers had already assembled in the street. We had created a liberated dance zone!

Our mission, we decided, was to make a mockery of the cabaret law, thereby garnering media attention and eventually public support for its eradication. We knew that to get attention, we would have to organize dramatic spectacles, something bigger than our trip to *Footloose*. The answer was obvious: the DLF would organize New York's longest conga line, from Houston Street to Tompkins Square.

It was the beginning of January, and the weather was bitter cold. Risking frostbite, Faceboy and I went out, hung posters, and left flyers in every bar, shop, and café in the East Village, trying to recruit dancers willing to conga outdoors in the middle of winter.

Our posters caught the eye of many journalists, who called us and wanted to write pieces on the cabaret law. At the time, no one was writing about the law. Hence the authorities were doing what they always do when they think no one is looking: they behaved badly. So we made people look, which is what protests are designed to do.

About two hours before the conga line was set to begin, I walked by the corner of Houston and Essex, where, to my

horror, at least a hundred cops, paddy wagons, and NYPD motorcycles were stationed awaiting the dance action. I ran to Robert's and told him and Face.

Faceboy said, "If they tell us we can't do it, we'll tell them it's okay. We'll leave slowly, *in a line, with a beat playing.*"

With much trepidation, we walked over to Houston and Essex, where Faceboy spoke to the cops, some of whom remembered us from the *Footloose* action. To our relief, we discovered they weren't there to stop us; they were there to escort us and ensure our safety. Our conga line now had police escorts.

Hundreds of dance commandos showed up, clad in ridiculous costumes and evening wear, even a group of people dressed as giant insects. I wore my Doo-Doo costume and carried a large American flag, since I felt what we were doing was patriotic.

Finally we were off, beginning to conga while singing to a conga beat, "Giu-li-an-i-is a-jerk-*hey*!" There were maybe four hundred marchers altogether, but as we marched, people flooded the sidewalk, pouring out of the bars on Avenue A to join us. The *NY Post* estimated seven hundred dancers. At one point J-Boy said, "Rev, get on a bench and look!" I hopped up, turned around, and saw nothing but people, all of them having fun and *dancing*.

When we got to Tompkins Square, Robert and I made short speeches encouraging revelers to "fight for your right to party!"

We also sang our battle cry: "Mr. Mayor, we have not yet begun to wiggle!" As the party got crazier, the cops made it clear that we'd overstayed our welcome. We could have caused a fuss and gotten arrested, but Giuliani made it so easy to get arrested. To not get arrested was the real challenge, and just knowing we had already infiltrated the media was enough.

The next day, the *New York Times* and *NY Post* both ran stories on the event.

Robert thought the New York Civil Liberties Union might be interested in what we were up to, so he called the head of the NYCLU, First Amendment rights advocate and lawyer Norman Siegel. He offered to help if we ran into any trouble with the Man, going so far as to give us his home phone number. One of the things he told us is that the Supreme Court doesn't consider social dancing a form of expression, and it is therefore not protected under the First Amendment. He encouraged us to keep doing our dance actions while he worked on a more logical means of eradicating the law.

We followed the conga line with a hokeypokey circle around City Hall, a Times Square Twist-a-Thon, and a Million-Mambo March.

With each dance action, more dancers appeared who wanted to help fight tyranny on the dance floor. Publications began to write extensively about the DLF, and *Paper* magazine asked Rob, Face, and me to pose for their "beautiful people issue." We each got to be one-third of a beautiful person.

Paper gave us presents and invited us to fancy parties.

We always brought along our friend Tom Tenney, a theater producer who'd recently moved from Chicago to New York. At open bars it wasn't unusual for him to go streaking or create some other equivocal havoc. At one swanky *Paper* party, Tom and I decided to "liberate" the velvet ropes. While the bouncers were busy ogling women in tight clothes, Tom stuffed the ropes under his jacket and we ran down the stairs. At the bottom of the stairs, I found two metal stanchions. Heavy as they were, we dragged them outside, hailed a cab, and took them to Collective Unconscious.

A Canadian television show called *Ooh-la-la* contacted the DLF wanting to do a story on us. When the TV crew arrived in town a week later, we took them to a gay bar called the Cock, where Faceboy stripped down to his underwear and danced to "Hot Stuff" on top of the bar.

The following day, we took them to the Cuban consulate, where we attempted to defect to Cuba so that we could legally dance. For this action, Ennis dressed as a naive American tourist who "just wanted to go dancing" and who bore gifts of Goya products to show our goodwill. Several intimidating men in suits came outside to speak with us. I showed them our list of nonnegotiable demands, which were as follows:

1. We demand the repeal of all New York City cabaret laws regulating DANCE.

2. New York City will recognize "DANCE" as expression and will afford DANCE all First Amendment protections.

3. Henceforth all New York City public transportation will feature DANCE music, preferably live.

4. Every Saturday night is an official New York City DANCE holiday.

5. Henceforth, our National Anthem will feature a beat.

6. From now on, all New York City judges must wear "John Travolta" masks while court is in session.

7. Henceforth on every Tuesday and Thursday pedestrians must conga across New York City intersections and crosswalks. Every Wednesday and Friday will feature alternate side of the street DANCING.

8. From now on all New York City employees will take a mandatory 10-minute DANCE break at 4:00 p.m. during the workweek.

9. Mayor Rudolph Giuliani will be obligated to perform Demand #8 clad solely in a pair of Reverend Jen "Manties" and his DANCE must be silly.

[Manties were men's underwear I sold that had my picture on the crotch along with the phrase REV. JEN LOVES ME.]

10. New York City will undertake the formation of a "department of silly DANCES" to study and evaluate the Mayor's compliance with Demand #9.

The Cubans weren't swayed by our list, and eventually we were told to go home by a scary man in a suit.

Organizing the dance actions was exhausting, especially since we were often faced with apathy. I tried to hand out flyers on the street, but this was before Bush, before subway backpack searches, and before the Patriot Act, so disinterested hipsters looked at me as if I were an alien for giving a crap about civil liberties. Eventually, enough people did care. After a couple of years of DLF actions, other "legalize dancing" groups formed (though none of them had the same knack for absurdist hilarity), and Rob, Face, and I were able to take a break. Even better, the Department of Consumer Affairs recently made a public statement admitting that the laws are "unworkable" and "outdated." They called a public hearing on the cabaret laws, where I was given a chance to speak before them.

I wore a tutu and elf ears. Gretchen Dykstra, the head of Consumer Affairs, was quoted in the paper as saying she'd never seen elf ears at a public hearing before.

When I got up to speak, I was nervous, but managed to get through a one-minute speech that wound up being quoted on the front page of the *New York Times*. It was a point Prichard made when we started the DLF.

"We have the right to life, liberty, and the pursuit of happiness," I said. "And what is happiness if not dancing?"

Sadly, despite all of the above, it is to this day illegal to dance in New York City.

22

being a supermodel is cool

One Monday night, I'd just done a performance at a bar called Luna Lounge when a good-looking young couple approached me.

"We want to give you some makeup," they said.

They opened a little box filled with cosmetics.

"This is eye shadow for drunks," the woman explained, presenting a small disk. "It has chamomile in it so when you pass out with it on, it's good for your eyes."

"This is *mood-elevating* lipstick," the man said in a British accent. He kind of looked like David Bowie. He handed me a tube of lipstick shaped like a bullet vibrator.

In exchange for the makeup, I gave them a copy of *Sex Symbol for the Insane*.

They were a married couple named Tony and Cristina, and they owned a cosmetics company: Tony & Tina

Vibrational Remedies. They lived on Ludlow Street, one block up from Collective Unconscious, and they invited me over the following day.

When I got to their apartment, they were listening to Duran Duran, smoking weed, and arranging unicorn figurines on their coffee table. They told me they'd taken ecstasy, gotten married, and started their company all in one weekend.

They were the most optimistic people I'd ever met. Tony told me he was working on paintings he hoped would "vibrationally" cure diseases.

"What diseases?" I asked.

"You know, cancer, depression, anything," he answered.

Tony and Tina had been fans of mine ever since they saw me traipsing about the neighborhood in elf ears. They wanted to work with me and concluded I should be their supermodel.

"But you wouldn't be like a *model*," Cristina said, "you'd be like a *role* model."

It appeared I had met the two people on earth who considered me a role model.

"You live your own truth daily, Rev," Tony declared.

This was the year Calvin Klein said, "I don't think people are that interested in models anymore." He then began using celebrities such as Foxy Brown and Liz Phair in his advertisements. Tony and Tina took it a step

further by choosing me—a completely unknown, insane Art Star.

Now that I was their supermodel, I started making proposals. The first order of business was Reverend Jen Trading Cards, which I suggested we create and distribute with their merchandise. Furthermore, the different cards should focus on the many hats I wear as a role model. Tony and Tina loved the idea.

A few days later, J-Boy photographed me performing everyday activities—cleaning my ears, reading poetry while painting my nails, doing an incantation, daydreaming, talking on the phone, and more, for the front of each card. For the back of each card, I wrote corresponding text. We decided on activist, daydreamer, creative visualizer, Art Star, businesswoman, lover, and literary giant. Within a few months, thousands of cards arrived at the Tony & Tina warehouse.

The first ad, which ran in *Flash Art*, featured a photo of me along with the claim "This is the only animal we test our cosmetics on." This was followed by several other ads, featuring me frolicking at home.

Though the ads elevated me to a new level of celebutante, what every supermodel needs is a big party where she signs her "official contract." Because Tony & Tina had almost no advertising budget at the time, they pretended to give me a blender, as I pretended to sign my

contract. The band Fischerspooner was scheduled to play at the big event and in preparation for the show, they built a massive elevated Plexiglas cube in the center of Tony & Tina's SoHo office.

The invites to the party were made of clear pink plastic.

Eddie, Tony & Tina's "intuitive" makeup artist, was a psychic. He developed a look for me that he called "elfin movie star," attaching long, wispy eyelashes to the corners of my eyes and dusting gold across my cheekbones.

A thousand or so people came to my party, including Marilyn Manson, but no one knew who I was or why they were there. The banister in the hallway collapsed due to the excessive weight of drunken people going up and down the stairs. A.J. pretended to be my bodyguard and wore a dark suit along with an earpiece. His main job was to beat Brodeur off me whenever he tried to touch me, which happened frequently. Francesca played my publicist and walked around with a stack of pictures of me. "Would you like an autograph from Reverend Jen?" she asked the partygoers.

Most asked, "Who's Reverend Jen?"

Fischerspooner sat in the cube having their hair done, then played as dry ice enveloped the cube. I spent most of the party waiting in line to pee because my bladder's so small.

At the end of the night, I went home alone and passed out, cradling a doll with my face silk-screened onto it.

A month later, the cube still sat in the office. Tony decided to curate shows within the cube and asked me to inaugurate the space with a show—*Reverend Jen, a Mid Career Survey*.

Within the space, I hung a comprehensive retrospective of my life's work. It included an audio tour narrated by my friend Don Eng. I also created a catalog and an alter ego named Mary Sellman, who gave tours to visitors. Mary Sellman was a character that had been brewing inside me for a while, a fiftysomething former soccer mom who'd become a docent to fill the void in her life. She wore a floral dress, octagonal glasses, and a huge, curly wig. She also carried a flask wherever she went. In the fictional history I created for Mary, she'd worked at the Met, MoMA, and the Frick, but had been canned for drinking on the job. She was now a freelance docent, working the Chelsea circuit. To test Mary out, I premiered her at a John Currin opening at Andrea Rosen Gallery, where my tour group of curious art lovers asked questions like "Is this good art?" After that, Mary brought tour groups to Chelsea a few more times.

My midcareer survey stayed in Tony & Tina's office for months until one of their "superiors" demanded they take it down because it was an "eyesore."

Following the midcareer survey, Tony and Cristina let me use their color copier as payment for being their supermodel, which was probably a huge mistake. Every day I showed up at 9:00 a.m., before they even got to the office.

I copied books, flyers, posters, and press kits. No one else in the office had a chance to use the copier because I hovered over it all day long. Because I used their copier so much, it began to break down once a week, and I soon got the idea I was no longer welcome.

"Kate Moss doesn't come by Calvin Klein's office to use his copier," Tony said.

"But I've got to copy these pictures," I told him, holding up pictures of the gelflings from *The Dark Crystal*.

"Why?"

"Because I'm doing collages where I'm having sex with them."

"You're sick."

"Why? They're pretty"

"Flowers are pretty, Jen. I don't want to have sex with them," Tony said, horrified.

I never used their copier again. Shortly thereafter, they started using real models. Soon after that, they sold out to Wella, the company that made Wella Balsam in the seventies, and not too long after that, the company went out of business.

23
1999

When I was a child, I had a lot of hope for 1999, which Prince promised would be very cool indeed. Instead, 1999 turned out to be one of the lamest years to date. The year the pint-size pop star declared we'd all be partying our lives away turned out to be the high point of the Internet boom. Suddenly "We're gonna party like it's 1999" meant holing up in one's home and ordering pints of Ben & Jerry's from Kozmo.com while simultaneously downloading porn.

People went to Internet cafés so they could sit in front of modules with their backs turned to the other people in the café. The year 1999 was the most antisocial ever to occur in the history of the world.

At least I managed to get a job that year. A friend of Monica's had a friend who was opening a pub and was looking for someone to dress as a leprechaun and hand out

brochures. The pub owners hired me after hearing my impressive résumé of humiliating jobs.

The summer heat was awful as I dredged about in my costume, handing out flyers to disinterested yuppies who openly mocked me. After a few weeks, my leprechaun gig came to an end and I was left ill, unemployed, and impoverished.

One shitty thing about being unemployed is that you have more free time to go out drinking, but less money to do it with. Luckily my friend Bruce was a bar reviewer for a magazine called *SHOUT*. I often went along with him and helped him "review" bars by drinking for free. Sometimes his reviews had themes. For instance, when he reviewed bars around Port Authority, he dressed as Midnight Cowboy and I dressed as a teen runaway. In another article, he reviewed three different bars: the Blarney Stone, the Blarney Stone, and the Blarney Stone.

Often, the evenings ended at Bar on A, an Art Star hangout on Avenue A that we'd nicknamed "Bottle on A" because of the excess that went on there. One evening at Bottle on A, Bruce ran into a guy who wrote for *SHOUT* named Benjamin, who offered to buy me a beer in exchange for a copy of *Sex Symbol for the Insane*, which I was carrying around. I handed him a copy and he handed me a pint of Bass.

The following month, I got a copy of *SHOUT* in the mail. They'd featured *Sex Symbol for the Insane* in the

"Don't Miss" section. Having nothing to lose, I called them up and asked if I could write for them. I'd never written for a magazine before, but they let me have a go at it, and soon I was penning a monthly column for them, "Urban Elf Report," which I wrote for several years.

Despite my success as a columnist, my home life was again in turmoil. Beth had become angry because my stuff seemed to be taking over the apartment, even though I let her use the big bedroom, which was twice the size of my own. Still, I had many props. For my latest show, I'd built six-foot-tall papier-mâché mushrooms as well as a mush-room-shaped throne.

One evening, I came home to find Beth staring angrily at one of the mushrooms.

"There's a mouse caught in the mushroom," she said.

I cut the mushroom open, ruining it, but didn't find anything.

"Why can't you put your stuff in storage?" she fumed.

"I don't make beautiful things so I can put them in storage, and, plus, I'm poor. I have *no money for storage.*" I needed plenty of things, such as a doctor, a dentist, and a new pair of shoes, but I couldn't afford any of these things. About the only thing I could afford was Budweiser.

The mushroom incident pushed me over the edge. If Beth didn't understand why it was cool to have giant mushrooms in our home, she didn't belong there. I asked her to move out, and a huge fight ensued. For two months,

she pretended to look for an apartment but continued to stay on while giving me the silent treatment. Not until I laid down an ultimatum of one month did she finally pack up and move out. Shortly thereafter, J-Boy stumbled upon a sweet sublet and moved out.

My friend Lorne, a gay comedian who needed a place to stay, moved in. He seemed oblivious to my props' taking over the apartment.

Soon after Lorne moved in, fame loomed on my horizon again. Ennis began working with an agent who tried to sell *Toolz* to a TV station. Ennis moved into a huge loft on the corner of Broadway and Houston, which we called Toolz Headquarters.

My friend Hank Flynn joined the cast of *Toolz* and contributed a number of brilliant characters including Dirty Rockin' Steve, a metalhead roadie from Massachusetts.

Hank thought it'd be fun if Dirty Rockin' Steve went to Ozzfest in New Jersey and hung out with real metalheads. Because I had a Dorothy costume, I decided to go along with him and to pretend I thought it was a *Wizard of Oz* fest.

Our friend Lars, who drove us to New Jersey, made a pit stop along the way so Ennis could get a shot of Dirty Rockin' Steve and Dorothy hitchhiking on the side of the New Jersey Turnpike. With thumbs outstretched, we held up a sign that read OZZFEST OR BUST.

When we finally pulled into the Ozzfest parking lot, I

leaned out the car window and asked Ozzy fans, "Do you know where I can find the wizard?"

Several Ozzy fans replied, "Dude, I think you need some doses."

We drove by a group of cops and I innocently asked, "Do you know where I could get some doses?"

Once on foot, I approached a long-haired dude and asked, "Have you seen Toto?"

"No way, dude! I hope Toto isn't here. They suck!" he exclaimed.

For hours, we interacted with the metalheads, some of whom terrified me. One young man insisted on showing me a trick wherein he made a "birdbath" in his testicles by turning them inside out and filling them with Budweiser.

Eventually, the Ozzfest episode ended the way all episodes ended—with police officers insisting Ennis put his camera away.

Shockingly, the only *Toolz* member to ever get arrested was an NYU intern from Texas who was hauled into a station for placing several thousand *Toolz* stickers up around the metropolitan area under Ennis's guidance.

It's amazing to me that we were able to acquire interns by simply calling New York University and asking for them, and even more amazing that our interns actually obtained school credit through their involvement with us.

When we decided to participate in the annual Coney

Island Mermaid Parade, we sat around smoking weed and drinking beer while our interns built our float for us.

The Mermaid Parade occurs every summer solstice in Coney Island. Hundreds of New Yorkers march down the boardwalk alongside elaborate sea-themed floats while wearing sea creature costumes, along with plenty of sunscreen to protect their ghostly, urban bodies from the sun.

We wanted our float to have a Coney Island seashore theme, so we instructed our interns to apply sand, fake hypodermic needles, condoms, and trash to the sides of a borrowed flatbed truck while we "supervised."

Ennis suggested I dress as a sea creature, and I knew immediately which creature I would embody. I would realize the unfulfilled fantasy of my youth by bringing the mythical figure of the Sea Monkey to life.

For a lot of people, parades offer an opportunity to revel in a celebratory atmosphere, to be with loved ones, eat fried foods, and wear colorful costumes. For me, parades offer a unique challenge: what is the most masochistic, obtuse, and unwieldy costume I can create, which will prevent me from enjoying myself in any manner whatsoever? And how can I make said costume so unattractive as to prevent any member of the opposite sex from speaking to me?

The Sea Monkey costume fulfilled all of these requirements. While less refined masochists toy with outdated trinkets such as nipple clamps and hot wax, I know that the secret to true masochism lies in a full-body

spandex/polyester unitard, worn beneath the blazing sun in the middle of June.

Rather than simply documenting the parade, we created a subplot in which my Sea Monkey character was the victim of an environmental disaster. We scripted a scenario in which Hank played an embittered, old sea captain who had been plagued by guilt after his ship accidentally spilled a massive quantity of radioactive waste onto the Coney Island seashore, killing several manatees and other adorable sea animals, including a whole colony of brine shrimp. However, one tiny brine shrimp had been empowered by the radioactive waste (like the Mutant Ninja Turtles) and had actually grown stronger and larger and had returned to the Coney Island boardwalk to exact revenge upon the old captain.

For character inspiration, we looked to the film *In the Line of Fire*. Like Clint Eastwood's character, the old sea captain turned to the sauce after experiencing bitter failure, and like Malkovich's character, the Sea Monkey had turned to random acts of terrorism. *Attack of the Five Foot Sea Monkey*'s finale comes when the Sea Monkey reveals to the bewildered captain that it has placed a bomb in the Coney Island Aquarium on the very day of the Mermaid Parade!

The camera rolled as Hank chased me down the Coney Island boardwalk, finally pulling me to the ground by my spiked tail. As we began to wrestle, we drew a crowd of excited onlookers, who watched as Hank ripped off my tail.

"By killing me you'll only make me stronger!" I screeched as the crowd applauded.

At the end of the parade, our heinous float received the dubious honor of third prize, which I think we only got because we bribed the judges. Nevertheless, Ennis proudly displayed our trophy at Toolz HQ.

The new headquarters were the perfect location—directly above the starting point of the annual marijuana day parade, where thousands march to protest the illegality of marijuana.

During our first year there, Ennis and A.J. stood on the roof of the building and threw Fritos and Doritos onto the assembling marchers.

While the marchers screamed, "Thanks, dude!" the cops were less appreciative and responded by chasing A.J. and Ennis, who managed to outwit and outrun them, thus becoming the perfect decoys for anyone who wanted to light up a joint.

The following year, we dressed as drug dealers and carried a banner that read DRUG DEALERS AGAINST LEGALIZATION . . . KEEP OUR PRICES AND OUR CUSTOMERS HIGH!

Eventually, our agent got us a development deal with Howard Stern Productions and a few gigs with Burly Bear, a TV Network that was broadcast on college campuses at the time. Burly Bear lent us a full-body, realistic bear costume, which Hank used to feed the out-of-control streaking phase

he was going through at the time. Placing the bear head over his own head, he stripped down to his birthday suit while A.J. put on the bear body leaving his head exposed. The two then raced down Broadway in broad daylight, Hank naked but for the bear head, with A.J. chasing him wearing the bear body, while Ennis videotaped.

Despite minor success, I was still a broke mess, getting hired and fired from jobs weekly. I tried to start a business called Rent-an-Elf, a freelance service that provided quality elves to busy professionals for all their errand-running needs, but it never took off.

I got a job at a start-up Web company where I got paid a generous hourly rate for reviewing different websites. It was the easiest job I have ever had. I didn't have to wear a costume. I didn't have to use my brain. Some days there *was no work to do at all.* Looking back at how little I did, it does not shock me how many online businesses lost money. This was a beautiful time to be a young American.

24

lord of the cockrings

The Web boom was a golden age for Art Stars, who could finally afford not only beer and weed, but props for their shows as well. During this era of decadence, Tom Tenney produced a monthly show called *Grindhouse-A-Go-Go*, where the Art Stars "put on plays." Every Friday at midnight for $5, *Grindhouse* audience members piled into Surf Reality and got a complimentary can of Budweiser along with the weirdest shows ever witnessed.

Tom asked me to write the first script and I turned in nine pages, which the actors somehow stretched out to fill an hour. The piece was set in the fictional land of Hal, Halitonia, and it featured a gay wedding, wizards, a cow, ray guns, a cardboard Subaru Brat, and live disco music.

An Art Star named Purple Organ wrote some of my favorite *Grindhouse* shows. Because Purple Organ invested

in Yahoo! at its inception, he became a rich Art Star overnight. He lived in a huge loft full of stacks of porn, empty bottles of Snapple, and humongous bags of weed. He had dreadlocks down to his waist and wore outfits of his own design, which often included assless chaps. One outfit stands out as having giant shoulder pads constructed out of a Jar Jar Binks mask. Purple's Web earnings enabled him to go to the costume shop and buy a plethora of costumes that he then wrote scripts around.

One such show, *Kinko's Boob Couch*, took place at a Kinko's run by a Teenage Mutant Ninja Turtle and Barney Rubble, where the Unabomber set off a bomb that broke all of the copiers. Then for some reason, everyone at Kinko's had to go to Crunch gym and work out. But then the Unabomber set off another bomb that made everyone at Crunch insane.

I wrote a script entitled *Lord of the Cockrings*. In it Scroto Baggins, a computer programmer from Secaucus, New Jersey, wanders into a sex-toy store and buys a magical cockring. When he puts the cockring on, he is transported to Middle-earth, where he learns that he must destroy the cockring to save Middle-earth's inhabitants. At the end of the musical, Scroto destroys the ring by tossing it into a science-fair-style papier-mâché volcano. At the show's finale, a stagehand stood behind the volcano and poured baking soda and vinegar into it, causing an explosion.

The cast was insanely drunk before, during, and after

the show. It was a train wreck. Mike Raphone, who was playing an apple tree, stormed off the stage fuming, "I can't work under these conditions!"

Most *Grindhouse* shows were directed by Robert Prichard and hosted by Faceboy. At the start of each, Faceboy jokingly promised the audience a "mandatory drunken, gay orgy" after the show.

During the monthlong run of *Lord of the Cockrings*, a listing in *HX* magazine (a gay publication) picked up on the "drunken, gay orgy" announcement. Gay men who read the listing showed up, watched the show, then took off their clothes and danced around to the live band. Eventually, *Lord of the Cockrings* became a film, but unlike the bloated $300 million New Line version, mine had nudity, rock 'n' roll, and an ending.

25

to hell with the devil

When Tommy Bigfinger told the cast of *Toolz* about an event called the March Metalfest Meltdown, two days of hard-core metal, porn stars, and pro wrestling, we knew we must go. Ours would be a spiritual journey into the abyss of youthful angst—the South Jersey Expo Center, to be exact. Our mission: find our inner metalhead, emulate rock stars, and, as usual, humiliate ourselves in the name of art.

There are plenty of ways to ensure that one gets ostracized at a heavy-metal gathering. You can wear a Kenny G T-shirt or a Nelson T-shirt, or you can go one step further and dress as the Christian hair-metal band Stryper, which is exactly what we did.

Stryper, the supergroup behind such hit albums as *The Yellow & Black Attack*, *In God We Trust*, and *To Hell with*

the Devil, were superstars in the eighties. Their message was simple. They were out to preach the word of Jesus through cheesy hair-metal, while wearing matching yellow-and-black outfits.

Finding yellow-and-black-striped outfits in the year 2000 was not easy. But Ennis's girlfriend scoured the city to find the most appropriate duds available. She did such a splendid job that by the time we rolled into southern New Jersey in our lavender tour bus, not only did we fool shocked onlookers, we fooled ourselves. We *were* Stryper.

To create drama and tension, A.J. attended dressed as Stryper's nemesis and every metalhead's hero, Satan.

I gasped with joy when I first laid eyes on our tour bus. It was the size of ten Lower East Side apartments combined, and it had a giant image of Marilyn Monroe airbrushed on the back. In retrospect, with bands such as Anal Blast, Dying Fetus, and Corpse Vomit playing the festival, it should have been clear to us that this was not the Mötley Crüe, Ratt, Poison variety of metal, and that pulling up in a lavender tour bus was really not that cool. Because we couldn't afford the tour bus on our own, we shared it with Osiva, a band that Tommy Bigfinger was managing. They were the only band at Metalfest obnoxious enough to get thrown offstage.

When we entered the Expo Center, the place was filled

with social miscreants and angry youths. The vendors were selling T-shirts emblazoned with masturbating nuns and laughing devils. One kid walked by us wearing a shirt that read JESUS WAS A CUNT.

Ennis had reserved a table, which Kathleen, our newfound producer, decorated with Stryper posters and merchandise. We stood on the table and spoke to the crowd through our megaphones, declaring that we had reunited and were starting a Bible camp.

Shockingly, many people actually thought we were Stryper, and as a crowd formed around us, A.J. entered as Satan.

"What are you doin' in my house?" he demanded.

The crowd chanted, "Satan! Satan! Satan!"

A.J. grabbed our megaphone and challenged us to a wrestling match at the nearby wrestling ring. The crowd nearly bowled us over running to the ring. They wanted to see blood—Stryper blood.

I know little about wrestling, so when I got into the ring, I was confused. I was supposed to begin the match by slamming Satan on the back with a folding chair that was sitting in the ring, but I was so afraid of hurting him that instead of slamming the chair, I gave A.J. more of a love tap. He played along, falling to the ground in mock agony. Immediately we began throwing elbows and haplessly trying to imitate the *Smackdown*.

Unfortunately, our match was cut short when two pro wrestlers appeared in the ring. The real match began at 7:00 p.m., not 8:00 p.m. as we thought! We quickly exited the ring before the spandex-clad wrestling stars had a chance to pummel us. However, we continued our match in the hallway, where we slammed each other with folding chairs, tables, and even a fire extinguisher.

The crowd cheered as Satan chased us into the cafeteria, where he pretended to slice Ennis's head in a meat grinder. The eternal battle between good and evil finally came to an end after we doused Satan with holy water, temporarily blinding him as we escaped to our tour bus.

Throughout Metalfest, we portrayed characters other than Stryper. A.J. played a bouncer who was trying to "weed out the wimps" by refusing entrance to anyone not carrying weapons or drugs. Hank played a barber attempting to forcibly give the crowd mullets, and I rehashed my role as docent Mary Sellman, who was searching for her goth daughter, Raven, whom I also played. Mary Sellman then met Dirty Rockin' Steve, again played by Hank, and the two hit it off, venturing out to a tour bus where they smoked angel dust and fell in love.

Back inside the venue, we convinced the EMT workers to let us lie down on their stretchers, where we pretended to have drug-induced freak-outs.

After two days of silliness and deafening metal, it was time to head home. As our lavender bus departed from the

Expo Center, Hank cranked up Guns N' Roses and we cracked open what beer was left.

We didn't pull into Toolz Headquarters until four in the morning. I headed home, slept, and woke up at 8:30 a.m. for part two of our adventure. Ennis, Hank, and I put our Stryper costumes back on and headed to Weehawken, New Jersey, where we attended a church service in full regalia. Kathleen had called the church ahead of time and told them we were a famous Christian rock band who were the subject of a documentary.

Hank and I made the mistake of smoking weed before church. When the preacher introduced us to the congregation, we started to crumble with silent giggles. My face turned red and tears of laughter rolled down my face. Were there a hell, I would definitely burn in it.

A few weeks later, after Ennis had edited the Stryper episode and we'd become obsessed with other matters, Kathleen told us some exciting news—Stryper was playing a reunion gig, the first in ten years, at a Christian metal show in New Jersey. Back to New Jersey we went, only this time we didn't dress as Stryper. We dressed in a mildly conservative manner and claimed to be from a cable show that featured "human interest stories."

Stryper granted us an interview, and they turned out to be the four nicest people I'd ever met in my life. I expected them to be hypocrites, preaching the word of God while

secretly banging groupies in their van, but they were very much like Jesus. Kathleen and I even developed a crush on the lead singer, Michael Sweet, but we realized that unlike other rock stars, he probably didn't cheat on his wife. As Stryper played, we danced joyously, singing every lyric to every song. We became their biggest fans.

26

the vaginas monologue

Memorial Day weekend 2000, I got the worst stomachache of my life. If you remember the scene in *Alien* where John Hurt's stomach bursts open and he gives birth to alien spawn, you'll have some idea of what it felt like. So I cabbed it over to Saint Vincent's Hospital in Greenwich Village, where I donned the ass-less paper gown of shame.

I told the doctors my symptoms: "Nausea, cramps, and vomiting. I think I'm dying."

"Do you have insurance?" they asked.

"I come from a magical land called the Lower East Side. No one there has insurance."

Within minutes, I was told I had gas, given a prescription for Pepcid AC and sent home. A day later, my stomach had swollen up like a troll's, and the severity of my pain had

doubled. Lorne insisted on going back to the emergency room with me. There, a young Ben Affleck look-alike stuck a thermometer in my mouth, told me I had a 104-degree temperature, and sent me to the waiting room.

After several hours of waiting, I once again lay upon a gurney, where young medical students basically punched me in the stomach repeatedly asking, "Does this hurt? . . . Does this hurt? . . . Does it hurt when we punch you in the stomach?" For some reason, the doctors decided I had an STD, and with each question about my sex life, my stomach grew larger and my pain grew worse. In the back of my mind, I was compiling a list of past sexual experiences. "Oh, God, it was the skinny one. Maybe it was the one with the nipple ring, or the one who worked in the Pepsi factory."

Finally they gave me a gynecological exam, but when even my vagina revealed no clues, I was given a sonogram. The doctors pointed to what looked like an early Pollock and said I had ovarian cysts, which were possibly the source of my pain. They asked me to sign a waiver, which would allow the doctors to remove my ovaries if need be. I was in so much pain that I could barely sign my name and I started to cry hysterically out of fear and mistrust. Lorne calmed me down by giving me a foot rub and telling me to look for rings on the fingers of the doctors.

The doctors opted to do "exploratory surgery," meaning they would put a tiny camera in my stomach that would

reveal my ailment since, in layman's terms, they still didn't know what the fuck was wrong with me. *Oh my God*, I thought. *What if they find that my stomach is filled with eight gallons of semen and I have to have my stomach pumped just like Rod Stewart, and all of the junior high school kids in America make fun of me?*

At 11:00 p.m., one day and nineteen hours after my initial emergency room visit, I waved good-bye to Lorne and was wheeled inside the operating room. The nurses put little sticky things on my shoulders, and in one instant I thought of every horrible operating-room scene I'd ever seen in the movies, namely Cherie Currie coughing up blood in *Foxes*.

The last thing I remember was an anesthesiologist putting an oxygen mask over my face and telling me to breathe. Each breath brought me relief and oblivion. Later I realized that if I am actually a mere mortal, and I have to die just like everyone else, this is how I want to go. In that moment, when the anesthesiologist, aka God, tells you to breathe, you fall into a deathlike stupor, into peaceful unawareness, and it is far from scary. *Life is scary. Pain is scary. Awareness is scary.* Death is inevitable and who knows? Maybe you'll get to come back as a bonobo chimp.

Two and a half hours later, the doctors woke me up and wheeled me outside, where Lorne was waiting.

"You were screaming at the top of your lungs when you woke up," the nurse told me.

"Oh my God, that's so uncool," I said. I hadn't remembered them waking me up. I only knew that I was alive and in great pain, though significantly less pain than before.

Going from total darkness and unawareness into light and awareness in seconds is pure terror, like being born a second time. According to some philosophies, when a person is in a dreamless sleep, it's as close to the death state as he or she can come. Sometimes people come out of anesthesia and say things like "I love you." My uncle John, who is of Lithuanian descent, came out of surgery speaking perfect Lithuanian, even though he can't speak a word of it consciously.

Lorne and I had a nonsensical conversation about catheters, and how convenient they'd be for the Anti-Slam. We could drink all the Bud we wanted and not have to get up to pee! Lorne asked the nurse how soon I'd be drinking again, along with several hundred other inappropriate questions she couldn't answer.

The nurse told me the problem had been my appendix, but I just assumed they'd taken it out. No one told me it had ruptured. No one told me I'd had gangrenous appendix matter floating around in my body. In fact, the doctors avoided me altogether.

When I woke up the next day in a hospital bed with an IV in my arm, it started to dawn on me that I hadn't received a routine appendectomy. I was in agony. Peritonitis

had set in and the IV was pumping antibiotics into my system. After a few days, when I could get out of bed, I began to refer to the IV as My Buddy because it went everywhere I went. In retrospect, I should have called it the Ex-Boyfriend. The wheel on my IV cart was busted, making it impossible for me to get anywhere with it, and the staff completely ignored my pleas for a new cart. Not until the sixth day when I shouted obscenities at the nurse did I get a new one. Dante's hell was nothing compared to Saint Vincent's hell. It was as if they wanted to destroy your will to live so that you didn't get too upset when you thought they were going to kill you through negligence. If I may make an *Outsiders* analogy, I went from being Ponyboy Curtis to Dally Winston.

Because my stomach had been ravaged, I wasn't allowed any food or water for several days. My lips looked like Frodo Baggins's as he climbs the fiery rocks of Mordor. Finally a nurse dampened some sponges and Faceboy held them to my lips. Faceboy came to see me every day to ensure they hadn't killed me. On one occasion, he sat down to give me a back rub and sat on something hard. He lifted his ass and realized the nurses had left a hypodermic needle on my bed. It was like being in a crack house without the bonus of crack.

My stomach was covered in bandages, and I knew whatever lay beneath must not be pretty. One morning a doctor came into my room with a group of medical

students. This was nothing new, as I had gotten used to having no dignity. But then the sadistic doctor took hold of my bandages and ripped them off as hard as he could. The pain was so severe I started screaming.

"It's only tape," he said.

I looked down at the gaping, oozing, bloody wound on my stomach. It looked as if it'd been stapled shut by lunatics. I'd been butchered within an inch of my life.

"I don't think the morphine's working," I told the nurses. Then they took me off of it, and I cried for twenty-four hours.

I probably would've gone insane had it not been for two things: morphine and the love of the Art Star community. I actually had a morphine button, which I could push and it released the drug into my body every eight minutes. The Art Stars eyed my morphine button with jealous curiosity even though hospital security was so bad, any of them could easily have stolen his or her drug of choice. From day one of my hospitalization, my room was packed with friends, who came bearing unusual gifts. Pornography was the gift of choice, and it seemed no matter how many normal magazines I put on top of my copies of *Dude* and *Latin Inches*, they always ended up on top of the pile right as the nurses were coming in to take my temperature.

Because I was captive, Brodeur stopped by to see me

several times, wherein I pressed the morphine button repeatedly hoping for an extra drop.

"Get out. I don't want to see you," I told him.

"But the nice little old lady in that room was happy to see me," he said, pointing to the room next door. He then gave me letters featuring pornographic drawings of him screwing the female nurses at Saint Vincent's.

One letter said, *Word on the street is that the drinking finally caught up with you and they took your liver too.* Another said, *If they still have your appendix, can I have it?* and it featured a drawing of Brodeur cuddling my appendix.

My sister, Wendy, and my brother Chris flew in from Maryland. Chris, who'd just returned from Graceland, brought me an Elvis nightgown. From the moment I put it on, I could feel the presence of the King. Someday, I am going to open a hospital and instead of having statues of saints and crucifixes everywhere, there will be ceramic statues and black velvet paintings of Elvis. I am going to call it Rock 'n' Roll Hospital. There will be music piped through the hallways, and a library of porn mags to choose from. All the morphine buttons will have smiley faces on them, and all of the sheets will be leopard-print. The male nurses will wear hot pants, and the female nurses will look as if they just stepped out of the pages of *Extreme Fetish* magazine.

As a child, whenever I had to go to the hospital, the statues of saints used to freak me out, especially the hapless Mary. They all looked so serious and gaunt. It would be nice if we had more fat, joyful saints, ones who didn't live to die, who didn't save themselves for God, who maybe boned Ann-Margret and died on the toilet.

When I was finally released from the death clutches of Saint Vincent's, they basically put a boot up my ass and shoved me out the door with no instructions whatsoever. After a few days, my scar got infected, necessitating a return trip to the hellhole, where I was finally told how to care for my wound.

A few weeks after my emancipation, I went to a barbecue at Brodeur's place. (His roommate, Aaron, was throwing the party, while Brodeur stayed in his room writing letters.) At the barbecue, my friend Big Mike took a Polaroid of my stomach, and everyone thought it was a picture of an ass. The scar, which runs north-south down my belly, looks like a red, irritated ass crack, and because I drink so much beer, my stomach is swollen on either side, like two big ass cheeks.

Everyone there wanted to see my scar. For months after my operation, this happened everywhere I went. I'd lift up my shirt and show people, then they'd act totally grossed out. Either that, or they'd say, "*Dude*—I had my appendix taken out!" and then they'd show me a little appendectomy scar. I told them only pussies have their

appendix taken out. If you're a true badass, you let it burst.

For a while, my scar was extra-gruesome because a small, bloody hole opened up about three inches above my pudenda, which I had to pack every few hours with bacitracin-covered gauze. Whenever I pulled the slimy gauze out, it kind of looked as if I were pulling my intestines out. Though Brodeur had yet to see me do this, he insisted on coming over and videotaping it, because he thought if a jury saw the tape, they'd award me hundreds of thousands of dollars. But when he hit RECORD and I lifted my shirt to start "packing," he recoiled in horror, screaming, "You could get a job at Coney Island! You are like the girl with two vaginas!"

I used to think my scar was heinous, and I missed my smooth, little potbelly, but I got used to my new stomach. It sort of makes me look like a sewn-up rag doll or Sally from *The Nightmare Before Christmas*. It's really the most goth fashion accessory of all time.

I tried to sue, but no one would take my case because I have no money. When you're poor, it's harder to get decent health care, and it's harder to do anything about it when you get screwed. In fact, the hospital tried to *sue me*. They even closed my bank account, which contained all of $107. The city marshals then threatened to seize my property until they realized I had none. But just this week, the *New York Times* announced that Saint Vincent's Hospital is

closing its doors because it's $700 million in debt. I guess all the people they killed through negligence couldn't pay their bills.

Though I'm no doctor, I've been told that a CT scan has a 95 percent detection rate for appendicitis. I didn't get a CT scan, and I'm going to guess it's because I'm uninsured. I'm not sure when it was decided that some people deserve health care and others don't, but it's ultimately an inhumane idea that's also conspicuously convenient for the rich. Oddly enough, I happened to be in D.C. the day before the Senate voted on the health-care reform bill. I'd been visiting family in Silver Spring and had gone downtown to the National Gallery of Art to see *The Sacred Made Real: Spanish Painting and Sculpture, 1600–1700*. It featured a lot of sad-looking saints, a Mary Magdalene that looked like a mermaid, and one particularly bloody Jesus. It was not unlike the decor at Saint Vincent's, actually. Upon leaving the National Gallery, I walked out into the sunlight and soon heard the muffled sound of chanting. As I got closer to the Capitol, I could make out the chant: "Kill the bill! Kill the bill! Kill the bill."

Within minutes, Teabaggers surrounded me, all of them white, all of them angry, and to be honest, all of them pretty fucking ugly too. It was, I imagined, what a KKK rally must be like. Plenty of pro-life posters were floating around, which is odd since what they were protesting was *health care*, which could, in fact, save lives.

When I walked by a poster of Obama with a Hitler mustache, I stopped to take a picture for my editor. I heard a woman behind me say, "Let the lady take a picture, honey, and then you can pose with it." When I turned around, I saw the woman was talking to a girl of no more than six. I felt sick. My only hope is that the child will someday rebel and become an Art Star.

27

the shortest-running
show on broadway

I wish I could say that after my appendix ruptured, I stopped engaging in a frivolous social life and hunkered down and devoted myself to a *serious* art project requiring all my time and focus. Quite the contrary, if anything I went out *more* and my art became stupider than ever.

In the spring of 2000, it was announced that *Cats*, the longest-running show in Broadway history, would close its doors in June, leaving hundreds of cats unemployed. The Winter Garden, once a bustling tourist attraction, would be vacated.

What to do with such a vast, empty space? I thought. Surely I couldn't let the Winter Garden fall into the hands of drug lords or, even worse, Disney retailers.

I had just finished writing a musical called *Rats* that was the antithesis of *Cats*. I thought maybe *Rats* could be as big as *Cats* or, at the least, maybe some of the unemployed cats could get jobs as dancers in *Rats*.

On June 6, I resolved to head up to the Winter Garden that afternoon to present a sneak preview of my hot new musical. Wearing a Minnie Mouse dress, rat ears, nose, and tail, I hopped the train and headed for the Theater District and international stardom.

I got there at 3:00 p.m., just in time for the matinee, but to my shock, the theatergoers had already gone inside and taken their seats. Coming from a downtown-theater background, I hadn't realized that Broadway shows actually start on time.

Luckily, Ennis had arrived on the scene with his camera and it was a warm spring day, so my trip uptown wasn't totally wasted. Tourists were everywhere, and they wanted to take my picture, so I flashed my "jazz hands" at them and hammed it up for their lenses. Children waved to me and wanted to shake my hand. I felt like the aged cat in the famous *Cats* poster.

Pretty soon, I began to sing my first number, "We Don't Have Thumbs." Unfortunately, I'd done a show the previous night, so my voice wasn't in the best condition. However, I was more concerned with successfully interpreting the pathetic nature of the rat than with sounding "nice."

The song was a crowd-pleaser. Even the seemingly ambivalent ushers, who were smoking cigs on their break, perked up as I sang, "We don't have thumbs. Why do you run from us? We don't have thumbs. Why do you try to kill us? We just want to look at your pretty apartments, but you shove us back into the darkness. We want to be your friends, but you won't let us, because you're a bunch of snobbish jackasses. We don't take up much space. In fact you can barely see us, so why all the mistrust? We can't even open up your refrigerators. We're not like other roommates."

After my first number, I went right into the gangsta rap single "Badass Rat Rap." (*Rats* has street appeal, unlike some of those other musicals.) I kicked such phat lyrics as "I like to drink 40s and eat Styrofoam. Turn out the lights and I'll scurry through your home. Try to lay out a glue trap and your ass'll get smacked cuz homey don't play that!"

After kickin' my rap, I performed "Someone Put an Ear on My Back," a song about how scientists had recently grown a human ear on the back of a rat. (I saw it on *Oprah*.) For this number, I wore a gray shirt with a fake human ear attached to the back.

The Winter Garden's security seemed to be getting antsy. I'd told them earlier that I was doing a "photo shoot," but failed to mention the musical that went with it. So, I skipped the lighthearted numbers and moved directly into the show's finale, "Put the Glue Traps Away," a song

that summarizes the plot of *Rats*—the endless struggle between rats and men. (Unlike *Cats*, *Rats* has a plot.) As I sang this piece, I did an interpretive dance upon my giant, fake glue trap, pretending to be stuck, writhing to free myself from the agony. Unfortunately, gale-force winds were blowing the glue trap off the sidewalk and my rat ears off my head, making it difficult to interpret the situation. (Just one of the many reasons why it should've been inside the Winter Garden.)

Finally, I stood up and took a bow. There was no bouquet of roses, no paparazzi, no wild applause, which all seemed appropriate for a musical about the world's lowliest creature.

As it became more than apparent that *Rats* was not going to enjoy the success of *Cats*, I began to holler, "*Rats*—Now through June sixth!" In one last-ditch effort I went inside the Winter Garden to see if I could get my script to the right people.

"You can't be in here," the security guards snapped.

"I just want to give you a script," I pleaded.

"Look, we told you once nicely. If you don't leave, we'll call the cops."

I turned around, and like a lowly rat, I left, defeated. But all is not lost. *Rats* may not have found a home in the Winter Garden; it may not have won a Tony; but it now had the distinction of being the shortest-running show on Broadway.

28

the troll museum

I'll be the first to admit that I was extremely stoned when I decided to open a troll museum in my apartment. But the important thing is that even after I sobered up, I still thought it was a good idea.

One afternoon I was trying to nap and a shelfful of trolls fell off my bedroom wall and barely missed my head. My surroundings had grown so chaotic that they were attacking me. Getting rid of my trolls was simply not an option. I've been collecting them since 1982, and I love them in a way that non-troll-collectors might deem unhealthy.

As I was picking trolls off the bedroom floor, my cosmetic-mogul friend Tony called. He invited me over to his apartment, which was then located directly above Luna Lounge.

At Tony's, we smoked what I now think was a magical joint and drank a few beers before going down to Luna for a cold pint.

Almost as soon as I sat down at the bar, the idea popped into my head.

"I want to open a troll museum," I told Tony.

"That sounds like a good idea. You *should* live in a troll museum."

"It could become as popular as the Met!" I exclaimed, imagining busloads of people viewing my collection.

"That would be excellent. You wouldn't need a job. You could just hang out giving tours all day."

"I'm totally gonna do it."

A month later, Reverend Jen's Lower East Side Troll Museum opened to the public.

Unsurprisingly, the opening was out of controll. Art critic Charlie Finch wrote up the museum's opening in *artnet* magazine, and celebutantes far and wide turned out to celebrate on September 23, 2000, from noon till midnight. I stayed awake for three days preparing the museum—hanging paintings, setting up the bar, and building a troll shanty that featured a psychedelic bedroom with a tiny Led Zeppelin poster and two trolls "doing it" on a bed.

My two-headed troll (the *Mona Lisa* of my museum) was placed in an alarmed, glass cube. I also constructed display units for the hundreds of different trolls in my

collection—a pregnant troll, a hippie troll, a punk-rock troll, a troll with its face burned off by a blowtorch, troll puppets, troll "lace huggers," naked trolls, clothed trolls, big trolls, small trolls, a black troll, a silver troll, a robot troll, a scratch-n-sniff troll, and so many others. I placed a TV in the corner of the museum that constantly played troll-related videos.

At noon on opening day, I put on an evening gown and awaited the museum's first visitor. At 12:05 p.m. my friend Pete Welby arrived and was the only guest for the next two hours. After that, the place filled up, which was a real accomplishment since Damien Hirst's opening at Gagosian was on the same night. Budweiser, boxed wine, and punch were served, and a tuxedo-clad waiter (played by Bruce) made his way through the crowd, serving up marshmallow Peeps, several varieties of cheese, and Pop-Tarts, as Led Zeppelin blasted out of the stereo. Guests mingled in the kitchen while my friend Nora's nine-year-old son ran a roulette table. At the evening's crescendo, I performed a "ribbon-cutting" ceremony, which was unfortunately aborted when the ribbon unceremoniously fell off the wall.

Opening-day visitors bought practically everything I'd laid out at the souvenir stand—beaded T-shirts that bore catchy slogans such as OUT OF CON-TROLL AT REVEREND JEN'S LOWER EAST SIDE TROLL MUSEUM; I WENT TO REVEREND

JEN'S LOWER EAST SIDE TROLL MUSEUM AND ALL I GOT WAS THIS LOUSY T-SHIRT AND A WHOLE NEW APPRECIATION FOR TROLLS; and even I SURVIVED THE OPENING OF THE REVEREND JEN'S LOWER EAST SIDE TROLL MUSEUM along with Troll Museum flyswatters, ashtrays, plaques, mirrors, and bumper stickers (which read I BRAKE FOR TROLLS).

On the way out, many visitors slipped some cash into the donation box. Like the Met, the Troll Museum offers a *suggested donation*. However, because we are just getting started, our price is a bit higher than theirs ($2,990 higher to be exact).

Since the museum's inception, it has been called the "eighth wonder of the world" (by one person). And it has been featured on the WB network's evening news, Spanish and Japanese TV, and in every publication from the *New York Times* to *Toy Collector* magazine. It was also featured on MSN's front page, which wrought havoc on my life, as overexcited troll fans didn't bother to make appointments, but simply showed up at my apartment. I'd come home from a jog to find a family of five outside my door, clamoring to get a look at the trolls.

Since I opened the museum, it has been my goal to conceive praiseworthy exhibitions. I didn't have to look far for inspiration when I laid eyes upon the *Armani: Retrospective* at the Guggenheim, which motivated me to put on an *Armani at the Troll Museum Retrospective.* I

wrote press releases claming Armani had designed a little-known collection of troll outfits that the Troll Museum had acquired. I then made tiny Armani-esque troll outfits and sketches of troll outfits that I hung around the museum. I copied verbatim the text about Armani that I found in the Guggenheim's catalog, then changed it slightly to make it sound as if it were discussing his couture for trolls.

Promoting the museum has been simple—word of mouth travels fast in this city. Occasionally, I promote the museum in fancy neighborhoods where residents might not know it exists. Sometimes I wear a sandwich board that asks on one side TIRED OF THE SAME OLD ART? And on the flip side WHY NOT CHECK OUT THE TROLL MUSEUM? and I march in front of the Metropolitan Museum of Art giving out brochures.

Despite the Troll Museum's success, many people still deign to ask, "Why is it that you sacrificed your living room in order to build a Troll Museum?"

For starters, I never used my living room. Living rooms are used for vegging, an activity that is foreign to me. Second, I noticed a dearth of troll museums on the Lower East Side, and I also noticed a shortage of fun LES activities that were not directly related to sex, drugs, and rock 'n' roll. Third, while trolls have always fascinated me, many people seem to take them for granted. I wanted to take the seemingly banal troll out of its everyday context and put it

in an environment where its extraordinary qualities would be exemplified.

Lastly, despite that I am not an extremely goal-oriented person, I do have one goal in life—never to be bored. Opening the Troll Museum in my living room has ensured that this will never happen.

29

the lower east
side decency squad

There's nothing in the First Amendment that
supports horrible and disgusting projects!
♥ *Mayor Rudolph Giuliani* ♥

In an effort to counteract the objectification of the female body in the media, I have always promoted the objectification of the male body. This I have done by encouraging full male frontal nudity at my open mike and also by featuring an erect penis in close-up within the first five minutes of my movie, *Lord of the Cockrings*.

Several years ago, I also developed an annual male beauty pageant—the Mr. Lower East Side Pageant. The

pageant is an extravaganza of dudes, similar to the Ms. Universe Pageant if all the contestants were hairy and liked Budweiser. To compete in the cutthroat pageant, contestants don't have to live on the Lower East Side. (Because who can afford it nowadays?) They simply must possess qualities that would make them a proper representative of the LES. The three categories contestants compete in are 1-minute talent, swimsuit, and evening wear, combined with question and answer.

The chosen monarch gets a crown that comes complete with a detachable bong, a toilet-paper sash that says MR. LOWER EAST SIDE on it, and a six-pack of Budweiser, along with the knowledge that he has been chosen by the people. The runner-up receives the dubious honor of Mr. TriBeCa and gets to wear a smaller, vagina-shaped crown throughout the year. Special prizes are given for Best Male Tits, Congeniality, and Best Nutsack.

The most enjoyable thing about the pageant is that any woman or gay man who shows up automatically gets to be a judge. It is without a doubt the craziest night of the year in New York. There are never fewer than 150 drunken, angry women and gay men in attendance.

While most Mr. Lower East Sides aptly do nothing for their tenure, Mike Amato, who was elected in October of 2000, took the position seriously. He began by wearing his sash and crown everywhere, along with wacky striped trousers and frilly blouses, a getup reminiscent of Gene

Wilder as Willy Wonka. He delivered state of the union addresses at the open mikes and put forth an amendment to rename the Lower East Side "Melon Bank Taco Bell Shanty Town."

Around the time that Amato was elected, another New York City official, Mayor Giuliani, had reached the zenith of his insanity. When the Brooklyn Museum's *Sensation* show exhibited a painting by Chris Ofili titled *The Holy Virgin Mary* that depicted a black African Mary surrounded by images from blaxploitation movies, close-ups of female genitalia, and smatterings of elephant dung, Giuliani had a massive freak-out. Ofili, who is of Nigerian descent, explained that in his culture elephant dung has deep spiritual associations, but Giuliani's delicate sensibilities had been offended, nonetheless. Months later, the same institution showed Renee Cox's *Yo Mama's Last Supper*, a large photograph in which the artist portrays herself as a nude Jesus. Giuliani's ass was *so* chapped at this point that he decided to form a "decency panel"—a random group of morons selected to impose decency standards on art in publicly funded institutions. This gave Mr. Lower East Side Amato the idea of forming *his own* panel—the Lower East Side Decency Squad. Mike asked me to collaborate with him, and I was more than happy to write and send out press releases for the group. The LES Decency Squad claimed to be in complete solidarity with the mayor, but went way further, condemning *everything* as indecent.

The press releases announced, "Some say the Mayor has gone too far. We say 'Not Far Enough!'"

Mike and I appeared on liberal radio station WBAI, where we announced the creation of our squad and took calls from infuriated listeners.

The following week, we went to the Metropolitan Museum of Art, where we protested the nudes and the heresy in the William Blake exhibition and the homoerotic nature of the Greco-Roman art section.

We marched in front of the Met's steps in conservative outfits carrying signs that proclaimed SISTER WENDY IS A HERETIC; MORE RUDY! LESS NUDEY!; and BLAKE = INDECENCY—NOT WITH MY TAX DOLLARS!

Liberals and art lovers who were spending a day at the Met gave us hell, not comprehending that we were just having fun. The ruckus grew so loud that the cops came.

After our protest, Mike launched a Decency Squad website. The front page featured an image of Michelangelo's David with an animated fig leaf that moved across the screen, eventually covering David's wenis. It also featured our plans for a redesign of the Met, which included:

1. Remove all graven images, including the entire medieval section (to be replaced with a stock market trading floor).

2. Demolish the entire Greco-Roman section and replace it with landscape paintings (but no phallic-looking trees or mushrooms).

3. Add a multimillion-dollar Bob Ross wing (happy, decent little trees).

4. Combine the nude statues with the Jackie O. clothing collection.

The LES Decency Squad was planning several other protests, including putting a giant pair of underpants on the bronze bull statue on Wall Street, when news of Rudy's adulterous affair and prostate cancer whisked talk of the decency panel under a rug.

30

ruins

When Ennis moved to LA, the Bermuda Triangle of talented dudes, I was devastated. *Toolz* had been the greatest show on television, but like all great things, it did not last. Today Ennis produces reality TV and lives in Hollywood, marking the end of an era, like Susan Dey going from *The Partridge Family* to *L.A. Law*.

Before Ennis left, we went to see *The Dark Crystal* on the big screen at Cinema Classics.

"We have to get there early," I told Ennis. "It might be sold-out."

"Rev, it's noon on a Sunday in the East Village. I don't think we have anything to worry about."

Ennis was right. We were the only people there.

As I watched Jen, the heroic gelfling, search for the crystal shard, my eyes welled up with tears. I recalled the

nights a decade earlier when Dog and I watched it together and he had reenacted the movie on my stomach, tenderly marching his fingers along my flesh like Landstriders. The Mystics on-screen reminded me of him—wise and kind. Tears ran down my chin and onto my Yoda T-shirt, as Ennis squeezed my hand.

"It'll be okay, Rev," Ennis said, passing me a flask of whiskey.

Taking a sip, I had a sinking feeling—I had made some poor life choices and was now going to be poor and alone forever.

A few nights later my friend Bill gave me a tarot reading.

"Ask the deck a question," he said.

I asked, "Will I ever find love again?"

He spookily moved the cards around, then he had me pick a card and turn it over. Out of all the cards in the deck, I pulled the Hermit.

In spite of the tarot's answer, a few days later a new man entered my life.

Nick Zedd e-mailed me, requesting an appointment at the Troll Museum. It was signed, *Yours Forever.*

I'd had a crush on Nick since seeing him on the set of *Terror Firmer*. He'd been wearing a Bride of Frankenstein wig and lab coat, examining a pregnant Toxic Avenger who was about to give birth to a midget in a Toxic Avenger mask. He was so pale he looked as if he slept in a coffin, and he was of indeterminate age. I reckoned he

could have been anywhere between the ages of 25 and 675.

I soon forgot about him, but a few weeks later he sauntered into Faceboy's open mike, sat down, rolled his eyes, and left after two minutes. *He is too cool for me*, I thought, which is why I was perplexed when he asked to see the Troll Museum. No one cool ever came to the Troll Museum. I googled him and found out he was an "underground filmmaker."

When Nick arrived at the Troll Museum, he barely spoke. He just stared at me the whole time with his giant, light blue eyes that never blinked.

"This is a two-headed Uneeda troll from 1967. Some people call them Wishniks, which is actually the name given to them by the brand," I blabbed as he gawked at me. Before he left, I handed him an invitation to a *SHOUT* Valentine's Day party the following night.

Still, I didn't think Nick was interested in me. I imagined he liked badass, punk girls, so I was surprised when he showed up at the party and asked me to be his valentine. The last time someone had asked me to be his valentine was in second grade.

Hours later, Nick and I passionately made out at Mars Bar, the vilest bar in New York City. In between kissing, we sipped drinks while a wasted man next to us screamed, "Cocksucker," at the top of his lungs. The whole place reeked of vomit and beer. We went back to my place, where

Nick fucked me as only a crazy person can. The next morning, my mental alarms went off when he woke up at 7:00 a.m. and began dressing.

"Why are you leaving?" I asked. He told me his roommate, Isabelle, who was also his ex-girlfriend, got jealous if he stayed out all night. To make matters worse, she was French, beautiful, and insane.

When Nick left, I called Faceboy.

"This is going to hurt," I said.

"What are you going to do?"

"I'm going to do it anyway."

People who say, "It can only get better," never dated in New York.

A week later, Nick told me he loved me as we kissed again at Mars Bar.

I'm not sure if what I felt for Nick at the time was love. It was more like fascination and lust. I knew he was bad for me, but I wasn't looking for stability. I wanted to delve into the dark side, and he was a willing guide. In bed, he would pull my hair and hold me down and bite me so hard there were hickeys all over my arms. Maybe I was a masochist. Possibly I was just bored and Nick presented me with a whole bunch of new opportunities for ruining my life and making art from the ruins. I'm not sure, because I still can't afford therapy, but for a while my fling with Nick Zedd was thrilling. It was like a roller coaster I hadn't been properly

strapped into, and I just kept waiting for the fatal ninety-degree drop.

He'd grown up in Maryland, about ten minutes from where I'd grown up. Because he was possibly six hundred years old, we hadn't connected back then. Now we made a point of traveling home together to visit our families. I made sure college basketball was on when I introduced him to my father, who, I correctly guessed, would be too absorbed in the game to notice I was dating a vampire.

My siblings, however, noticed.

"Will Nick be coming out of his coffin to join us this evening?" Wendy would ask.

I enjoyed the Addams Family aspect of our coupling, as did Nick. He begged me to wear the elf ears upon meeting his mother.

In New York, most of our dates were at Mars Bar, where I once witnessed a man fighting with a woman, who may or may not have been a hooker, over $60. The bartender locked the man outside and the woman inside, but within a few minutes the man crashed his head through Mars Bar's window to continue the argument. Another time I was at Mars Bar and I felt something hit my shoe. I looked down and a man was sleeping on my foot.

One night, Nick and I were at Mars Bar when a fat woman in tight leopard-print pants who was missing a front tooth strolled in and screamed, "Nick what are you

doing here with this woman? You told me last week you would love me forever!"

"What the fuck is going on?" I asked Nick, who looked uncomfortable.

I asked her who she was and she told me she was Nick's girlfriend. Nick nudged me and said, "Let's go."

I refused to leave and he stormed out. I turned to the woman and asked, "When was the last time you slept with him?"

"Tuesday," she said.

I offered her a drink, but she chased after Nick. Outside, I could see her crying. She fled and he returned, sat down, and ordered a drink.

"If you want, I'll stop seeing her," he said.

"I want you to stop. But I need to know why, if you love me, did you need to sleep with her?"

"I guess I like variety."

Nick *loved* variety, and he proved it by ogling every woman on earth but me.

For the first time since puberty, I was unhappy with my body. If we were watching TV, he would point to a voluptuous actress and say, "That looks like Isabelle."

"That looks like you," he'd then say, pointing to Granny from *Beverly Hillbillies*.

He tried to convince me to gain weight and dress like a prostitute. He hated my freckles, small breasts, abdominal scar, and a thousand other things he saw fit to vocalize. We

fought constantly. He was incredibly smart and creative, but he used most of his brain function manipulating, lying, cheating, and opening my fridge to ask, "You got any food?"

When I complained about Nick to Tony, he said, "Well, *you* manifested him."

"What are you talking about?"

"When I asked you what you wanted in a boyfriend, you said, 'Someone weird with a big dick.'"

"But I wanted someone nice, too."

"Well, you have to be specific when you ask the universe for something."

Eventually, Nick and I started making movies together, which put an even greater strain on our relationship. The usual strife between director and writer was magnified by our sleeping together.

When I decided *Lord of the Cockrings* should make its leap from stage to screen, I asked Nick to direct it, mostly because I felt sorry for him and thought he needed a project. I spent days making cardboard scenery and decorating Monica's loft (our set) like Middle-earth. But the night before shooting was supposed to start, Isabelle cracked one of Nick's ribs with a baseball bat during an argument.

The show went on with Mitch (our cameraman) and me directing the first two days of the three-day shoot.

When Nick did show up, he stood around while Ennis, who'd come from LA to reprise his role as the evil wizard Ganfelch, did most of the work. Nick had no faith in my

writing and continually told me he would take his name off the credits if he didn't like the way the film turned out. He only changed his mind after he saw the audience crippled with laughter during the premiere.

Nick had the power to make me doubt my desirability, but he never had the power to make me doubt my ability as a writer and an artist.

Before the premiere of *Lord of the Cockrings*, Nick and I went to see the multimillion-dollar New Line version of *Lord of the Rings* together. I spied a life-size cutout of the film's four hobbits in the theater's lobby. The following day, my buzzer rang. When I opened the door, Nick was standing next to the cutout of the four hobbits. He'd stolen them for me in broad daylight. He was fond of stealing for me. Sometimes he shoplifted flowers and stuffed them under my coat when we were out walking.

Romantic gestures of thievery aside, he wrought havoc on my life. Through various forms of manipulation, he convinced me I was too heinous to attract anyone else. Meanwhile, I was certain he was banging his roommate, which he denied. She'd taken to calling my apartment at all hours, leaving psychotic messages. Usually she would end the message by calling me "American trash" or simply "whore." Sometimes she just played Serge Gainsbourg records into my machine at 3:00 a.m.

Isabelle and I eventually came to blows one night at Otto's Shrunken Head tiki lounge, a colorful watering hole

on Fourteenth Street. Otto's held a monthly striptease contest where Nick spun records and projected movies. I frequently entered the contest and won due to my creativity in the striptease genre. One month, I wore a helmet and footee pajamas, stripped out of my footees to "My Generation" by the Who, and crashed into furniture while trashing my footees like one of Pete Townshend's guitars. I won first prize that night, just barely beating my friend Lloyd, who stripped a piece of furniture.

On the night I met Isabelle, I was dressed as an old lady. I'd done a striptease to "Pour Some Sugar on Me," where I pulled packets of Sweet'n Low out of my taupe knee-highs and poured them onto my naked body, which sported a frightening, long, gray merkin.

After winning first prize—a massive piggy bank full of money—I put my floral nightcoat on and sat down with my bud Tom Tenney for a drink. The place was abuzz because Asia Argento, the Italian actress, had shown up with producer Harvey Weinstein. Asia was in town promoting her movie *Scarlet Diva* and had invited Nick to be her date to the film's premiere. I was horrified. She was beautiful, rich, and famous, but Nick promised me his only interest in her was financial. She'd offered to help find a producer for a feature-length screenplay I'd written. When she arrived, Nick even made a point of handing her my synopsis.

But as Tom and I drank our beers, we noticed her

making eyes at Nick while kissing my synopsis instead of reading it.

As Asia and Harvey left, Isabelle showed up, which I hadn't expected. Not recognizing me in my old-lady getup, she walked past me and stood next to Nick in the DJ booth.

I should probably have left, but I decided to get extremely drunk instead. Emboldened by the sauce, I revealed my true identity to Isabelle. Nick stayed behind the DJ booth.

A brief verbal confrontation followed, where Isabelle called me a whore, and I told her she shouldn't call a sweet old lady a whore. Nick stared off into space as though the entire thing weren't happening.

I sat back down next to Tom, but was knocked off my seat moments later as Isabelle pounced on me from behind, knocking my gray wig and spectacles off. Her hands were around my neck and she was doing her best to choke me to death. *This is not how I want to die,* I thought, but then Tom managed to grab her. He flung her off me and I watched her fly through the air like a Frisbee, finally landing on her side. The entire bar stared.

Tom calmly picked up the piggy bank and said, "C'mon, Rev. We're goin' home."

On my way out, I saw my synopsis, covered in red lipstick marks, floating in a puddle of beer.

Tom and I took the piggy bank to the Blarney Cove next door, where we got even drunker, while enjoying the

company of old men who quietly sat at the bar and stared straight ahead.

By the time we left the Blarney Cove, Tom was too drunk to take the subway, so I told him he could crash at my place.

At the Blarney Cove, I vowed never to speak to Nick again. The vow only lasted a few hours. Nick had gone from Otto's to his apartment, where Isabelle had tried to kill him too. He fled and went to my apartment, where he let himself in with the set of keys I'd idiotically given him. Wandering into my bedroom, he found Tom and me passed out in my bed. Though we'd slept together platonically, as Nick walked in, Tom woke up and tried to nudge me. When he did, I unconsciously lifted Tom's shirt and began kissing his chest.

Nick threw Tom out of my bed, and in the morning we behaved as though nothing strange had happened.

Friends were appalled that I continued to date, let alone speak, to Nick, but it was as though I was under an enchantment, some kind of black magic that I'm still not entirely sure wasn't the cause of my involvement with him. (Until I can afford a shrink, this is the best answer I can come up with.)

My sanity began to crumble. Bags formed under my eyes, and I started to look like a child in an Edward Gorey illustration, as if the life had been sucked out of me. I'd given the vampire a little taste, and it felt as if all I could do

was lie down and let him take more. I should have bolted my front door and festooned it with garlic. The one thing I learned from the cinematic masterpiece *The Lost Boys* is that you should never invite a vampire into your home. I not only let him in, I gave him keys.

31

america's city

One of the great things about New York is that it's possible to become a New Yorker. One cannot go to LA and become an LA-er. New York will adopt pretty much anyone who is willing to live here.

There is even a 151-foot woman at the entrance to New York's harbor with an open invitation inscribed at her base: "Give me your tired, your poor, / Your huddled masses yearning to breathe free, / The wretched refuse of your teeming shore, / Send these, the homeless, tempest-tost to me: / I lift my lamp beside the golden door."

Years ago, people in other countries got a load of this and thought America must rock. So they came in droves, except for the African slaves, who'd been brought against their will and already knew that America certainly did not rock. Soon the many immigrants who came to New York

also discovered that America wasn't quite the Cancún spring break par-tay they'd imagined.

However, many immigrants were fleeing from even worse shitholes. Famine, state-sponsored murder, destruction, war, religious persecution, political strife, social chaos, widespread poverty, diseases, and natural disasters are all things that motivated people to get the hell out of Dodge and come here.

Once they got here, they lived in heinous, cramped tenements much like the one I live in now. Only when they moved in, *Wall Street Journal*–reading hipsters didn't live across the hall. Also, many housing laws hadn't yet been passed, so sometimes their toilets were outhouses behind their buildings. If they lived in six-floor walk-ups like me, they would've had to go in chamber pots and then carry their pee down the stairs. Can you imagine if you were drinking beer and had only one small chamber pot *and* lived in a six-floor walk-up?

Carrying chamber pots up and down stairs wasn't the only inconvenience back in the day. In the early 1800s, yellow fever killed thousands of people, and throughout the mid-1800s, cholera killed thousands of people. Then in the 1860s, the American Civil War killed thousands of people. On top of all this disease, war, and death, immigrants found that to pay for rent, food, and everything else, they had to work long hours for "the Man." Sometimes this ended in disaster. In 1911, a fire broke out at the Triangle Shirtwaist

Factory and 146 garment workers were killed, mostly young immigrant women.

Despite all of the horror and death, New York City's population miraculously kept growing—even after Margaret Sanger opened the first U.S. birth control clinic in Brooklyn in 1916. This happened because New Yorkers know how to par-tay, and people will invariably go to where there's a good party.

Everything here caters to this party. NYC's street-grid system means it's really hard to get lost here, no matter how fucked-up you are, and NYC's subway system means you never have to select a designated driver.

Even in 1920, when Prohibition threatened everyone's good time, speakeasies popped up all over the city, so people partied even harder than before.

Then the Great Depression came along. To say things were shitty would be redundant. *Obviously* they were shitty. It's called the Great *Depression* after all. But that didn't stop builders from entering a 410-day manic state during which they erected the *tallest skyscraper in the world*.

The Empire State Building was completed in 1931, and it made everyone else in the world just a little jealous of New Yorkers—partying till dawn, riding their handy subways while drunk on illegal booze, then having sex without procreation thanks to birth control from Margaret Sanger's local clinic, all while staring out their windows at the TALLEST BUILDING IN THE WORLD.

New York was simply too awesome, and people resented its awesomeness. In 1972, when the even taller Twin Towers were erected, people resented New York even more. It was simply too cool. So people said mean things about New York. They said its inhabitants were assholes, that they were a rude bunch of hippies, punks, faggots, commies, pornographers, anarchists, Antichrists, prostitutes, satanists, strippers, pinkos, derelicts, opportunists, and freaks who all smoked crack and didn't lead normal lives the way they were supposed to. A lot of this was true, which is why New York was so fun.

And then something happened.

I heard it before I saw it—a terrifying, thunderous explosion. It woke me up, and I ran to my bedroom window, expecting to see a tenement building collapsing, as they often do, or even thinking maybe my own building had started to collapse. People were on their roofs staring toward Delancey Street, their mouths agape in horror, some screaming. I ran to my kitchen window and saw that both of the Twin Towers had holes in them and were on fire.

I thought the city was under attack and that I was about to die. Banging on Lorne's door, I screamed, "Lorne, wake up!"

Lorne and I stared out the window in shock. He turned on the radio, and we learned that planes had struck the Towers. When they fell, I don't remember the sound they

made, I only remember a collective horrified gasp and then people pouring up the street, covered in soot.

In the weeks that followed, everything changed.

Suddenly, people loved New York because they saw that all the pinkos and freaks really cared about each other. They realized that even though New York is a city where people beat the crap out of each other over taxicabs and openly call each other fuckheads, it is also a city where millions of people coexist on a tiny archipelago without killing each other because of a profound respect for life, liberty, and the pursuit of happiness.

They saw New York's humanness.

We were like the most popular girl in class who suddenly gets her period while wearing white pants. You can't hate her anymore. You want to offer her a new pair of pants and a tampon from your purse.

People wanted to help. They wanted to adopt us. So a megalomaniac mayor who'd created a decency panel while carrying on an adulterous affair was suddenly "America's Mayor," and we were suddenly "America's City," even though we'd been fired from being America's capital way back in the 1700s.

People came to New York in droves wearing OREGON LOVES NEW YORK buttons and FDNY T-shirts. They shopped and ate and tried to help us be awesome again. Little American flags popped up everywhere, and everyone everywhere else in America got so angry as they gathered

around their TV sets watching newscasters try to cover their gigantic boners as they repeatedly aired maudlin interviews with grieving family members and trotted out new "America under Attack" graphics. Toby Keith, in particular, was angry and promised to put a boot in the ass of anyone who messed with the U.S. of A.

Meanwhile in the newly appointed America's City, a heinous smell permeated the air, one even grosser than before. It was so strong—a mix of dead bodies, fiberglass, metal, everything blown into tiny fragments, hanging in the sky. You couldn't smell it without thinking of the dead. You couldn't leave your home without mourning the dead.

The morning after 9/11, I left my apartment and saw a photo of my next-door neighbor and his brother on a missing poster. I hadn't realized they'd worked at Windows on the World at the top of the World Trade Center. They *had been there* when the planes hit. I said hello to them every day, but I didn't know where they worked.

Most of the missing posters were really death pronouncements. You either walked away or you didn't. I knew I would never see my neighbors again. I broke down. Sitting on my doorstep, I sobbed, thinking about their wives and children. When I picked myself up and crossed Delancey Street, I saw trucks carrying the National Guard moving across the Williamsburg Bridge. No one else was out on the street. I felt as if I'd survived a zombie movie. Everything was quiet except for the trucks. People were

hiding, huddled around their televisions. Our asshole president was hiding too.

Sometimes I bought flowers and set them down next to all the other flowers and candles outside our building left under the photos of the brothers. Makeshift memorials like this were all over the city, covered in candles and flowers.

Soon the missing posters fell off of lampposts or were taken down. Mostly when you saw one, you knew the person in the picture was dead. It was like seeing ghosts every time you turned a corner.

Three years later, when the Republicans brought their convention to New York City, I noticed a tiny, handwritten sign on a lamppost. It was someone's protest against the whoring out of the city that person loved:

> *Dear Mr. President,*
>
> *If Crawford, Texas, suffered a massive attack and thousands of your neighbors died, would I bring all of my friends there and have a big party?*

When I saw that sign, I knew New York had once again become awesome, and I felt proud to be a New Yorker.

New Yorkers might argue, bitch, and bicker at each other, we might pay exorbitant rents for apartments we hate in neighborhoods we do nothing but complain about, while loathing our local politicians who, for the most part,

turn out to be sociopaths, but collectively, we love and defend our city passionately. And tonight when I get drunk and ride the handy subway home and have sex without procreation using my official New York City condom, all while staring out my window at the now battered downtown skyline, I trust the world is watching with envy.

32

tiny creature

One afternoon, I was traipsing up Essex Street when out of the corner of my eye, I caught a glimpse of the most beautiful creature in the world—a minuscule, blond baby Chihuahua cavorting in the window of a dingy pet shop. The pet shop was so heinous, it looked like a crack den fronting as a pet shop. I'm still not sure if it was actually a pet shop.

But the Chihuahua was remarkable. It could not have weighed more than a pound, yet it trounced on its fellow cage-mates with the intensity of Stone Cold Steve Austin, finally making itself comfortable atop the belly of a Pekingese.

My pupils constricted as though I'd just stared into the sun. This was no dog. This was an elf queen trapped in the body of a dog. Nowhere on earth did a creature have such

disproportionately large, perfectly pointed elf ears. They were like humongous radio antennae rotating atop its head, receiving information from other dimensions. As if in a trance, I walked toward the window. The glass made me feel as if this creature were in prison and I must free it. It did not notice me. Instead it played, stomping its playmates with unmitigated joy. But as it turned toward the window, it looked directly into my eyes. In its eyes, I saw a spirit far older than its tiny body would have you believe.

I went home, but I could not sleep, write, eat, or function. My love for this tiny beast consumed me. Was this simply the gestation of my maternal feelings? I was about to turn thirty in a week. Was it really a human child I wanted? A baby would someday grow up and have to attend college. It would need clothes, food, babysitters . . . a whole host of things out of my budget. Plus, I don't really like people and don't necessarily ever want to make one.

For these reasons and more, it seemed this creature was what I wanted. I don't believe that true, unending happiness can be achieved without a lobotomy, but I do believe that happiness can be achieved in minute doses. One way happiness can be achieved is through companionship with animals, especially with dogs, who love us even though we are assholes.

The following day, I jogged to the pet store. Chaos overtook the puppy cage as a lady appeared with large dishes of food. The Pekingese and two other fluffy canines

barked and accosted the bowls, hungrily devouring most of the food. But not the little elf dog. It hung back, calmly watching the others with a look of Zen tranquillity. I took the plunge and went inside, but I was too nervous to say anything to the lady in charge. I walked over to the cage and slipped my fingers through the bars. Elf dog approached and began to lick with fervor.

"Hallo, Reverend Jen Junior," I said, noticing that it was a bitch like me.

For years, I had obsessed over obtaining a sidekick, preferably a female Chihuahua who I would name after myself. "There is something really disturbing about a single person living alone with an animal named after themselves," Lauren once said to me.

"I will come back for you," I said to the little creature, who stared back at me knowingly.

Upon exiting the store, I inquired as to the cost of my new friend, and that she cost as much as my rent did not dissuade me. Because my discovery of her coincided so perfectly with my thirtieth birthday, I knew that checks would soon arrive from relatives who feel sorry for me, because I live below the poverty line.

A few days later, I received several birthday cards containing cold, hard cash. Combined with my sizable winnings from the striptease contest the previous week, I was flush.

The following morning, I waited outside the store

until they opened. I quickly handed them all of my money and carried Reverend Jen Junior away. That night, I took her to Faceboy's open mike, her first taste of the thousands of hours of bad shtick she would witness in her future.

"She's like a pixie in a dog body," my friend Warren observed.

My friend Janice took one look at Jen Junior and proclaimed, "My ovaries hurt."

My attachment to Reverend Jen Junior grew overnight. She was absurdly intelligent and learned her name right away. Only her name was a bit verbose. She needed a nickname. Because people call me RJ, that wasn't going to work so I soon began calling her JJ.

She was the physical incarnation of magic I'd searched for high and low. But something was wrong. I could feel it. She played rambunctiously, but soon got tired and needed a siesta.

Chalking it up to her still being less than two pounds, I figured she just needed to gain some weight and fed her Nutra-Gel, a gooey substance that helps baby dogs gain weight. But she still wasn't gaining weight, and one morning I woke up and found her shivering at the foot of my bed as if she were having a seizure. I tried to give her food, sugar water, and Nutra-Gel, but she turned her head away, dejected.

It was only seven in the morning, but I found the

number of a vet who said she could see me right away. I put JJ in my arms and ran to the vet's office, crying.

When I got there, the vet told me that Reverend Jen Junior was hypoglycemic and would need glucose. It looked as if she would slip into a coma as I handed her tiny body to the vet. I loved her more than anything else in the world. I was terrified.

Outside, I called Tom, who met me in minutes. The vets told me I could visit JJ as often as I liked, and I took them up on this offer, visiting her close to twenty times over two days, along with several other Art Stars.

When they first brought JJ out to me, my heart stopped. She was at death's door. A big pink bandage where there'd been an IV was around her tiny neck. I held her to me and wept into her fur and prayed that she wouldn't be taken from me. That night, I didn't sleep, but just kept thinking, *Please be better. Please be better . . .*

Two days later, the vet told me JJ was doing well and I could take her home. When I got to the animal hospital, the vet brought JJ out and she was like a different dog. They'd pumped her full of so much food that she was a plump two pounds. She looked like a tiny piglet. Life and joy flowed from her.

It is impossible to take her presence for granted because she amazes everyone with her otherworldly wisdom and Zen stature. She is also the most alpha female I have ever met and tends to sit on the heads and faces of other dogs.

She even has a boyfriend now, a black Chihuahua named Taco, whose head she humps.

When Jen Junior and I walk down the street, people stop and say she looks like all kinds of things—a baby kangaroo, a bat, a rat, Dr. Evil's cat, an alien, Bambi, and so on. But I have always thought she looks like a woman out of a Vermeer painting, as if she were made of light.

As we walk along the street, she is democratic, a social butterfly who flutters from the rehab clinic to the hipsters in front of Moby's tea shop, wiggling her entire body back and forth with elation, indiscriminate of socioeconomic status or fashion choices.

She surveys the garbage that lines the stench-laden sidewalks of the Lower East Side like a man combing a beach with a metal detector, eyes on the prize—a chicken leg or rat carcass. She sees a German shepherd and starts to lunge—too much love for her tiny frame, as if she were going to burst, licking up the sweetness of the earth.

33

a swan full of beer

I am like an idiot, my mind is so empty.

♥ Lao-tzu ♥

I done told you once, you son of a bitch
I'm the best that's ever been.

♥ Johnny ♥

One day, I read Nick's journal and confirmed my suspicions: he'd been fucking everything east of the Bowery, including his roommate and the toothless woman in leopard-print pants. I know it's a breach of trust to look in someone's journal, but it's also a breach of trust to lie to your loving, monogamous elf girlfriend for the sole purpose of screwing women who aren't as pretty or smart.

I took what belongings of his were in my apartment and left them in the hallway. I called his voice mail and simply said, "I never want to see you again."

When he returned, he banged on my door until I answered. A huge fight ensued.

"You're ugly inside and out," he said.

"Yeah, well, you're old." Why I said this, I'm not sure, since I like older men. But he was concerned with aging, unlike me. I am amazed that I am able to age. Every day that I don't die thrills me. So I told him he was old and slammed the door.

I then took his keys and froze them into a block of ice. Then I hung my head over the toilet and vomited. I felt violated, and I wondered what was wrong with me that he had to screw other women.

Desperate, I called Tom and Bruce. Earlier in the week, we'd made tentative plans to see the Charlie Daniels Band at Pat Garrett Amphitheater on Route 78 in Pennsylvania. Tom and I noticed a billboard advertising the show on our way back from Hank Flynn's wedding to a woman named Jen he'd met on the set of *Lord of the Cockrings.*

It was a trip we'd discussed taking but never thought we'd actualize. Now we had to actualize it. I had to get as far away from New York as possible, as quickly as possible.

Bruce managed to borrow a car, and at 10:30 p.m. the three of us took off for unknown land.

I brought JJ, who sat on my lap the whole time. Along

the way, we stopped at a truck stop and bought an American flag, which we put on the car to ensure that no one would beat us up. Tom bought a bandanna that said REBEL TO THE END! with a skull and crossbones on it, and Bruce bought an even more heinous one, which said PROUD TO BE AN AMERICAN. They affixed them to their heads while I bought a classic-rock compilation cassette tape, which we popped in the car radio. I cried when "Love Hurts" came on, but then sang along ecstatically when "Science Fiction/ Double Feature" played.

Four hours later, we arrived at the Midway Motel, a dilapidated motel that Tom and I had become obsessed with after seeing it from the highway on our way to the wedding. The Midway had clearly been built in the fifties and had not been renovated or cleaned since. Many of the windows were boarded up. It was like the set of *Psycho*. An embittered Indian man, the Midway's proprietor, gave us the keys to room 6.

Upon entering room 6, our jaws dropped in amazement. At one side of the room stood an enormous water bed, on the other side—a land bed. A mirror hung from the ceiling above the water bed. Fake wood paneling in a variety of brown shades covered the walls. The carpet was a swirl of different shades of brown. A mysterious, bloody sheet was draped over a broken air conditioner in the corner.

It was too late to buy beer anywhere so we soberly passed out. Tom and I took the water bed, which had no

sheets on it, and Bruce took the land bed, which had sheets. Jen Junior curled up next to me. (According to Mexican shamans of old, it is good to have a Chihuahua sleep next to your belly if you have stomach ailments since they are like little heating pads, and I'd certainly had my share of ailments since my stay at Saint Vincent's.)

We were awoken Saturday morning by the sound of migrant farmworkers who were staying in the next room trying to close the trunk of their vehicle out front. Two bullmastiffs who belonged to the person living in a trailer behind the Midway barked in a Cujo-like rage.

We needed supplies for the big show, so we drove for what seemed like hours until we reached Kmart and civilization. On the way, we stopped at a petting zoo and Jen Junior rubbed noses with a potbellied pig. We saw a wise-looking snow monkey, reduced to swinging in a yellow plastic airplane-shaped swing.

At Kmart, I got two tube tops for a buck-fifty, and Tom got a blanket for the Charlie Daniels event. We realized we needed a bucket for ice and for the thirty-pack of Budweiser we'd picked up. Tom went outside to smoke, and Bruce and I went to Kmart's garden section to find a bucket. What we found instead was a hollow plastic swan, which we figured could hold about eight beers. We also picked up a purple, plastic jack-o'-lantern.

On the way back to the Midway, we saw a strip joint called Al's. We went inside and asked if JJ would be allowed

in even though she was only five months old and a Chihuahua to boot. "She's adorable," the bouncer said. "But I can't let her in." We walked outside, dejected and considered doing a protest wherein we marched wearing signs that read AL—UNFAIR TO CHIHUAHUAS!

Tom warned a bunch of dudes who were headed inside, "Good thing you left your Chihuahua at home!"

Back at the Midway, I took a sponge bath in freezing-cold water while Tom filled the swan with ice and Budweiser, thus producing a *swan full of beer*. We downed a couple beers and Tom laid out some 'shrooms he'd grown in his apartment. They were divided neatly into three tiny piles. We only wanted to get a tiny buzz from the 'shrooms, but when you're dealing with plant matter, you can never be quite sure how hard they'll hit. We swallowed a few, not expecting to feel much of anything.

Still sober and in touch with reality, I made a little bed for JJ and gave her a bone. Tom, Bruce, and I left for the Pat Garrett Amphitheater, just up the road. Almost immediately upon entering the amphitheater, which we noticed was filled with good old boys in ten-gallon hats, the 'shrooms began to kick in harder than anything else I have ever taken or experienced in my life. I looked at Tom and Bruce. They were thinking the same thing, basically: *HOLY SHIT.*

We attempted to put a blanket down among the crowd, but we were like infants who were amazed and terrified. In

my waking state, I am frightened of Republicans, and now, TRIPPING, I was surrounded by them. We all agreed that we had to get away from people right away, so we went to the farthest corner of a field, where people had parked their cars, and laid down our blanket. We'd just paid $20 to sit as far away from the concert as possible.

The sky was moving at Mach 4. I saw faces in it. I saw Charles Manson in it. I saw beatific, smiling children in it. The trees danced like Sigmund the Sea Monster. I murmured, "Who knew?" over and over.

According to Tom, our friend Sam was the only person up until that time who had sampled these 'shrooms, and she'd sat naked on a rock for several hours asking, "Who knew?" repeatedly.

The world was terrifying and beautiful. Courage was required simply to keep my eyes open because of the depth of what was being exposed. The Porta Potti was like an iron maiden that was going to kill me. Would I ever live through this? The grass was my friend. I put on lipstick and told Tom and Bruce I had an interview with a blade of grass.

A band called Twitty Fever was playing. They were horrifying. For starters, they were a Conway Twitty *cover* band, and they weren't even playing Conway Twitty songs! We joked about asking for our money back. I reminded Tom and Bruce that we hadn't eaten, so we somehow walked to the funnel cake stand and bought funnel cakes. Tom accidentally reclined on a funnel cake, crushing it. We

made plans to go to the funnel cake complaint bureau or to Pat Garrett, who, we suddenly decided, must run the funnel cake complaint bureau, since he ran the amphitheater. We were covered in funnel cake by the time Pat Garrett's band took the stage.

Suddenly, Pat Garrett was master of the universe and we were in his parking lot. Pat Garrett made *everything*. A plastic bag floated by us in the breeze, and we decided Pat Garrett must have made that bag because it was so sturdy and so delightful and he must've made it float by us for our contemplation and amusement.

We wanted beer but were afraid to go into the sea of rednecks to get it. We considered calling a fellow Art Star named Gerber, who was then living in Pennsylvania, and asking him to bring us a swan full of beer. We plotted what we would say. "Gerber, find a car. Find a swan, fill it with beer, and throw it over the fence of Pat Garrett's parking lot, and *hurry*."

Tom finally mustered the courage to go for beer. Bruce and I were terrified for him. It was as if we were sending our only son off to Vietnam. We waited with bated breath until, what seemed like hours later, a figure appeared in the darkness—*it was Tom!* He was alive and he had *cold beer*. That beer was heaven as it traveled down my esophagus.

As the beer traveled through me, Pat Garrett, master of the universe, continued to rock. For the life of me, I will

never remember what they sounded like. All I know is that they were gods.

I smoked a cigarette as I watched the band, even though I quit smoking years ago. I needed reality, and reality is best represented in death, and cigarettes represent death. I inhaled deeply. I still remembered how to do it. I wasn't an infant. Infants don't know how to smoke.

Breaking the number one rule of tripping, I pulled out my Covergirl compact mirror and looked at my reflection. My reflection was ancient—an image of myself from thousands of years ago in another life—the same eyes, same soul. If you had asked me before this experience if I believed in reincarnation, I would have said anything's possible, but now I am certain of it.

The woman looked Native American. She had my exact features, but darker skin, darker eyes, long black hair, and hundreds of wrinkles. She comforted me the way a grandmother or a Woolworth's waitress might, yet I knew it was me, my past that I was seeing. She told me that she had been hurt and she was able to rise above it every time, and that this made her stronger. She appeared there to tell me this. She had been everything—a warrior, a healer, a teacher, a mother—she knew everything. Even now, in my sober state, I can look in the mirror and see her, or I can close my eyes and see her, and it helps eliminate any fears that I have.

The message she had for me was simple—fear is useless.

If you screw up in this lifetime, thousands of others are around the corner.

She told me to embrace everything, even my sorrow. I started to cry because I was no longer fighting life. I let it embrace me. I lay back with my head on the grass, and I touched the earth with my hands. I could feel every blade of grass, the texture of each one on my skin. I was connected to the earth and the sky. We shared the same energy. I could see and feel oneness.

The old woman told me to close the mirror and go back to my friends. I closed the mirror and rolled around on the grass laughing.

I missed JJ. Tom and Bruce assured me that I would see her soon. I thought of her eyes and how they held thousands of years of wisdom like the woman in the mirror.

Pat Garrett's godlike set was coming to an end, and soon Chuck D., aka Charlie Daniels, would take the stage. Bruce, Tom, and I began to confer about the possibility of me "hooking up" with the plump, bearded country star, who rose to fame after "Devil Went Down to Georgia" shot up the charts. This led to a discussion of various sexual acts that Charlie Daniels would perform upon me in room 6 of the Midway. We discussed the possibility of making Charlie Daniels porn, a whole new genre of porn.

After about two hours, the 'shrooms evened out a bit. Bruce went into the sea of rednecks and came back alive with barbecued sandwiches, the only type of food available

other than funnel cakes. The food strengthened us, so we were able to emerge from the darkness of the parking lot into the field, where people awaited the headliners. We noticed a small group of people dancing wildly and laughing hysterically to no music at all. They were tripping too! We gave them a thumbs-up and moved along, positioning our Pat Garrett–made blanket a few feet from the beer line.

It was time. Charlie Daniels took the stage. I cannot say I remember much of the show. Charlie Daniels played "The Star-Spangled Banner" and the crowd went nuts. I think he played it twice. His musicianship was so remarkable, it made me think that if he did have to battle the devil to get a golden fiddle, he would beat the "son of a bitch." We were blown away. If Pat Garrett was God, then Charlie Daniels *made* Pat Garrett.

Then he played "The Devil Went Down to Georgia" and the crowd went even crazier. It seemed to be loaded with important metaphors about courage and believing in yourself. We screamed and danced, hooted and hollered. We were one with the rednecks. Politics aside, we all wanted Johnny to win that golden fiddle—for the poor, proud artist to conquer the Lord of Darkness, and he did, and he always would, so long as Charlie Daniels ruled the earth.

The concert ended, as did our hallucinations. We headed back to the Midway, still buzzing from 'shrooms, but no longer incapacitated. I opened the door to room 6 and JJ darted out at me with her ears back and her whole body

wagging back and forth. I scooped her up and held her wiggling three-pound frame. The same tears of happiness that rolled down my cheeks in Pat Garrett's parking lot now poured from my eyes.

We noticed our neighbors, year-round Midway residents, having a party outside where they sat on lawn chairs drinking beer. We decided to join them. I grabbed JJ and Tom grabbed the swan of beer and opened the door. What stood before us was the most dysfunctional group of people that have ever graced Pat Garrett's world or any world, for that matter.

The several beers I'd poured down my throat took hold of my mind, so it gets a bit blurry at this point, but I will do my best to string this portion of the story—the Midway party—together with accuracy. There was Frank, a shirtless gentleman with a blond mullet who looked about thirty. He was the brother of Danny, a skinny boy with long brown locks, a pointed nose, and what might have been an Iron Maiden T-shirt. Danny was roughly twenty-five. Then there was Rob, who was also shirtless. He had short, wavy brown hair and wore black velvet pants.

"Can we touch your pants?" Bruce and I asked. He was with a plump girl who had long brown hair, a pretty face, miniskirt, and fishnet stockings. Two other women were there. One of them, a blonde, sat on the hood of her car chain-smoking and crying.

All of them were on parole. Frank was on parole

because he'd gotten in a fistfight with his mom. Unfortunately, one of his punches didn't connect and had landed upon the nose of the blonde on the car, his wife of four days. She was crying because their marriage had already turned sour when Frank accused her of boning Danny, his brother. The others were on parole for drugs. Despite this, they were fascinated that we'd taken 'shrooms, a seemingly exotic drug on Route 78. Tom gave them what residue we had left.

They told us that room 6 was a special room, the only one with a water bed in the whole damn joint. They also informed us that it used to be a crystal meth lab. I went into room 6 to get more beer for the swan, and Tom came bolting into the room.

"You gotta see this, Rev! They are pissing on one of their neighbors!" he exclaimed.

I followed Tom and Bruce to a room at the end of the row where an open door revealed Cody, a boy of not more than nineteen who lay upon his disheveled bed, covered in pee. Apparently, one of the local forms of entertainment was pissing on Cody, who had a habit of drinking until he passed out with his door open.

"Son of a bitch deserves it! We're gonna piss on him tomorrow night too. Stupid fuck," Rob said gleefully. I wondered if they derived sexual pleasure from this sadistic act, but it seemed far more mundane to them, like watching a baseball game or playing Ping-Pong. From that

moment on, we joked about peeing on Cody as if a toilet weren't even an alternative.

"Have you seen Cody?" I asked Tom. "I have to pee."

Moments later, Cody emerged from his room, a fresh-faced blond in jeans and no shirt, with a well-sculpted yet skinny physique. Immediately, the Midway regulars began poking fun at Cody. Rob even began to push Cody, threatening to kick his ass for no reason other than that he was Cody.

"We are in the middle of a *Cops* episode," Tom said. I began to wish *Cops* would show up so I could make an unexpected cameo in TV land. Cody took the abuse in stride, popped open a beer, and sat down. The conversation was madness—drugs, marriages, family feuds, beatings. They had a never-ending supply of stories, and we both had a never-ending supply of beer. My troubles in New York seemed small. These folks were nihilists.

Soon Rob offered us cocaine. Tom and I stupidly said, "Sure. Why not?" We followed Rob into a Midway room decorated with black-light unicorn posters where he presented us with a pile of white powder, which was probably actually Drano and baby laxative with a pinch of cocaine. Tom leaned over the mirror and snorted a line.

I bent my head down to do a line and suddenly remembered I hate cocaine. "You know what? I really don't want to do any," I said, lifting my head up. We exited the unicorn-themed room and rejoined the party. Bruce and I

went back into room 6 and chatted. JJ climbed onto Bruce's lap and began to snooze.

"I love JJ so much," I said, again feeling happiness soar through me. I sat on the edge of the land bed in my boots, skirt, and top.

According to Tom and Bruce, I fell asleep in this position, sitting on the bed with my boots barely touching the ground and my head next to JJ's. Bruce was now trapped because he did not want to wake JJ or me, but he and Tom were forced to move me out of fear that my sleeping in such an uncomfortable position would result in my having a stroke.

I woke Sunday in the water bed with my boots on, fully dressed. That is when I realized one of the reasons that I was able to 'shroom so intensely with Bruce and Tom was because I knew that no matter how wasted I got, neither of them would try to touch my vagina.

Somehow, we managed to pack up our things and hit the road.

As we pulled away from the Midway, Bruce said, "I don't know why anyone goes to the Hamptons."

Rain poured from the sky as truck drivers tubed our tiny car with water.

The crazed energy that had inhabited our bodies for the past forty hours now subsided, and we were tranquil.

For two days I'd escaped the pain in my heart, my confusion, and my anger. Going back to New York meant

facing my life. I could not retire from the life I had thrown myself into even though part of me wanted to turn around and run back to the Midway. I knew the Midway's novelty would soon turn into despair. I had dodged pain, filled the void in my heart with activity. The tears I cried were from the joy of delving into different planes of existence.

Like the Man of the Future in *The Outer Limits'* "Sixth Finger," I had transcended the physical and become pure energy. Of course in the end, the woman who loves the Man of the Future tosses him back into the mysterious evolution chamber, which he entered once as a normal man. She then cranks the de-evolution knob so far back he begins to turn into an ape. She quickly realizes her error and cranks it just a bit forward so he once again becomes the regular guy she still loved.

I still haven't figured out the point of this episode. Maybe it's just that no matter how far we evolve, our hearts will always pull us back down to earth. But for a few hours, I had become the Man of the Future, pure energy, reaching up to the sky—my mind and heart opening.

We drove through the storm and reminisced about our friends at the Midway as if our adventure had been years ago. Classic rock was too rowdy for our serene mental state so Tom popped in a Lou Reed tape. Lou Reed sounded as tired as I felt, chanting the words to "Satellite of Love." It was like a mantra, and I thought about how I wasn't alone in my orbit around this planet.

I had been driven out of my mind, but it was temporary. I was still sane or whatever I have pretended sane is all these years. Some have theorized that insanity is the only sane reaction to an insane world, so maybe I'd been driven sane.

I felt like a space traveler who'd been to distant planets and back, but the most remarkable thing was that I hadn't. I'd been in Pennsylvania. Now like Dorothy upon her return from Oz, I would return to my life of work, poverty, and dudes. Only now I would know just how good blades of grass feel when you lie on them and let the world in. I would know that the universe is magical whether you're tripping, dreaming, awake, or sober. And like Dorothy sitting up in bed attempting to relate her story to a dismissive audience, I would get on the mike at Surf Reality in a few hours to attempt the same.

34

the church of the open mike

When I got back to the Lower East Side, I took a long, hot shower, cleansing myself of the Midway's grime, the funnel cake debris in my hair, and the grass stains on my knees. Afterward, I sat at my computer and attempted to write down all I'd experienced in Pat Garrett's parking lot and beyond. Several pages later, I printed it out and stuffed it in my purse, along with a couple of 24s of Bud. Throwing on my magic elf ears and putting JJ in *her* purse, I then headed over to *Faceboy's Open Mike*. It was *where art went*, and where art was always waiting at the Church of the Open Mike. It was the only church that had ever wanted me and the only church I'd ever wanted, possibly because it was full of people like me—*Art Stars*.

My friend Milton says the Art Stars are "the most amazing people alive who will never amount to anything,"

and he's probably right. Most of us decided a while ago that we'd rather be entertaining losers than boring successes. We came to New York, or *from* New York, blazing trails of ambition only to realize no wizard was behind the curtain. No one being or thing could solve all of our problems and make us whole. In learning this, we discovered something greater: *the trail.*

It's the trail you take and the people you take it with that make you whole. As Aerosmith so wisely pointed out, "Life's a journey, not a destination." And they should know. Just look at them.

This journey I've been on isn't exactly the trajectory I'd planned for myself as an eighteen-year-old art student. It hasn't been something that anyone *could* ever plan for herself. I came here twenty years ago hoping to conquer the art world or at least to become an established painter, only to realize I'd rather hang out in art holes with nudist poets and people who only go by one, usually strange, name. In other words, I discovered that much as I hoped to become an established artist, I preferred being *antiestablishment.* One is not more noble than the other, but being antiestablishment is certainly more fun, and *fun* is the most underrated value on the planet.

The happiest moments of my life I probably can't remember. But of the memories I *do* have, the happiest ones usually involve hanging out with other Art Stars and making art or even just laughing in the face of adversity. I

often think of us playing Mad Libs in my hospital room at Saint Vincent's: Faceboy, Bruce, Ennis, Kat, and a few others, all of us guffawing wildly and having a great time, even me. Despite that I had an oozing, bloody hole in my stomach, gangrene, and what I correctly suspected was more than $60,000 worth of accruing hospital bills, I felt like the luckiest person in the world that day. Even one of the nurses said, "You have the best friends in the world." She didn't know they were busy stealing hospital gowns, visitor's passes, bread, and gelatin, but she was right.

epilogue

This is like the segment at the end of a movie where you find out what all the characters are up to. I guess we'll start with my dad. He died this year, the day before Halloween, at age seventy-nine. I'd been busy living an existence of bohemian extremism, filling up journals with crazy adventures, when I got the call from my mom.

"Jenny, I think you better get home. Bill's on life support."

Life support. Two words you never want to hear. Two words that produce an instant sinking feeling, a feeling that all the other shit in the world doesn't matter. Two words that when you hear them, you don't think you've heard right.

But I'd heard right. My father, who'd never been on the *longevity plan*, who refused to give up fried chicken and

vodka, who'd already survived a couple heart attacks, cancer, war, and divorce, was now in the hospital with respiratory failure caused by pneumonia along with diabetes and most likely heart failure.

So a few hours later, I was walking into Holy Cross Hospital, where the Virgin Mary was still standing sentinel outside, still looking sad after all these years. Inside, my father was propped up in his hospital bed, his blue eyes open despite the drugs dripping into his system and the tubes going down his throat.

The funny thing about life support is that most people who are on it would rather be dead. My dad's mission, as communicated to us through notes and body signals, became to *get the fucking tubes out of my throat*. When they finally pulled them a week later, he had heart failure and gave orders not to resuscitate. Through hospice care, he was moved home along with a hospital bed, an oxygen tank, and a quantity of morphine normally only transported by drug cartels.

At home he drank Godmothers and watched the World Series and *Oprah* with my mom, my siblings, his golden retriever Piper, Rev. Jen Junior (who refused to leave his lap), and me. There were ups and downs, days where it seemed he might manage to get out of bed, and horrible nights where his breathing grew so labored he begged to die.

When I wasn't with my father, I took Piper and Jen Junior out in the backyard and stared at the Enchanted

Forest of my youth, listening for the stirrings of Gooby and Jim, wishing I could rewind to the seventies when my dad was sitting at the kitchen table drawing and Midget-Land was still a teeming metropolis.

After a week at home, my father suddenly refused all food and drink, including vodka: a sure sign that he was not long for this planet. A few hours later, he closed his eyes, his breathing slowed, and it was obvious he was getting ready for the big trip. For some reason, a cricket hopped through his bedroom window and quietly sat vigil by my dad's deathbed. I like to think it was there to help him leap over the last big boundary to the other side, to be his guide the way Jiminy Cricket was for Pinocchio.

So the cricket, Wendy, my mom, Piper, Rev. Jen Junior, and I waited.

And on the old end of thirtysomething, as I held my father's hand and watched the life go out of him and felt him turn cold, I discovered a kind of heartbreak that makes all the previous pages seem trivial.

He was, like his cartoon *Robed Avenger*, a mild-mannered defender of the oppressed and occasionally an enemy of the guilty. He was and is the only hero of mine who wasn't a made-up character on TV, scoring right above Wonder Woman and the Fonz for first place. Picasso once said, "Every child is an artist. The problem is how to remain an artist once we grow up." My dad not only remained an artist, in many respects he remained a child,

seeing the world with a sense of wonder and maintaining the belief that all people are good. That's why, at times, it's so hard to believe that he's gone. He never seemed to grow old like other people, so I almost never expected him to die.

The good news is that I gained some faith on my trip to Pat Garrett's parking lot, in the idea that nothing ever dies. Strange to use the word *faith*, but the kind of faith I'm talking about has nothing to do with baptisms or bishops; it's about love and oneness, knowing that you are just a small part of something much bigger, a swirling mass of energy that's both broken and perfect and governed by some force that giveth and taketh away, and there's nothing you can do about the takething except to know that it will ultimately giveth back again. What this force is, I don't care. It makes things a little easier, this faith, which is why I'm sitting here, not wearing any pants, writing the epilogue for this book instead of drinking myself into oblivion. I'm not wearing any pants because I'm too excited about finishing this book in the next hour to bother putting pants on. However, because it's cold, I'm wearing a sweater.

I still live in the Troll Museum with Reverend Jen Junior, and I will probably live here until the building is condemned.

Faceboy and I still talk on the phone every day. Even though he's retired from hosting his open mike and I only host mine monthly, the scene is still going strong and is

still full of people who desperately need therapy but can't afford it.

Dog P lives in Hollywood and is now married and successful but, from what I hear, still wacky. The night before my dad died, Dog showed up in a dream and gave me a hug. I'm pretty sure on some subliminal level he knew I was about to suffer and he wanted to comfort me. I'm also sure that the feeling I got the first time I saw him means that we'll run into each other forever, even if it's only on the astral plane.

Monica also moved to Hollywood, but moved back to New York two years later, while Ennis, Zack, Bigfinger, Lorne, and countless other Art Stars have all made LA their permanent home. Tommy Bigfinger was working in the nanotechnology field but is now selling juice cleanses with the Hare Krishnas. Hank Flynn, who once ran down Broadway wearing only a bear head, is now a newscaster.

Brodeur ran for mayor, and I even voted for him; so did fourteen thousand other people. He sued the Giuliani administration for the time he spent at the Cross Bar Hilton learning about credit card fraud. Despite this, he also got thrown in jail by the Bloomberg administration.

Patrick no longer lives at Collective. No one lives at Collective anymore because once the fire department discovered people living there, they kicked everyone out. Then the building got sold to real estate developers. Then Collective moved to Tribeca across the street from Tribeca

Grand Hotel, where a beer costs $9. Collective stayed there for a few years before officially closing its doors.

I don't know what happened to the Midway residents, but imagine I'll see them on an episode of *Cops* someday.

Even though Alan Watts said that once you get the message, you should hang up the phone, Tom, Bruce, and I 'shroomed together a few more times post-Midway. The last time was in Maine, where we'd gone to escape the Republican National Convention in New York. Tom tripped so hard he looked at me and said, "It would be impossible to trip harder than this." I think he was right.

During that same trip I got terribly ill, something that's never happened to me on 'shrooms. A Wiccan girl who was there told me she would cure me. She held out a tarot deck facedown.

"Pick a card," she said.

"I want to pick the hardest card," I told her.

Grasping a card I could barely get my fingers on, I slipped it out and turned it over. The card I picked was Politics, and it featured the face of a gnarled, green politician holding a lovely porcelain mask in front of his face. He was smoking a cigar that turned into a snake with a forked tongue. Seeing as how we'd all just fled the Republican invasion, the card couldn't have been more appropriate. I cried and laughed so hard the nausea left me.

"Of all the beautiful cards I could've picked," I sobbed.

Bruce tried to hurl it into the fire but I stopped him.

"We need the cards no one wants," I said, remembering the Hermit card from years ago. I didn't get its meaning then, but now I do. I've heard the reason the Hermit is pictured walking is because he's on a spiritual journey. He symbolizes introspection and knowledge. His lamp is a symbol of the inner light of truth.

I'd asked the deck if I would ever find love again and that's the card it gave me—the card of self-discovery. It's not what I wanted, but it's what I needed.

Thanks to Facebook, I am now in touch with both Julia and Jeff. She lives in Ithaca but visited me a few weeks ago. We talked for hours just like the first time we met.

The first time I went to Central Park was with Julia. We were lying on the grass in Sheep Meadow staring at the sky when she suddenly said, "Tall buildings try to fuck the clouds."

New Yorkers don't just want to kiss the sky; they want to fuck it. New York is a city built on desire. This is why it never sleeps. New York is a city in revolt against the mundane.

The city will give you surprises, patience, and arrogance. It will give you the best and the worst sex, the best and the worst friends, and the best and the worst stories of your life. And it will actually give you a life if you don't already have one. In return, it will ask only for everything that you have. I live in discomfort in a tiny apartment where my sink, toilet, and shower are all in different rooms, within a

neighborhood that smells like ass. My country club is the bodega. My beach is my roof, and my backyard swimming pool is a shower in a closet in my kitchen. My wildlife consists of rats, squirrels, roaches, and whatever bacteria inhabit the toilet seats at Mars Bar. And I pay exorbitantly for this discomfort, because I love New York.

In return, New York embraces me, lets me kneel on its sidewalks, and do flat-outs on its pavement at sunrise as it reaches up to screw the sky. New York gives me every type of person, every type of food, and every type of activity known to man. It gives me more choices than 7-Eleven. In my neighborhood, there is a large dog run, a medium dog run, and a small dog run, all in the same park. There is a dildo store, a psychic, an Off-Track Betting, a methadone clinic, and twelve bars within a two-block radius of my apartment.

New York demands that its inhabitants engage in its revolt against the mundane. When Doo-Doo wrought havoc at the Disney Store and when the DLF twisted in Times Square, we were joining the city in the longest, craziest party ever thrown.

Of course, party crashers are inevitable. If you walk down Ludlow Street today, you won't find Collective Unconscious, Barramundi, or Luna Lounge. They've all been bulldozed to make room for luxury housing. Where Surf Reality once stood—where Art Stars paid $3 to drip sweat from nude interpretive dance—there is now a Bikram

Yoga studio where people pay $15 to drip sweat doing *clothed exercise*. Where Baby Jupiter stood, there is a French bistro. Where the first Collective stood, there is a bar that doesn't serve Budweiser. Italian wine bars have taken the place of bodegas that smelled like cat pee. People who carry golf clubs and tennis rackets now live in my building. The Lower East Side had seven storefront theaters in 1998. Now there are none.

And you still can't legally dance here!

Despite all this, I refuse to quit pursuing happiness here. I don't want to be one of those artists that reaches a certain age and then spends the next forty years bitching and moaning about how cool everything once was. I came to New York in 1990. Things haven't been cool since I moved here. I guess that makes me lucky. If I'd gotten here in 1980, I'd probably be in rehab right now.

I got here too late for the beats, Studio 54, *or* punk rock. But I tried to make my own party and transcribe the thoughts and feelings of the bohemians of the "most uncool generation" in the lamest, least sexy era in history. While other generations got Led Zeppelin and LSD, we got Starship and online instructions for growing our own 'shrooms. Historians usually refer to us as Generation X, though most historians don't bother to write about us at all. We're the kids who grew up aspiring to nothing more than being able to turn on jukeboxes with our fists like the Fonz. We're the slackers, the underachievers, the losers,

and we're faced with a world that's warring, starving, sick, and melting. While Prince wasn't right about 1999 being a par-tay, he was right that "we could all die any day." There is a lot of work to be done by us so-called slackers, and I hope that we can prove ourselves worthy and leave some kind of legacy for Generation Z, who are, remarkably, even worse than us.

But right now, I can't even bring myself to put on a pair of pants.

acknowledgments

There are a lot people and animals to thank for showing support and love as I wrote this book. These are just a few.

To Reverend Jen Junior, thank you for patiently hangin' out during my writing benders and for being loyal, wise, and fabulous. To Faceboy, thanks for encouraging me, not just to write but to stay alive too. To my family, thank you for raising me and not disowning me despite my misadventures. Wendy, thank you for being part of several of those misadventures. To my friend, Jonathan Ames, thank you for introducing me to my agent, Rosalie Siegel, who I also must thank for finding *Elf Girl* a publisher. And many thanks to Jennifer Lyons and everyone else at the Jennifer Lyons Literary Agency for continuing to work with Elf Girl and whatever lunancy I type up next. Huge props to Jeremie Ruby-Strauss, Emilia Pisani, and everyone at Simon

& Schuster for (obviously) putting this book out. To Julia, I offer gratitude for being a friend in New York when I had none and for being one half of the most spectacularly shitty rock band to ever exist. To Brid, Pan, Bast, Hecate, Venus, and all the other Deities to whom I pray, thanks for listening. To Murray, thank you for grooving with the eternal now. To Sam and Nancy, thank you for giving me computers on which to revise this after mine died in a massive steam explosion. To the Art Stars, I am grateful for the community and the continued yucks. In particular, I owe gratitude to Bruce, Tom, J-Boy, Uncle Steve Wenis, Prichard, Velocity, Kat, Mangina, Ken, Monica, Diva Queen, Raphone, Gerber, Hank, Moonshine, Gambine, Amato, Diane, Michelle, Rona, Holly, Taco, Starlet, Bigfinger, Ennis, Jen, Brer, Linc, Lorne, Milk Kan, J. P., Courtney, George, Izzy, Lisa, The Novices of the Old Ways and anyone who's ever performed at the Anti-Slam. Finally, I owe most of all to my father who taught me to be an artist. Dad, if they have libraries on the island of eternal bliss, I hope you read this and smile.